Other Books by Rudolf Arnheim

Art and Visual Perception: A Psychology of the
 Creative Eye
Visual Thinking
The Power of the Center
Entropy and Art: An Essay on Disorder and Order
Parables of Sun Light: Observations on Psychology, the
 Arts, and the Rest
The Genesis of a Painting: Picasso's *Guernica*
The Dynamics of Architectural Form
Film as Art
Radio: An Art of Sound

Collections of Essays

Toward a Psychology of Art
New Essays on the Psychology of Art
To the Rescue of Art

THE SPLIT AND THE STRUCTURE

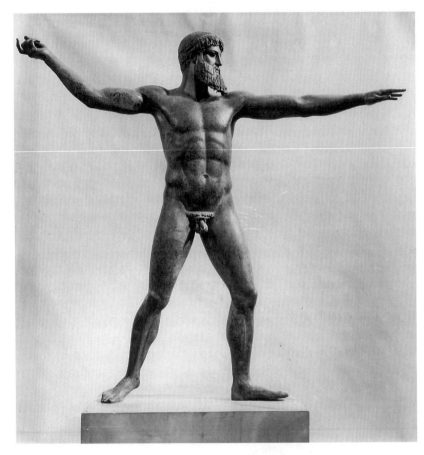

Poseidon. Greek bronze, fifth century B.C.E. National Museum, Athens.

THE SPLIT
AND THE
STRUCTURE
Twenty-Eight Essays

RUDOLF ARNHEIM

University of California Press

Berkeley · Los Angeles · London

University of California Press
Berkeley and Los Angeles, California

University of California Press, Ltd.
London, England

© 1996 by
The Regents of the University of California

Library of Congress Cataloging-in-Publication Data

Arnheim, Rudolf.
 The split and the structure : twenty-eight essays / Rudolf Arnheim.
 p. cm.
 Includes bibliographical references and index.
 ISBN 0-520-20477-8 (alk. paper).—ISBN 0-520-20478-6 (pbk. :
alk. paper).
 1. Art—Philosophy. 2. Artists—Psychology. I. Title.
N70.A688 1996
701—dc20 96–13346
 CIP

Printed in the United States of America
9 8 7 6 5 4 3 2

The paper used in this publication meets the minimum requirements of
American National Standard for Information Sciences—Permanence of Paper
for Printed Library Materials, ANSI Z39.48-1984.

To my Mary
as ever

Contents

Foreword ix

I

The Split and the Structure 3

Learning by What Is Around 13

Two Sources of Cognition 17

The Two Authenticities of the Photographic Media 24

II

The Way of the Crafts 33

Outer Space and Inner Space 42

Inside and Outside in Architecture 45

Drawings in Design 52

Notes on Religious Architecture 57

III

What Is an Aesthetic Fact? 65

From Pleasure to Contemplation 73

The Symbolism of Light 78

A God's Perfection 83

Gauguin's Homage to Honesty 85

The Echo of the Mountain 92

Deus ex Machina 97

A Maverick in Art History 104

IV

Learning by Looking and Thinking 113

As I Saw Children's Art 120

Artistry in Retardation 126

A System of Expressive Movement 133

V

The Face and the Mind behind It 139

Consciousness—an Island of Images 144

Form as Creation 151

From Chaos to Wholeness 156

VI

Two Ways of Being Human 165

Lemonade and the Perceiving Mind 169

The Dynamics of Problem Solving 174

Acknowledgments 179
Index 181

Foreword

The word "structure" appears for good reason in the title of this fourth collection of my essays. What is said in the book is guided, directly or indirectly, by the notion of structure. Structure seems to be needed as an arbiter wherever this civilization of ours is split by selfish interests and fighting for either-or decisions. The essays want to speak with the voice of reason, because they want to show how the parts require the whole.

Since polemical complaints about what is wrong are not my favorite response to the world, most of the essays explore the nature of structure affirmatively: how it comes about, what is the nature of its incentives and objectives, and how it celebrates perfection. I am trying to show how artists grope for structure to shape powerful and enlightening images and how the scientists' search for truth is a search for structure.

For this collection, quite a few essays have been thoroughly rewritten, and almost all others have been retouched.

Off and on also, as all this play of theories is presented, the audience will get a glimpse of the puppeteer, who looks up from behind the scene, to find out who is watching and listening.

I

The Split and the Structure

The arts, the sciences, and cultural life quite in general have to cope with a social and political problem that seems to resist a sensible solution all over the world. Wherever one looks and whatever one reads in the newspapers, the dominant subject is the violent conflict between people who do not get along with one another. Whole countries, but even the smallest communities, insist that their vital interests, their historical or religious traditions, and their present needs require them to be left alone. To live with their neighbors or to live under the same roof makes for insoluble conflicts. One argues, one shouts, one fights and murders. The world threatens to break up into particles, because there seems to be no other way out. The only safe way to survive begins to look like the towers of San Gimignano.

On the other hand, however, to do things in common is of obvious advantage and indeed a vital necessity. Countries make treaties to provide mutual help and to exchange goods. Trade barriers and border controls are cautiously lightened. Companies merge across the oceans. In the schools, the study of local cultures is supplemented with that of others abroad. Religious denominations look for common principles. Families help each other. Communication and cooperation is becoming more indispensable every day.

But how to reconcile these two contradictory tendencies? What we observe around us is distinctly discouraging. Few people seem to believe that one can bridge the opposite interests invested in clinging to separation and attaining union. The selfish and emotional motives of such narrow-minded behavior are all too obvious.

Much less attention has been paid to an equally influential difficulty, a problem of thinking. The human mind finds it more difficult to deal with complexity than with separate, single objects. Opposites are more aggravating than conformities. This makes for cognitive problems I propose to discuss in the following.

First published in *Michigan Quarterly Review,* vol. 31, Spring 1992.

One practical solution of the dilemma, often praised as particularly democratic, is compromise. In daily life, this is indeed acceptable. If my partner likes to walk fast but I need to walk slowly, we can settle for a medium speed—provided the concessions do not touch the core of our physical and mental requirements. More often, however, a compromise forces the partners into a structure that does not add up to a whole. It impairs one person to the advantage of the other, and vice versa. This may provide the incentive for creating a genuine new whole, but in and by itself it is a mere shotgun marriage of separate structures, each consistent within itself but leaving in their fusion an unremedied flaw. The strivings of each partner are disturbed or impeded by those of the others. The tension created by the discord may lead to a more unified whole, but it may also produce an explosion. Obviously, the desirable and more interesting solution is one in which the needs of all partners are fitted to a whole, leaving them without unresolved tensions.

This theoretical problem has been the central concern of such scientific developments as gestalt psychology. It raises practical situations to a level of abstraction at which the needs of the partners appear as directed tensions, that is, as vectors in a system of forces. From the beginning, such forces are never isolated. Their most basic striving, in the physical as well as in the psychological realm, moves toward a structure that obeys one basic condition. It wants to arrive at an optimal equilibrium, in which all vectors hold one another in balance to obtain a stable overall situation. This drive involves the tendency to attain the ideal structure at the simplest level compatible with it. A good gestalt is precisely such an ideal state. It is a configuration or pattern of entities operating at maximum efficiency. Psychological theory investigates the principles by which a gestalt achieves its optimal state of balance; it also explores the factors interfering with it.

The ideal state is most successfully approximated in the biological realm by organisms and in the psychological realm by the mind's highest aspirations in utopias or in works of art. In political practice, this state is never reached or even much thought about in earnest. The most admirable attempt to relate a social utopia to what actually takes place in the lives of nations is Jean-Jacques Rousseau's *Du contrat social*.[1] What he describes as the common will or popular sovereignty is the closest equivalent to the abstract realization of a good

The Split and the Structure

The arts, the sciences, and cultural life quite in general have to cope with a social and political problem that seems to resist a sensible solution all over the world. Wherever one looks and whatever one reads in the newspapers, the dominant subject is the violent conflict between people who do not get along with one another. Whole countries, but even the smallest communities, insist that their vital interests, their historical or religious traditions, and their present needs require them to be left alone. To live with their neighbors or to live under the same roof makes for insoluble conflicts. One argues, one shouts, one fights and murders. The world threatens to break up into particles, because there seems to be no other way out. The only safe way to survive begins to look like the towers of San Gimignano.

On the other hand, however, to do things in common is of obvious advantage and indeed a vital necessity. Countries make treaties to provide mutual help and to exchange goods. Trade barriers and border controls are cautiously lightened. Companies merge across the oceans. In the schools, the study of local cultures is supplemented with that of others abroad. Religious denominations look for common principles. Families help each other. Communication and cooperation is becoming more indispensable every day.

But how to reconcile these two contradictory tendencies? What we observe around us is distinctly discouraging. Few people seem to believe that one can bridge the opposite interests invested in clinging to separation and attaining union. The selfish and emotional motives of such narrow-minded behavior are all too obvious.

Much less attention has been paid to an equally influential difficulty, a problem of thinking. The human mind finds it more difficult to deal with complexity than with separate, single objects. Opposites are more aggravating than conformities. This makes for cognitive problems I propose to discuss in the following.

First published in *Michigan Quarterly Review*, vol. 31, Spring 1992.

One practical solution of the dilemma, often praised as particularly democratic, is compromise. In daily life, this is indeed acceptable. If my partner likes to walk fast but I need to walk slowly, we can settle for a medium speed—provided the concessions do not touch the core of our physical and mental requirements. More often, however, a compromise forces the partners into a structure that does not add up to a whole. It impairs one person to the advantage of the other, and vice versa. This may provide the incentive for creating a genuine new whole, but in and by itself it is a mere shotgun marriage of separate structures, each consistent within itself but leaving in their fusion an unremedied flaw. The strivings of each partner are disturbed or impeded by those of the others. The tension created by the discord may lead to a more unified whole, but it may also produce an explosion. Obviously, the desirable and more interesting solution is one in which the needs of all partners are fitted to a whole, leaving them without unresolved tensions.

This theoretical problem has been the central concern of such scientific developments as gestalt psychology. It raises practical situations to a level of abstraction at which the needs of the partners appear as directed tensions, that is, as vectors in a system of forces. From the beginning, such forces are never isolated. Their most basic striving, in the physical as well as in the psychological realm, moves toward a structure that obeys one basic condition. It wants to arrive at an optimal equilibrium, in which all vectors hold one another in balance to obtain a stable overall situation. This drive involves the tendency to attain the ideal structure at the simplest level compatible with it. A good gestalt is precisely such an ideal state. It is a configuration or pattern of entities operating at maximum efficiency. Psychological theory investigates the principles by which a gestalt achieves its optimal state of balance; it also explores the factors interfering with it.

The ideal state is most successfully approximated in the biological realm by organisms and in the psychological realm by the mind's highest aspirations in utopias or in works of art. In political practice, this state is never reached or even much thought about in earnest. The most admirable attempt to relate a social utopia to what actually takes place in the lives of nations is Jean-Jacques Rousseau's *Du contrat social*.[1] What he describes as the common will or popular sovereignty is the closest equivalent to the abstract realization of a good

gestalt. As I try to sketch social organization as an ideal structure, I am thinking of Rousseau's basic approach and many of his examples, even though his method differs from mine.

My attempt follows a recent study in which I derived a theory of composition for the visual arts from the general principles of structure.[2] Since these principles are abstract, they apply to any kind of organization. While focusing on the arts, I was alerted to analogies with social institutions, because by looking at an artwork one comes to see it not as a conglomeration of innumerable units, each separated from the others by its demands, powers, and attitudes, but as single configuration of directed forces. In the ideal case, these forces constitute one unified structure. In less integrated states, the whole may be beset by hiatuses and inconsistencies.

This is an unrealistic view, but it makes one look beyond politics committed to the particular aspirations of continents, nations, and individual parties of all sorts. If instead one considers the problem of structure in general, the striving toward a total, organized whole is revealed as a manifestation of a general law of nature that brings benefit when obeyed and damage when counteracted.

A first property of a structure is its range. How much space does it occupy? This is not merely a matter of geographical extension. Rousseau notes that "there are certain limitations for constituting of a State, to which, if it does not adhere, it ceases to be at its best. If it be too large, it cannot be properly governed; if too small, it cannot support itself" (bk. 2, chap. 9). The range of a structure is determined by how much it needs and can accommodate for its best functioning. When it stretches over more space than its resources can organize, or, conversely, when it is too restricted to properly unfold, the disproportion will lead either to an overly thin texture or to a stifling of its performance. In the latter case, it threatens to burst or to invade territories not free for occupation.

The available space, held by interacting forces, may seem to call for being organized by a single structure. Particularly this is the case when, in the words of Paul Valéry, "le temps du monde fini commence" (the time of the completed world begins).[3] A world in which everything depends on everything else needs a single overall structure. Such a structure, however, may suffer from tension-producing faults, which make separation preferable. The resulting separation may be total, or it may require a network of partial interactions with

neighboring structures. The functional range of a structure may not coincide with its geographical expanse and not even with its own practical reach. When a civil war between Islamic and Christian forces upsets Algeria, France, still intimately connected with the former colony, cannot afford to ignore what is going on across the sea. On the other hand, medieval city-states, in spite of their proximity, fought each other as enemies. Even in the minds of many modern citizens, such as Mediterranean populations, the structure of their life space does not reach beyond the limits of the local community. The authorities at the nation's capital remain foreign, hostile powers, whose impositions and demands are either ignored or resisted. In Germany, after the collapse of the Nazi regime, the only functional structure remaining among the ruins was the family, struggling to take care of its own needs and defending itself against an outer world of threats. In ancient Athens, the give and take of the community excluded the slaves, who served as a mere resource. Even so, no structure can afford to act as a separate entity as long as it is subject to antagonistic or alien forces within or beyond its borders.

The best solution comes from the given structural conditions, not from arbitrary impositions. Boundaries between entities should derive as necessary splits between their structures. Rather than being confined by fiat, structures should confine themselves. According to Chuang Tzu, the cook of a Chinese prince explained to his master that a good cook never has to sharpen his knife, because when he has to carve the meat of an ox he puts his hand on it, presses with his shoulder, his foot, and his knee, and right away the skin splits and the knife slides smoothly between the natural sections of the body. "Excellent," exclaimed the prince, "I have heard the words of a cook, and I have learned how to deal with life."[4]

Any structure is made up of directed tensions. The interplay of these vectors creates the network of relations, which the structure weaves into a whole. The strains of energy interact within the structure and balance it. The balance of all vectors aims at limiting it to the minimum of tension it can afford. But not all vectors are constructive. Some act destructively. They disturb the structure by applying at the wrong place, at the wrong strength, or in the wrong direction. They upset the balance of the whole and create tensions straining for adjustment. They are the stuff of unrest, revolution, or earthquakes, which in the long view may be welcomed as attempts to straighten the way for a more constructive state of affairs.

Another feature of structure to be considered here is growth. Just as it is natural for organisms to grow physically, the mind aspires to make things get bigger. Acquisitions, however, become a productive gain only when they are properly integrated with the structure. Therefore, anything added to a structure is first of all a problem to be solved. Immigrants are an acquisition that may eventually enrich a country's structure, but in the beginning they are a problem. The acquisitive drive of a collector or of a colonial power makes for nothing better than an accumulation of properties, unless and until the structure is transformed into the larger whole containing and absorbing the new parts as necessary components. Growth simply for growth's sake, growth just to keep production going, is a purely commercial ideal, not compatible with the health of the structure when it overburdens the structure with more resources than it can use. The question is always: How much growth can we afford? How much growth do we need?

Growth goes with change, and change again is not merely quantitative but qualitative. In the pursuits of the mind, new discoveries and inventions keep the structure in a continuous flow of transformation. This prevents the development from proceeding in a straight line. There are leaps and retardations, obstacles and shortcuts. When in a study of Picasso's painting *Guernica* I analyzed the single sketches and phases in their temporal sequence, I had to face the artist's skips from conceptions of the whole composition to explorations of details, from returns to earlier stages to anticipations of the final solution.[5] Picasso also searched among various styles to present the same object. Only by a survey of the whole creative process could I realize how the gyroscope of the work's structure steadied it to maintain its overall consistency.

Psychologically as well as physically, every structure is focused on a center. In the simplest case, the center is provided explicitly by a person, an agency, or in the organism by a nervous system. The central ruler controls the functioning of the whole, which holds the entity together and in balance.[6] More commonly, each component of the whole has its own capacities and idiosyncrasies, and the art of obtaining perfect functioning consists in placing and employing them all in such a way that their role is in keeping with the free display of their nature.

A good artist accomplishes this feat in his work as an uncontested autocrat. He invents and arranges his material in such a way that no

destructive vectors cause inappropriate constraints and distort the structure. In the political realm, tyrants are rarely that skillful or that considerate, because such a ruler is himself too much a part of the score he is conducting. The ideal ruler is rather like a chess player who empathizes with the tasks and risks of the individual figures but directs their moves from above and outside the board, always with his eyes on the objective to be obtained by his team.

An active center makes for the easiest and most persuasive kind of structure. One knows who is in power, to whom one can apply, and who is to blame. A religion centered on a personal deity satisfies elementary thinking. But the organizing power of a structure may not reside in an actually given agency. Sometimes, works of art such as paintings do indeed present an explicit central figure or object, which determines the composition of its surroundings. But the center may also be empty. In that case, the central function is met collectively by the configuration of the vectors making up the whole. The totality of the individual arrows and weights creates a balance that determines its center without giving it an occupant. By reference to the center's virtual presence, each part defines its own place and function in the whole.

Such an organization requires a higher level of intellectual understanding than does an autocracy. Authority is not imposed by a central agency. It comes about only by the cooperation of all. Socially, such a system needs not only the active participation of all citizens; they also must be trained in their rights and duties and become acquainted with the issues to be decided by them. The knowledge, beliefs, and strivings of the citizens act as traits of the vectors in the structure. Rousseau says that "if there were a nation of gods, it would govern itself democratically. So perfect a government does not suit humans" (bk. 3, chap. 4). It may be impractical, but to strive for it is nevertheless desirable.

Theoretically, the total expanse of the field—in our case the entire planet—is governed best from a single center. It makes sense that areas depending on one another should regulate their interrelations by one overall system. Such a unity, however, is not only hard to obtain, it is also threatened by monotony. Although an all-embracing structure does not exclude the variety of the parts, it tends to suppress it, because every structure is pervaded by the powerful penchant toward simplicity and parsimony.

Every part, however, is a center of its own, ruled by its own organization. Properly balanced, therefore, a confederation of centers must give each member enough independence to flourish in its own individual fashion. At the same time, it regulates the give and take of each by the stewardship above.

Under pathological conditions, the partners act as rivals threatening to overpower each other or at least to compete. This makes the structure expend an unhealthy amount of energy on means of defense, which ought to be spent on the productive development of each and every unit. This is why any competition hampers the best functioning of a structure. To be sure, competition enhances activity, but it also distorts it by making people strive for a maximum achievement rather than the most suitable kind and degree of it. The healthful functioning of the human body, for example, is not served by athletic competition, nor does a commercial enterprise do its best for the community by trying to outsell its rivals. Any structure should reserve its resources for what is required by its own optimal state rather than waste them on unbalanced relations with its neighbors. Such a pathology upsets the give and take between countries. An example may be when one of them drains its energies by the consumption of addictive drugs, and this, in turn, distorts the economy of other countries by making them concentrate on the production of the drugs. Destructive vectors in one center of the structure are counteracted by equally destructive vectors in other centers. Such a skewed balance harms the whole as well as its parts.

Structures differ in the level of their dynamics. They may be in a state of tranquillity or at some level of agitation. In the arts, the level of arousal distinguishes Gluck's music from that of Beethoven or the Parthenon from a Baroque building by Borromini. At each level of dynamics, a fully successful organization can be achieved. A quiet folksong can be as perfectly structured as the breathless commotion of a Bach fugue, and the low level of change in one nation or one single family may make for as perfect a functioning whole as the restless turnover in another.

I hope to have shown how difficult it often is to overcome the narrow perspective of a social unit, a group or an individual, faced with the cognitive and emotional task of seeing its place and function in the whole structure. It is natural enough to be conscious of little but one's own needs and desires and to look egocentrically at the rest of

the world as means of serving one's own dynamic "vectors" and as an array of obstacles to one's freedom. Rousseau asked, "how can a man be free while he is subject?" In his essay on the concept of democracy, Max Wertheimer refers to a one-sided notion of the freedom of the press. "There are instances in which the principle of freedom of the press is used simply as a special case of freedom of business enterprise, of the right of an individual to make profits. Combine it with the principle of free speech, free self-expression, and, if only these two are taken into account, the result may be emphatic assertion of the right not to be bothered."[7]

If one has not learned how a structure is held together by the interaction of its components in the whole, one sees instead a mere agglomeration of pieces, each self-contained in its competitive struggle with the others. One may try to cope with this situation by proclaiming equality for all—equality, however, in the primitive sense of allotting the same to everybody, thereby ignoring the variety of abilities and needs that distinguishes people from one another. The result would resemble the distressing sight of a tract of row houses.

The common practice of running a democratic country is again that of treating it as a collection of pieces. One copes with the problem of a large population by governing through majority vote. This may be the only solution available, but it remains a makeshift, just as does compromise, to which I referred before. It is not obtained by cooperating to work out a structure satisfactory to the whole community, as is aspired to, for example, in Quaker meetings. Instead, one forces the needs of the minority into submission. Such repression creates destructive tensions.

What, then, is freedom? Obviously, it does not consist in everybody being allowed to do what he or she pleases. Nor can the constraints needed for the functioning of a community be left simply to the individual units, which do whatever they can get away with and use the powers they can master to fight their rivals. Instead, only the structure of the whole can determine the range of unhampered breathing space and action due to each component. Just as a chamber music player learns to express himself freely within the role awarded to him by the composition, and just as every element of a good painting looks free, but happily useful at its place on the canvas, an ideal social structure distributes its inherent dynamic tensions not by destructive repression but by the free functioning of all.[8]

It remains for me to point out that the requirements of structure serve also as a guide to ethical behavior. It is true that the rules of conduct may be decreed from above by religious or secular authorities. But when one looks at what such commandments call for, one finds that many of them aim at a well-structured community. These same objectives have been on the minds of thinkers through the ages. Whether they define the target as human happiness or as the perfectible resources of human nature, the aims of morality are surprisingly similar through time and space, because they derive basically from the requirements of the one human nature. Good and bad, virtue and evil are criteria for prescriptions of how to attain a workable social structure.

What has the foregoing discussion suggested for the relation between the split and the structure? We live only too obviously at a time when the split is more evident than the structure. Bloody wars between political and religious enemies destroy whole countries and threaten the peace of whole continents. Foreigners and immigrants are attacked by inhabitants. In governmental bodies, parties try to defeat one another rather than to cooperate. In education, a narrow-minded pluralism advocates a piecemeal dealing with as many nationalities and races as possible instead of striving for a coherent image of the highest achievements of humanity anywhere. On the other hand, powerful political or economic forces produce fusions that undo sensible divisions and necessary distinctions.

All the more important does it seem to be to realize that all the many active forces strive for the creation of structures, however selfish and short-sighted the approach may be in individual cases. Experience also tells that no solution puts conflicting tensions to rest until a workable balance has organized the whole. We know that it is in the nature of ideal solutions to lie beyond the vanishing point in the infinite. But unless we steer toward perfection, we are bound to fumble in the void.

NOTES

1. Jean-Jacques Rousseau, *Du contrat social ou Principes du droit politique* [1791]. Transl. *The Social Contract* (New York: Collier Macmillan, 1947).
2. Rudolf Arnheim, *The Power of the Center*, new version (Berkeley and Los Angeles: University of California Press, 1988).

3. Paul Valéry, *Regard sur le monde actuel* (Paris: Stock, 1931), 35.

4. Chuang Tzu, *Basic Writings* (New York: Columbia University Press, 1964).

5. Rudolf Arnheim, *The Genesis of a Painting: Picasso's "Guernica"* (Berkeley and Los Angeles: University of California Press, 1962).

6. Arnheim, *The Power of the Center.*

7. Max Wertheimer, "On the Concept of Democracy," in Mary Henle, ed., *Documents of Gestalt Psychology* (Berkeley and Los Angeles: University of California Press, 1961), 46.

8. Rudolf Arnheim, "A Plea for Visual Thinking," in *New Essays on the Psychology of Art* (Berkeley and Los Angeles: University of California Press, 1986).

Learning by What Is Around

In an obituary for Tamara Dembo, Joseph de Rivera wrote, "When she began her pioneering work in rehabilitation psychology, most people saw a person without legs as a 'handicapped person.' She, however, saw a person who could not go up the stairs. She saw the stairs as handicapping the person and successfully argued for ramps and elevators."[1]

Of course, to do so should also be considered one-sided, although entirely justified in this case by the challenging nature of the statement. But it would mean seeing the situation simply as the sum of separate entities, the impaired person and the stairs and then the relations between them. Such a separation makes for a conceptual distinction between the person with his or her self-centered goals and the surrounding environment, consisting of human society with its own demands and conditions and the world of objects with its variety of offerings and obstacles. Even now, to use a recent example, the psychologists Shan Gruisinger and Sidney J. Blatt, while pleading for a proper balance between the two social powers, argue that "evolutionary pressures of natural selection result in two basic developmental lines: interpersonal relatedness and self-definition, which interact in a dialectic fashion."[2]

I propose to limit myself in the following to the relations between the person and the surrounding world of objects, where the conceptual split has been evident. The best example is James J. Gibson's dealing with "affordances." How are people's needs taken care of by the objects surrounding them? They do so by offering "affordances," that is, properties suitable to satisfy the needs. To use Gibson's example, a letterbox affords the means of depositing mail. "Perhaps the composition and layout of surfaces *constitute* what [objects] afford." Gibson's consistent ontological mix-up of what is physical and what is phenomenal makes him assert that the physical characteristics *are* what anybody else would call the psychological traits of what objects offer to do. Objects, being physical, do not change. "The affordance

of something does *not change as the need of the observer does.*"[3] Therefore, in Gibson's view, there is a strict separation between observers and the objects of their needs.

Tamara Dembo never thought that way. She was a disciple and collaborator of Kurt Lewin. To Lewin, the psychological situation was an integrated field, in which neither the observer nor the observed objects exist in isolation. What matters are the dynamic forces, the vectors that issue from the person and from whatever else populates the environment, be they persons or objects, in motion or immobile. "Only by the concrete whole that comprises the object and the situation are the vectors defined which determine the dynamics of the event."[4]

The difference between a view of the world as an assembly of more or less separate objects, supplied with forces they send out or receive, and the modern view of a world that is no longer made up of objects but entirely of directed forces has changed our outlook fundamentally. By their very nature, such forces cannot be seen as isolated entities. They interact as a symphony—a dynamic field of vectors.

More specifically, the field is made up of centers of energy, sending out directed forces, often in response to forces deriving from other centers. In part, these forces support each other, in part they interfere with, deviate from, or merely modify each other. In practical life, this accounts for the infinity of interactions between the objects and actions constituting our environment and our own ways of going about our daily business.

The mere presence of things reminds us of what needs to be done and where and how the business should be accomplished. Our world is beset with signals of opportunities, duties, and warnings. This enhances our efficiency of conduct considerably.

Civilization has facilitated our chores, but at a high price. Transportation is a good example. Airplanes and subways get us to our destinations quickly and with little investment of our own energy. But we also lose the awareness of time and space, the very meaning of distance. Our senses miss the world of images and happenings on the way, which made for the pleasure of traveling. Climbing takes an exertion, but the very exertion is also an essential aspect of why climbing is sought as an enjoyable experience.

Compare the operation of a sailboat with that of a motorboat. The sailboat conveys the joyful contest between humans and nature. It engages all our abilities of observation, thought, and muscular control.

The motorboat cuts straight through the water by its own energy and is much less responsive to the complex dynamics of water and wind.

Learning by interaction is the most effective way of learning by experience. A child not stifled by too many toys learns by handling the things lying around: what they let it do and what they resist; what they can be used for, even though such use has to be discovered; what they are made of, inside and outside, and what happens when they are bent or broken. This invaluable way of learning is curtailed when television rules the day. With all the information television provides, it cripples the most productive acquaintance with the world.

The experiences of artists exemplify the dynamics of interaction at a less physical level. It has always been known that the work truly flows when it is taken over by the challenges of the task itself. The properties of the material or medium come into confrontation with the artist's conception, which gradually takes shape in the mind, in a dialogue with what the eyes see appearing in the work. The painter or sculptor watches the problems posed and the solutions offered by the constellations of visual energy centers in the shapes and colors of the work in progress. The visual vectors require a subtle balancing of the various directions and strengths. This same balancing of interacting vectors is equally needed elsewhere in every statement of thought and theory, but nowhere else does it offer a similar concreteness of spatial display. Hence the value of some training in the arts for education in the sciences and humanities.

Being located at some place within an environment provides also a primal training in overcoming self-centeredness. The perspective from the self's station point is a powerful first fact of information. What is distant and therefore hard to reach differs from what is close by. Things hang together and perhaps overlap or are remote from each other, depending on where the viewer is placed. Children learn by experience that this configuration does not persist unchanged when they move in space. The primary, subjective configuration is gradually replaced by an objectively existing one, which has its own way of being immobile or changeable. There is no better preparation for the relationship among persons, which is so much less directly perceivable.

One problem that has puzzled some theorists is how exactly the appeal of being used comes to inhere in objects in the first place. Gibson has given a good account of the affordances, that is, the physical properties enabling objects to be useful. How one comes to realize

their usefulness was then simply a matter of practical training. Such a description, however, ignores the spontaneous appeal certain objects seem to display as an aspect of their perceptual appearance. This is what Lewin had in mind when he originated theoretical thinking about this matter. He spoke of *Aufforderungscharakter,* that is, the invitational quality in the appearance of objects. (The concept was rendered in English by the bland term "valence.")[5] But how does such an invitation get into the percept? A simple example is that of a bowl. Its hollowness involves the dynamics of outer vectors moving into it, quite apart and before any thought of its practical use. It is true that such an expressive quality resides by no means in the shape of all objects. To a larger or smaller degree, however, and often only in some of an object's parts, such as the handles of tools, this inviting quality exists, especially in objects made by humans. Designers know that objects must not only fit their practical use but must also invite and guide the mind and limbs of the user.

The invitations inherent in a situation are rarely strict commands impelling the perceiver to obey. Lewin points to the varying degrees of freedom determined by the conditions of a situation. The freedom of choice depends in part on the strength of the local conditions but also on the range of a person's knowledge of what has happened before and what might follow. Interaction with the presently given takes place in the context of what we know about the past and the future.

I have given examples of the obvious fact that in our daily pursuits we depend on the objects surrounding us. What the examples will have shown and what matters is that persons and objects are not separate entities, supplied with relations that affect each other. Instead, all these components, persons as well as objects, behave as centers of energy, interacting dynamically in fields of forces. Viewed in this manner, our world comes alive as a happening of expressive events.

NOTES

1. Joseph de Rivera, "Obituary," *American Psychologist* 50 (1995): 386.

2. Shan Gruisinger and Sidney J. Blatt, "Individuality and Relatedness," *American Psychologist* 49, no. 2 (1994): 104–11.

3. James J. Gibson, *The Ecological Approach to Visual Perception* (Boston: Houghton Mifflin, 1979), 127, 138.

4. Kurt Lewin, *A Dynamic Theory of Personality* (New York: McGraw-Hill, 1935), 29.

5. Ibid., 77.

Two Sources of Cognition

There have been many impressive opportunities to observe the differences of the responses to world events by persons who derive their information mostly from television and those who rely mostly on the political reports of good newspapers. The differences are due to a multiplicity of causes, of which a most important one is the difference between visual images and spoken or written language. Television, although by no means lacking in speech, is dominated by vision. When, for example, the audience listens to a speaker or the performance of a pianist, the person of the performer on the screen dominates. He or she appears as the generator, whereas the speech or the music is merely the product. This switches the emphasis from the thoughts or the art someone has to offer to the person himself or herself. It has greatly contributed, for example, to the personality cult that has affected our political and cultural life so harmfully.

The cognitive difference between things seen and things read or heard is evident when one listens to how people respond to catastrophic events such as wars, acts of terrorism, or earthquakes. The television audience is impressed by the effects or symptoms of the disturbances, the violence of the attackers, the suffering of the victims. By contrast, those who listen or read are led to the causes of the events, to judgments on who is to be credited or blamed, and what should be done to remedy the damage. Obviously, the latter response is intellectually superior and more needed for a sensible conduct of human affairs. Any neglect, however, of what the direct evidence of our senses tells us about the impact on human experience may make the thinker overlook the human and practical consequences of what is wrought by the political and social forces at work.

In what follows, I will not deal with the broad social ramifications of the problem. I will limit myself instead to some aspects of what can be learned from a comparison between comprehension derived

First published in *Advances in Visual Semiotics* (Berlin: Mouton de Gruyter, 1994).

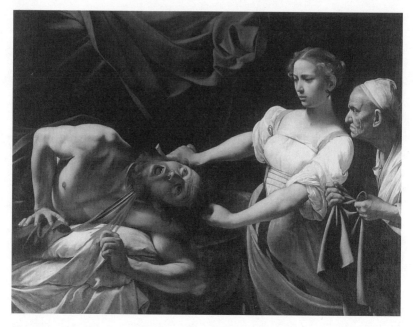

Figure 1. Caravaggio, *Judith and Holofernes* (1595). Galeria Nazionale di Arte Antica, Rome.

mostly from sensory perception or controlled mostly by the intellect. I will therefore go by the following two assumptions.

1. All comprehension of reality relies on two sources, namely the reality of sensory experience and the media of representation. Each of these two sources operates by conditions of its own; but both rely on conceptual structures.
2. All media of representation rely on perceptual as well as intellectual concepts; but the concepts of the visual media are more perceptual, while those of the verbal media are more intellectual.

To begin with, the following example will compare a narrative painting with the story it represents. When visitors to the Palazzo Barberini in Rome come across Caravaggio's painting *Judith and Holofernes* (fig. 1), they are struck first by the gruesome scene, the decapitated man, and the contrast between the calm determination of the heroine and the horror on the face of the maid. They may notice details of shape and color to flesh out the presence of the event. The biblical story is condensed in time and space. A single highlight has

been selected from the temporal sequence of action. The dreadful episode is frozen and made permanent. As such, it will monopolize the memory of visitors. Spatially, the setting is limited to the narrow tent of Holofernes, where the relevant elements of the story are assembled. The maid, who in the traditional story waits outside, is brought in as a witness, clutching the bag in which she will collect the head of the dead man.

If a visitor happens to consult the book of Judith in the Apocrypha, he or she will find the moment of the assassination remaining as the climax but embedded in a chronicle that extends in time and space. The visual concreteness of the happening is replaced with an enumeration of the actions performed. The reader learns of a political struggle between the king of Assyria, who insists on being not only the ruler of the whole world but also its only god, and the people of Persia and the Near East, who are resisting him. In the text of the story, Holofernes, the king's general, displays a complex state of mind, limited by no means to the brutality of the enemy. He is outwitted by Judith, who saves not only her hometown, Bethulia, but the highest sanctuary of the Israelites in Jerusalem. The story acquires its emotional drama in the imagination of readers, who derive lively mental images from what they have been told.

The comparison between the painting and the chronicle illustrates the difference between an essentially visual medium and an essentially verbal one. What needs to be stressed here in a more generally theoretical way is that all cognition of reality derives from perceptual experience, which provides our only access to reality. Perception, however, is not simply the mechanical absorption of received material. Perception, as distinguished from mere staring at the world, always involves the imposition of a network of concepts derived from the sensory raw material. Concepts are congealed generalities, whose nature depends on the medium that happens to generate them.

Every act of cognition requires such a network of concepts, regardless of whether it applies to a purely perceptual object such as a painting or to a verbal text. To decipher the painting, the viewer must first derive and impose a network of organized shapes and colors, without which the picture would not be comprehensible. This formal image is seen as the representation of the subject matter, which also must be understood as an organized network of relations. How does the stark parallelism of Judith's arms relate to the crooked arms of Holofernes, how the upright head of the heroine to the falling head

of the victim? How does the stance of the maid echo that of her mistress? How do the intricate turmoil of the bedclothes, the descending cloud of the tent's curtain, the bag clutched by the maid, and the free swing of Judith's gown comment on the behavior of the humans?

Readers of the chronicle, in turn, have to decipher first the verbal text by resorting to the network of syntactic structure and by grasping the relations between the various agents of the story. How does the ruler of Assyria relate to the more local assault on the Israelites? How does the private life of Judith relate to the political events in her country? Furthermore, because verbal language is a referential medium, the words of the text must be made to evoke mental images of the story; and these images call for a similar kind of conceptual structuring as does the viewing of a painting.

Broadly speaking, every act of cognition is located somewhere on a scale between two bases of departure, namely the exuberant complexity of perceived reality, which supplies substance, and the conceptual structure of a medium, which supplies form. Both are indispensably involved in every case. The mental development of cognition, phylogenetic as well as ontogenetic, takes off from a need of practical orientation. It endeavors to single out and identify isolable facts and happenings. One needs to tell humans from animals, trees from water. In consequence, early cognition conceptualizes a few significant items and builds the world from them. As an example, I mention the cosmology of the pre-Socratic philosophers, who derived physical reality from elements such as air, water, earth, or fire. Something similar is true of early pictorial representations. Figure 2 offers a particularly beautiful example of such an early stage of cognitive development. It is as elementary as early thinking and equally remote from naturalistic detail. It is a sample of folk art created by the Warli tribe of India. Such work is highly abstract, in the sense of staying close to the abstractness of perceptual concepts. All shapes of the painting cling to basic geometry. The house is composed of right-angled units, parallel relations, and overall symmetry. A similar simplicity describes the tree, whose structure is revealed as the hierarchy of trunk, branches, and leaves. The figures of a man and a woman threshing rice or grain have only minimal distinctions portraying their sex or costume, and the three dimensions of space are reduced to two, so that the bundle of straw lying on the floor looks to us as though it were floating up in the air.

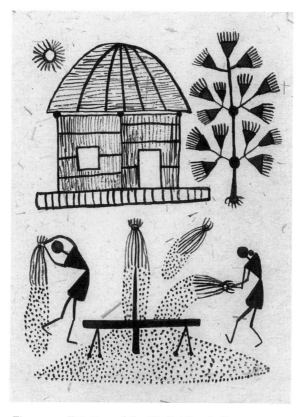

Figure 2. Painting of the Warli tribe, India.

By no means, however, does such early abstraction diminish the immediacy of lifelike action. On the contrary, the powerful expression of basic shapes enhances the action, the bending of the bodies, and the flow of the grain. This compelling immediacy of expression tends to be weakened by the complexity of naturalistic representation. The violent action of Caravaggio's *Judith* is brought to the eyes of the viewer essentially by what it preserves of the basic perceptual features of dynamic shapes.

It follows that the simpler levels of representation are not inferior in quality. All levels rely on the virtues of both sources of cognition. At every level of complexity, works of representational and aesthetic excellence can be created. Together they make up the whole, precious range of human vision and thought.

It is at the extremes of the scale that problems exist. The most radically conceptual worldviews hardly do justice to reality. A universe built on nothing but fire or water leaves out too much, whatever the majesty of its idea. Atomic physics reveals the very foundation of the material universe, but it does not pretend to enclose in its worldview the immediacy of human experience. And nonobjective visual art or mere ornament risks losing its relevance to what we can see and touch. At the other end of the scale, the intricacy of, say, a detailed argumentation or a narrative account may lose its structure of guiding forces and thereby interfere with its intelligibility.

What is the particular place of language in this system of cognitive media? A language is a stabilized set of signs, which serve as referential concepts by being assigned to known facts of reality. Nonverbal examples of such sets are sign languages, musical systems, or the multicolored sets of chips used to test the intellectual abilities of primates and other animals. Verbal languages share with these nonverbal sets the quality of being almost purely referential. They receive their meaning from convention. Although these meanings are derived from perceptual experience, they are products of their medium and partake in the preferences of media in general and the idiosyncrasies of their own medium in particular.

Most media work with segregated entities and refer only indirectly to the structure of the perceptual raw material, which presents a more or less coherent tissue. Within the precinct of the media, verbal language is the most comprehensive instrument of cognition. It embraces the sensory world in space and time as well as mental images, motivational forces, emotion, and rarified intellectual abstractions; but even the references of language to the world of experience remain purely indirect.

As far as the differences between verbal and nonverbal language are concerned, I will cite only the obvious example that many verbal languages treat things and actions as separate entities, whereas the directly perceptual media, especially the ones presenting movement, such as pantomime or film, display them as aspects of an inseparable experience. This creates obvious problems for the translation of perceptual experience into words or vice versa. An even more fundamental difficulty arises from the fact that verbal statements are sequential because they describe temporal happenings or logical trains of thought, whereas spatial simultaneity, such as the structure of a

painting or a panoramic situation such as the state of world affairs at a given time, yields only reluctantly to a translation into sequence.

I have tried to show that all cognitive exploration, whether it takes place prevalently in the intellectual realm, as in science or philosophy, or in the perceptual realm, as in the arts, must rely on organized structures of concepts, which are derived from the congealing of sensory raw material. Both means, the resources of direct experience and the instruments of concepts, are needed, whether by a scientist or an artist or indeed by any person curious about the world where he or she is living.

The Two Authenticities
of the Photographic Media

A dramatic episode in a recent court trial in Los Angeles has made us explicitly aware of the juridical, ethical, and aesthetic aspects of authenticity in the photographic media. A videotape taken of the action of four white police officers, who had stopped and brutalized a black motorist, was used as evidence to show whether the police had used unacceptable violence or whether their behavior was appropriate to what their duty required. During the trial, the truthfulness of the tape was challenged because it had been modified by such means as slow motion and stop action. This had been done to inform the jury most clearly of the decisive facts. The same modifications, however, were challenged because they changed decisive qualities of the crucial event. "Slow motion minimizes the violence. In the real world, a faster blow is a harder blow; a slower blow is softer. . . . Slow motion also makes the beating seem less real and more fantastic."[1] Stop motion also broke the dynamic impact of the action, and the removal of the soundtrack diminished the presence of the event even further.

Quite apart from the political drama of the trial, the episode could not but remind us of an ambiguity that has plagued the aesthetic and epistemological theory of the figurative arts. To the extent that the arts were representational, they aspired to a faithful rendering of the facts of reality; but in order to make their images comprehensible to the human mind they had to select, shape, and organize the material taken from reality—they had to find and impose form. By doing so, however, they had to partially reshape the facts of reality perceived by the eyes. Hence, aesthetic theory had to put up with a compromise.

Another way of presenting the problem is to say that the figurative arts are always dealing with two kinds of authenticity. They are authentic to the extent that they do justice to the facts of reality, and

First published in *Journal of Aesthetics and Art Criticism*, vol. 51, Fall 1993.

they are authentic in quite another sense, as they express the qualities of human experience by any means suitable to that purpose. The latter, the aesthetic function of representations, is greatly helped by the former, which offers recognizable images of creatures and objects. But the latter hampers rather than supplements the former: the fancies and liberties of the human imagination are anything but authentic when taken as documents of physical reality.

This dilemma was sharpened by the advent of photography. The mechanically obtained pictures revealed more clearly than the handmade images of artists ever could that when the imitation of nature was taken literally it could not fully meet the requirements of art in its usual sense. In his essay "Salon de 1859," Charles Baudelaire had published a section on "Le Public moderne et la photographie," in which he praised the ability of the new medium to serve the sciences and the arts, but only as "their very humble servant" without any further pretenses, "just as the printing press and shorthand have neither created literature nor added to it." But he warned against the popular craze for photography as the ideal fulfillment of what painting had always aspired to. "A vengeful God has answered the prayers of this multitude; and Daguerre was his Messiah."[2]

The competition between the two aspirations of authenticity has characterized Western figurative art ever since antiquity. On the one hand, great painters were praised for imitating nature so perfectly as to deceive humans and animals, and the sculptor Pygmalion's ivory statue was suitable to be transformed into a real woman. The striving for ideal perfection was always to be combined with lifelikeness. Once photography was able to take lifelikeness literally, however, it revealed more clearly the inherent imperfection of physical appearance. The accidental shape of individual specimens interfered with the search for canonic perfection and beauty, and the confusing untidiness of the sights projected by the camera lens tended to make images unreadable. It took training to read photographs, as we know from the puzzled responses of tribal natives confronted with them without preparation.

During the early decades of photographic art, one tried to maintain the standards of traditional painting by the proper selection and arrangement of subjects and by camera devices such as soft-focus lenses. Gifted portrait photographers such as David Octavius Hill and Robert Adamson were able to take advantage of the long

exposure time demanded by the early photosensitive material. Through the mere summation of accidental moments, they captured the lasting character and superindividual beauty of their sitters.

A preference for paintinglike photographs survives in the present; but it also has become clear that the photographic medium finds its highest achievement in works that preserve and stress the specifically photographic qualities of instantaneous exposure, the momentary revelation caught by the photographer as a vigilant hunter. Instead of concentrating on authenticity in its second meaning as pictorial composition, the best photographers obtained their finest results from the deliberate display of the fleeting moment. Even so, its most gifted representative, Henri Cartier-Bresson, never neglected what he had learned as a painter, namely, that no image conveys its meaning and expression readably without being carefully composed.[3] By entrusting himself to what he could frame with the viewfinder of his camera, he insisted that the photographer's "attitude requires concentration, a discipline of mind, sensitivity, and a sense of geometry."[4] The skillful union of the two authenticities became the program of both photographic media, still photography and film.

The new concern with the passing moment aroused an interest in the dimension of time, explicitly introduced into the photographic medium by the motion picture. Not only did the new invention enlarge enormously the range of phenomena accessible to visual art and thereby broaden the medium's authenticity of the first kind, it also shifted the aesthetic emphasis. It enriched authenticity of the second kind by focusing on action. This new worldview was formulated in 1960 in the principal thesis of Siegfried Kracauer's book *Theory of Film*.[5] It stressed the affinity of the photographic medium with the transitory, the indefinite, the fortuitous, and the indeterminate—an approach whose broad philosophical aspiration became even more evident when Kracauer, in a posthumous work, applied the same qualities to history.[6]

Kracauer's intention was most clearly expressed in the subtitle of his book on film, which called for "the redemption of physical reality." This claim was most timely, but it was also one-sided in that it neglected the indispensable contribution of interpretive form.[7] The opposite was true of my own book, first published in 1932. Devoted to "film as art," it was written to refute the belief that the photo-

graphic medium was nothing but a mechanical copy of the optical projection of nature.[8] I showed that by the framing of the image, its reduced depth, its limitation to black and white, and other qualities it used its restrictions of the optical image as an aesthetic virtue. I claimed for the film the traditional qualities of art. Thereby, however, I all but neglected the "documentary" aspects emphasized by Kracauer. In practice, any photograph or film partakes of both authenticities, because, as the poet Alphonse de Lamartine had said, it is "a solar phenomenon, where the artist collaborates with the sun."[9]

I will now turn specifically to the means by which the photographic media endeavor to make their images readable. Thereby they meet the conditions of any communication, be it aesthetic or merely informational, as for example in the sciences. To be readable, the image must be limited to what is required by the statement, it must be organized in an orderly fashion, and it must do so in such a way as to convey the intended meaning. In the case of science, this meaning refers merely to factual information; for the purpose of the figurative arts, the information is presented in such a way as to convey the desired expression.

This condition meets the demands of what I have called authenticity of the second kind. I have shown that it can only be partially met by the photographic media. More specifically, it makes a difference whether the means chosen by the photographer or filmmaker are derived from the medium itself or whether they are borrowed from pictorial technique. The first method works quite smoothly, the second is more risky.

The first procedure is familiar from the work of the cameraman and the film editor. The shots taken by the camera are framed and selected; the editor combines the suitable segments in the appropriate order. Viewers can be and should be aware of these formative interferences, which, however, do not harm the integrity of the chosen material. Almost equally compatible with the photographic media are combinations of several shots, fitted together in one coherent picture. They look like possible documents of physical reality, although they are not. They are not authentic in the first sense. An early example is the so-called combination printing of Oscar G. Rejlander, who fitted several negatives together in one picture.[10] More skillfully, Jerry N. Uelsmann has created mysterious fairy worlds of perfectly convincing landscapes and interiors, where positive and negative material,

giant size and miniatures fuse seamlessly.[11] In these works, the photographic medium rules undisturbed over dream kingdoms that look entirely trustworthy, and only the better knowledge of the viewers discloses that they are not.

The techniques used for such works are authentic in the second sense by creating convincing images; but they do not interfere with the nature of the medium. Our analysis of the photographic media shows that the video material introduced at the court trial to which I referred in the beginning obtained certain aspects of authenticity of the second kind. It elucidated some features of the physical episode under discussion at the trial by using slow motion and stop action—devices often used in scientific demonstrations or artistic interpretations, as, for instance, in the stop-motion or time-lapse films of growing plants. But those video shots also modified certain other aspects of the scene, which interfered with the material's authenticity of the first kind.

Thus far, I have discussed the picturemakers' techniques of shaping the material taken by the camera in one of two ways, namely, by deriving their approach from the resources of the photographic medium itself. Other formative procedures are taken from pictorial techniques, of which retouching is the oldest and the most obvious. The most legitimate use of retouching eliminates accidental flaws to obtain pictures that present the essentials of the subject in the clearest fashion, for instance, in photographs of machines or anatomical preparations. Retouching is also employed for the more objectionable embellishment of portraits or landscapes to obtain the cheap effects of prettiness and false perfection. Authenticity of the second kind depends on the validity of the interpretation obtained—a validity determined by documentary or aesthetic criteria: How fully has the interpretation of the essentials been achieved, for example, by an illustrator of scientific publications? How strong and meaningful are the images created by an artist?

It remains for me to refer to the latest technological development, which is likely to have far-reaching influences on the documentary and aesthetic character of the photographic media. Digital photography translates the photochemical image by computer into a mosaic of dots, or pixels, whose color and brightness can be altered at will. This dismantles the image's shape, which can be retained or altered in any of its elements. It increases the formative power of the imagemaker, and, when applied to the extreme degree, it becomes a pic-

torial technique like drawing and painting—with the difference that it can also avail itself of the particular techniques of computer graphics. When applied only slightly, however, digitalization will amount simply to a more refined procedure of traditional retouching.

What a pictorial technique, whether traditional or digital, cannot do is to duplicate the "snapshot" qualities of the photographic media, that is, the accidental, fugitive qualities recognized and appreciated as specifically photographic. I have pointed out that in the characteristic works of a good photographer like Cartier-Bresson the authenticity of the first order is deliberately sought and left untouched by the formative means of the second order, which is used to obtain a suitable composition. Similarly, discriminating viewers know that they cannot look for the total formative control of such a picture but that they are faced with a cooperation between nature and the human mind. Whether the traditional definition of art should be broadened to include such works or whether they should be called partial art is a decision that can be safely left to the Beckmessers. What matters is that the difference between the two kinds of authenticity needs to be respected.

If digitalization takes over to the extent that the photographic quality all but disappears, the distinction between the two contributing sources can no longer be made. William J. Mitchell, in his book *The Reconfigured Eye*, which has a most complete documentation on the subject, says that "the digital image blurs the customary distinctions between painting and photography and between mechanical and handmade pictures," and he concludes, "we have entered the age of electrobricollage."[12]

In any case, the digitalization of the photographic image will increase the distrust of the information offered by still photography and film. The initial belief that the new medium guaranteed the reliability of images had to be checked by increasing skepticism. The more the photochemical material of photography and film becomes subject to surreptitious modification, the more its consumers will learn to be on their guard. How much this caution will be strengthened by the digital technique only the future will tell.

NOTES

1. Patricia Greenfield and Paul Kibbey, "Pictures Imperfect," *New York Times*, April 1, 1993.

2. Charles Baudelaire, "Salon de 1859: Le Public moderne et la photographie," in *Oeuvres complètes* (Paris: Gallimard, 1961).

3. *Henri Cartier-Bresson* (New York: Aperture, 1976). Peter Galassi, *Henri Cartier-Bresson: The Early Work* (New York: Museum of Modern Art, 1987).

4. Galassi, *Henri Cartier-Bresson.*

5. Siegfried Kracauer, *Theory of Film: The Redemption of Physical Reality* (New York: Oxford University Press, 1960).

6. Siegfried Kracauer, *History: The Last Things before the Last* (New York: Oxford University Press, 1969).

7. Rudolf Arnheim, "Melancholy Unshaped," in *Toward a Psychology of Art* (Berkeley and Los Angeles: University of California Press, 1967).

8. Rudolf Arnheim, *Film as Art* (Berkeley and Los Angeles: University of California Press, 1957).

9. Alphonse de Lamartine, quoted in Beaumont Newhall, *The History of Photography* (New York: Museum of Modern Art, 1964), 61.

10. Newhall, *History of Photography,* 69.

11. Steven Klindt, *Jerry N. Uelsmann* (Chicago: Columbia College, 1980).

12. William J. Mitchell, *The Reconfigured Eye* (Cambridge: MIT Press, 1992), 7.

II

The Way of the Crafts

My choice of a country in which to spend a Fulbright year was Japan, because I wanted to live awhile in a place where the arts were not confined to museums and galleries but were still needed to shape the style of daily living and the objects of practical use. When I arrived in 1959 for a year of teaching, I was still early enough to witness much of this tradition, although Westernization was already making its mark.

What I was looking for was still evident in the way salesgirls folded an object in a sheet of wrapping paper or how children sitting in the subway were making origami cranes without paying much attention to what their hands were doing. It was also evident in the arrangement of food on the dishes at restaurants.

But common though this sense of exquisite design was in the daily practice of the people, its appreciation had all but vanished from the consciousness of professionals, who were increasingly attracted by Western standards and taste. It was therefore a revelation for me to come in touch with the work and thought of a few distinguished craftsmen and particularly the leader of the folkcraft movement, Soetsu Yanagi, founder of the folkcraft museums in Tokyo and Kurashiki. Not only did Yanagi all but rediscover the high quality of the ordinary production in traditional handmade utensils, he also found in the craft products of earlier centuries the standards to be recommended for the professional principles and moral attitudes of today's craftsmen and designers. A collection of his essays, translated with the help of Japanese scholars by the British potter Bernard Leach, a close friend of Yanagi's, should be must reading for all practitioners and theoreticians of the applied arts.[1]

What I propose to offer here is another look at two basic concepts, namely, function on the one hand and, on the other, what goes by the

First published in *Design Issues*, vol. 9, Spring 1993. Reprinted by permission of MIT Press.

name of the "aesthetic" or is called beauty in the more old-fashioned way. I can rely on an earlier essay of mine, now in need of fresh for-mulation.[2] This new look has been much encouraged by what I learned from Yanagi.

The architect Tom Heath has stated with particular clarity that there is an urgent need for the resolution of the conflict between two doctrines, functionalism, formulated essentially in terms of the eco-nomic demands of the owner and the practical needs of the user, and the aesthetic values, dear mostly to the architect and the designer and thought of as attractive shape, harmonious relations, and good pro-portions.[3] Attempts at overcoming the dichotomy between the two principles by redefining their one-sided definitions have not been lacking, and it is in the spirit of these attempts that I discovered in Yanagi's ideas a revealing confirmation.

Yanagi found the prototype of what he recommends as the desir-able approach of any practitioner of the applied arts in the work of artisans, "unknown, humble, and usually illiterate" (97), active in the Korean countryside during the Yi dynasty from the fifteenth to the nineteenth centuries. Remarkably, this cheap mass production, in-tended for the production of rice bowls for the daily use of the Ko-rean peasants, was imported and selected by the Japanese masters of the tea ceremony because of its exquisite formal qualities. This was around 1600, but its appreciation was revived by Yanagi and his fol-lowers. When I visited the great potter Shoji Hamada (fig. 1), a life-long friend of Yanagi's, at his country home in Mashiko, what he pulled out from his closets to show me were not his own pots but Ko-rean ones, his prize possessions.

How can one explain the existence of such artistic quality without the training of our art schools and the academic standards of aesthetic excellence? To us it would seem paradoxical that the mass production of daily utensils—nowadays one of the causes of lowered quality—did make, according to Yanagi, for the excellence of those popular products. Tradition, he shows, had gradually polished shape and pro-duction method, and the constant repetition of a piece of handiwork had perfected an elegance of stroke and sureness of proportion.

Hamada had two kilns, a small one and a huge one, capable of holding thousands of pots (fig. 2). I remember peering into the smaller one and admiring the colors of its glazed inside, brilliant like precious jewelry. When Hamada was asked why he also needed the

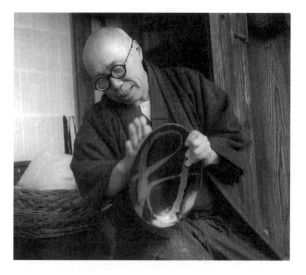

Figure 1. Shoji Hamada finishing a plate.

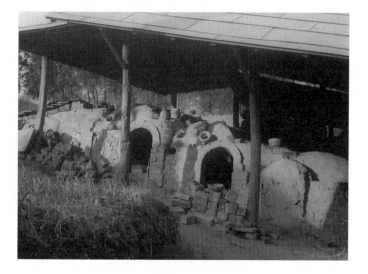

Figure 2. Hamada's smaller kiln at Mashiko.

large kiln, he answered, according to Yanagi (224), that when he worked at the small one his own self was in unchallenged control, with all the fallibilities of a single individual. When he worked at the large kiln, "the power that is beyond me is necessary. Without the mercy of such invisible power I cannot get good pieces."

As a Buddhist, Hamada was referring to the supreme law of nature, to which the artist must subject himself if he is to work in harmony with the necessitudes controlling not only nature but also the work of humans. This is not thought of as a repression but on the contrary as an increase of freedom, the way a sailboat gains its freedom by surrendering to the power of the wind (133). Our Western experience also has made us familiar with the frequent statements of artists and designers who report that true success is granted to them when the work's own inherent requirements take over and tell them what needs to be done.

What then are these requirements? I have become increasingly convinced that the notion of function, so fundamental to all applied arts, deserves to be broadened in its application to include much of what goes now under the heading of the aesthetic. This would help to overcome the conflict between the two principles and would greatly unify and simplify our answer to the question of what the arts are for and about.

As an example, one may think of the quest for economy or parsimony in the applied arts. A basic demand in the production of objects or buildings is that the work be done with a minimum investment of time, material, and labor. This same demand, however, operates also in the natural sciences, especially in physics. In a well-known statement in book 3 of his *Principia Mathematica*, Newton says: "Nature does nothing in vain, and more is vain when less will serve; for Nature is pleased with simplicity and affects not the pomp of superfluous causes." Newton describes the behavior of nature, but he clearly recommends it also as a model for the behavior of scientists and philosophers. Quite in general, when people have a good understanding of nature, they will deal with it wisely. Newton thinks also of ethical behavior, of modesty and simplicity.

Simplicity is equally familiar as a statement for and by artists. This was first raised as a theoretical principle by the psychologist Gustav Theodor Fechner in his *Vorschule der Aesthetik* of 1876, in a section entitled "The principle of the economical use of means or of the minimum measure of energy." He discusses the theory that in physiology

the aesthetically beautiful is likely to be also the scientifically correct description and that works of art should limit themselves to the minimum of what is needed to obtain their purpose. He wonders whether the principle of the smallest measure of energy might be put "at the head of the entire aesthetics."[4]

Quite in general, whether for the arts or indeed for any factual statement, parsimony has come to be recommended as a way of limiting oneself to what matters and avoiding distracting digressions. At times, all ornamentation was banned, to the extent of being considered immoral. (Remember Adolf Loos's famous pronouncement that "ornament is a crime.")[5] Simplicity as an aesthetic demand has been applied especially in Japan since the seventeenth century as the virtue of *shibui*, referring to what is austere, subdued, restrained, and also to quietness, depth, simplicity, and purity. (Yanagi refers to it on page 148.) When the masters of the tea ceremony selected the Korean rice bowls, they admired them because they were made without any artistic pretense and just for the purely practical use of the peasants.

The relation between unpretentious shape and the affinity of materials to nature was also deliberately stressed. For example, in the small buildings of Katsura Palace in Kyoto one notices among the wooden posts supporting the roof an occasional one left as an untreated tree trunk. The qualities of natural materials were and are appreciated not only visually but also by touch. The "teamasters were particular how the rims feel to the lips" (193)—a sensitivity we have not lost. When in Japan one takes the traditional hot bath in a wooden box, *ofuro*, the skin of one's body enjoys the affinity with the warm wood—how different from the hard glaze of our own tubs, which remain cold and foreign in spite of the hot water!

A reverence for nature went with the awareness that the shape of things is due to organic growth and that it was desirable therefore to retain the signs of the making in craft work. In the pottery chosen for the tea ceremony, "the shapes are irregular, the surfaces dry or sandy, the glazes of uneven thickness" (120). Yanagi insists that this is the decisive reason of the preference for "irregularity" in Japanese art, and he points to its derivation from the Buddhist belief that the things of our world are not constant and stable but in permanent flux of coming and going. This is convincingly described also by Kakuzo Okakura in the chapter on the tearoom in his *The Book of Tea*.[6] The Western preference for perfect and final shape derives, according to Yanagi, from the tradition of Greek rationalism, which resulted finally

in our industrial machines. By its very nature, the machine product displays perfect shape and symmetry, but the finality of such perfection also disavows human nature as living, growing, and changing.

Among the welcome imperfections of pottery was the "potential beauty" of fine cracks. I remember that when Bernard Rudofsky, the author of *Architecture without Architecture*,[7] was in Tokyo he photographed the tape mendings in cracked store windows as a demonstration of the artful quality of those patterns. The beauty thereby produced may indeed be called potential, because it derives from the unself-conscious sense of form guiding the lowly makers of such patterns and the people who appreciate them.

The sense of form manifests itself also in the preference for simple, regular, and often symmetrical shapes, which, needless to say, is not only a product of the modern machine but serves as the very foundation of visual order and orientation. Like the disposition toward parsimony, it is of the highest functional value. Therefore, all early building and artwork originate in simple, symmetrical shapes. Their reaffirmation in machine products greatly contributes to the practical and formal value of our modern tools of life.

There is a further aspect of functional value that is not commonly acknowledged as a property of the applied arts and considered instead a monopoly of the fine arts. Yanagi uses his chapter on the tea ceremony to discuss "the profundity of normal things" (185). By serving the ritual of contemplation, the tea ceremony tells how to see the objects of utility as pointing "to the Ultimate." The best example I can think of to illustrate this pretentious-sounding demand is the ancient royal tombs I saw on Okinawa, all but hidden in the lonely silence of an overgrown hill. I was told that their unusual shape represented the maternal womb, so that its simple door, which is opened and then walled up again each time it is used, is the entrance for the corpse but symbolizes also the egress of birth. Thus, the functional container for burial offers by its shape a powerful image of the inseparable unity of life and death.

Now obviously, such profundity does not suit all functional objects. A stepladder, a pocket knife, or a dentist's chair is not suited for symbolizing the Ultimate and would in fact violate its own function by trying to do so—as did the lions' feet on old-fashioned bathtubs. There exists, however, a hierarchy of degrees by which the shape of an object should reveal the meaning of its function. A chair may stand

for any stage of meaning, from the purely practical support of the seated body to the austere simplicity of Shaker furniture and the splendor of a throne. One can also look at a chair as a purely functionless object, as did Picasso when in 1961 he cut and welded a chair from metal sheets (now in the Musée Picasso in Paris). Nobody can sit on it, but one enjoys a sculptural study of obliquely tilted verticals around a central horizontal base—a play of visual relations that has a meaning of its own. It is not a chair, however, but only a reminiscence of one.

I have discussed ways of craftsmanship by the example of folk art, whose working method, style, and social setting may seem so remote as to be irrelevant to the modern designer. This objection is pertinent in many ways. But it needs to be remembered that, for example, the touch and imprint of the human hand, this precious quality, is still cherished not only in many styles of the fine arts but also in some good modern craft work of pottery, wood, and metal. Then again, not only today but in traditions distant in time and space from ours the traces of human "imperfection" have been removed and replaced by the venerable tools of the lathe, the plane, and the wheel. The perfection of shape and order that these tools obtain connects their products seamlessly with those of the latest devices of technology, the machines and computers. The criterion of acceptable quality of form remains what it always was, namely the question: is the maker's intuitive judgment in charge of the tool, or does the tool force the maker to accept its own preference of mechanical monotony and repetition?

Yanagi insists that the concern with individuality, the admired acquisition of the Renaissance, was all but absent in the best craftsmanship and that this accounts for the consistent excellence of its work. By concentrating on the task rather than the special achievement of the maker, the craftsman avoids the willful accidentals of personal whims. In conformance with the accepted style of the culture or period, the crafts also remain in keeping with the basic principles, which derive from the very nature of the medium. Our own civilization has been much harmed by the misinterpretation of "originality." In our commercial setting, original is what is different from the products of the competitor and therefore more likely to be chosen by the consumer. But originality more sanely understood reaches back to the origin, namely to the basic demands of the task. Under

such conditions, what matters is not who wins. Competition is understood rather as the shared endeavor to obtain the best result in a common enterprise.

Individuality, therefore, should be welcomed as an enrichment of new ways by which the common enterprise is furthered. It risks losing the guidance of the underlying principles, but those are never relinquished in the highest achievements of the applied arts, be they the Parthenon or the Ronchamp Chapel or the Barcelona Chair. Even works of high complexity are supported and are visually graspable by being based on a simple "structural skeleton," as I have called it.[8] As a single example I will mention Benvenuto Cellini's golden salt cellar, which he made for the king of France in 1543. The two figures representing the sea and the earth are intertwined in a symmetrical triangle of two inclined axes, and it is only because of this elementary schema that we can read the detailed design.

If, then, functionality deserves to be called the all-embracing formal principle of the applied arts, as well as the fine arts, what becomes of beauty, the prize concept of the aesthetic and so frequently evoked by designers? In popular parlance, the term refers to what is harmonious and well proportioned—embodied in our beauty queens. In aesthetic theory also, the beautiful has been commonly defined by these same properties, its function being limited to what arouses pleasure. For this reason, the aesthetic has come to be distinguished from function in its more practical sense, as I pointed out in the beginning.

One arrives at a more relevant meaning of beauty if one remembers that beauty is considered an essential criterion of validity by physicists and mathematicians. In a pioneering article, the physicist P. A. M. Dirac has written that "it is more important to have beauty in one's equations than to have them fit experiments."[9] And the mathematician G. H. Hardy has said that he was interested in mathematics only as a creative art. For him, there was "no permanent place in the world for ugly mathematics," and a mathematical proof should resemble a simple and clear-cut constellation of stars in the sky. Such a theorem, he said, is distinguished by "a high degree of unexpectedness, combined with inevitability and economy."[10]

The scientist's criteria of beauty turn out to be the same that I have shown in the arts, both applied and fine. Their indispensable functional purpose is to produce a clear, unambiguous means of giving form to a purpose.

NOTES

1. Soetsu Yanagi, *The Unknown Craftsman* (New York: Kodansha, 1972). Citations by page number will appear in the text.

2. Rudolf Arnheim, "From Function to Expression," in *Toward a Psychology of Art* (Berkeley and Los Angeles: University of California Press, 1967).

3. Tom Heath, *Method in Architecture* (New York: Wiley, 1984).

4. Gustav Theodor Fechner, *Vorschule der Aesthetik,* pt. 2, sec. 43 (Leipzig: Breitkopf and Härtel, 1925).

5. Adolf Loos, *Trotzdem* (Vienna: Prachner, 1931).

6. Kakuzo Okakura, *The Book of Tea* (Rutland: Tuttle, 1956).

7. Bernard Rudofsky, *Architecture without Architecture* (Garden City, N.Y.: Doubleday, 1964).

8. Rudolf Arnheim, *Art and Visual Perception* (Berkeley and Los Angeles: University of California Press, 1974), 92.

9. P. A. M. Dirac, "The Evolution of the Physicist's Picture of Nature," *Scientific American,* May 1963, 47.

10. G. H. Hardy, *A Mathematician's Apology* (Cambridge: Cambridge University Press, 1967), 113.

Outer Space
and Inner Space

Outer space has acquired its meaning only very recently, namely, when we succeeded in occupying dwelling places outside the Earth. Of course, astronomers have known for some time what the physical conditions on other planets and the stars might be, and for even a much longer time they have speculated on what things may look like on those alien surfaces. So too have the dreamers and the science fiction writers. But the notion of a truly different world, as distinguished from our terrestrial own, has really taken hold of us only since human beings set foot on the moon and were able to see our planet from that distance.

Coming to think of it, the decisive step did not require our actual presence on that foreign soil. What really made the difference was the first photograph, taken probably by a satellite and showing us the Earth in its colorful otherworldliness. It was not the physical distance but the visual detachment that made the difference. This should remind us that when we talk about spaces, about outer space and inner space, we are not referring primarily to physical facts. What we are dealing with is the psychological experience of our senses.

Once we are aware of this fundamental fact, the whole panorama changes. No longer are we concerned primarily with a world of objectively given things and spaces, quite independent of where we take our stand and from where we look. Instead, we realize that this objectified world of things and spaces is revealed to us only indirectly as a late acquisition, even though it may be our final, triumphant achievement. What comes first is a preparatory vision, however, that we never truly overcome. It is the world as experienced, the world as seen.

The puny, accidental, unimportant place from which we envisage

Presented at *Arttransition* for the Center for Advanced Visual Studies at MIT, October 1990; first published in *Leonardo*, vol. 24, no. 1, 1991.

the world is singled out as the center of the universe by virtue of the fact that it happens to be the only station point directly granted to us. Viewed from this center, there is no distinction in principle between outer space and terrestrial space, and indeed not even between outer space and inner space. There is no borderline between near and far, since everything is seen, first of all, in perspective. The moon remains, first of all, the shiny miracle that entrances the poets, the children, and the barking dogs. And only from that shiny image can the cosmologist, the telescope, and the astronomer take off.

For the moment, this switch of approach takes our farsighted vision away from the distances and makes us concentrate, with a new respect, on the narrow setting that gives us the stage on which our minds and bodies perform their daily duty. We are urged to do this, in part, because by exploring the conditions of our close environment and by thinking about them we are enabled to handle our practical affairs. But we also come to realize an even more important fact: The principles and laws by which the world at large can be understood are derived from observations made in our nearest surroundings, and they engage not only the distance sense of vision but also the vicinity sense of touch. Consider how fundamental to our understanding of the universe in all its aspects is our close and direct experience of the difference between near and far, up and down, vertical and horizontal, large and small, mobile and still. Without those concepts and the immediate experiences from which they derive we could not have begun to deal with the spaces beyond the direct grasp of our senses.

But there is more. Beyond our senses, the world is endless; but endlessness, by its very nature, can only be conceived globally. It cannot serve as the matrix for the particular things the world contains. Think of the notion of an endlessly expanding universe. We can manage an image of the whole as an evermore inflating balloon, but only if we give it a shape by imagining it as confined by a spherical skin. This confinement gives the world a center around which it can be pictured to expand. In doing so, however, we are depriving the world of its endlessness, the very property we are trying to grasp. In true endlessness there is no center, the center being everywhere and nowhere, and there is no direction, since motion occurs in all directions at the same time. There is no orientation in infinite space and no difference between motion and stillness, no difference between largeness

and smallness. Shipwrecked in this overwhelming immensity, we gratefully grabbed Newton's notion of absolute space, and when this was no longer admissible we were rescued by Einstein's insistence on the absolute speed of light.

Absolute measurements supplied us with the tools needed to keep thinking, but they also meant our return to the narrow environment of our domestic space. One of the great benefits of this domestic space is that basically it has the shape of a box. When in the fifteenth century Western painters began to define realistic space, they preferred to give their subjects the form of a boxlike interior. Such a confined shape facilitated orientation. It reduced the spatial dimensions to the vertical and the horizontal, and it supplied a dynamic counterpoint between the self of the viewer and the walls of the box. The viewer's self occupied the center, from which it sent out expansive energies in all directions. Instead of losing themselves, however, in endless space, these centrifugal energies were met by the counterforces rebounding from the walls. The self found its powers defined by an inner space.

We can clarify this situation by referring to the difference between convexity and concavity. The expanding self operates in convex space, a world populated by convex objects displaying their outer surfaces in an endless realm. But once caught in an interior, be it the Pantheon or a room at home, the self is surrounded by the concavity of inner space. Now it is captured in a narrow world, a world, however, that by its very restriction supplies the dimensions of the whole.

We understand now why architecture deserves to be called the queen of the arts. Like no other medium, architecture produces its creations by the interaction of outer space and inner space. In outer space it roams without boundaries through a world it fills at its own best judgment with neatly defined, surveyable units and whose interrelations it controls as the ruler. It defines our world as a social organization, in which we are not alone. At the same time, as the creator of an inner world, architecture leaves us to ourselves, free to invent and discover the rules and harmonies of the whole. By shaping for us the interplay between the outer and the inner worlds, architecture offers us the setting in which we can conduct our more particular business.

Inside and Outside
in Architecture

The words "inside" and "outside" reflect a dichotomy in direct experience. Inside and outside cannot be seen at the same time. This dichotomy reminds the psychologist of the corresponding one in his own field. The behaviorist, ignoring the inside of the mind, dwells in a world of external objects, animate or inanimate. These objects are defined by what they look like and what they do. Their appearance, complete in itself, points to no inside but leaves room for inferences on the nature of a hidden core. Conversely, the introspectionist, dwelling within the mind, can conjecture on the observer's own outer appearance only from what is sensed inside. One cannot see one's own face. The world as perceived from the introspectionist's viewpoint is never truly outside; it is rather an extension of the inside—a collection of obstacles and opportunities, as Freud has described the totality of the non-self. In psychology as well as in architecture, the two approaches, although exclusive of each other, require each other, and in both fields the need to integrate the two is a principal challenge.

Henri Focillon, in *La Vie des formes*, asserts that practical experience is limited to the approach from the outside. "Human movement and action," he says, "are exterior to everything; man is always on the outside, and in order to penetrate beyond surfaces, he must break them open." Therefore, he believes that architecture accomplishes an "inversion of space," to be considered its greatest marvel. "The unique privilege of architecture among all the arts, be it concerned with dwellings, churches, or ships, is not that of surrounding and, as it were, guaranteeing a convenient void, but of constructing an interior world."[1] It is true that architecture alone among the visual arts has to deal with outside and inside, although it shares with literature this privilege of reflecting the basic dichotomy of the mind. But by no

First published in *Journal of Aesthetics and Art Criticism*, vol. 25, Fall 1966.

means does the conception of the interior require an inversion of ordinary space experience. On the contrary, the sensation of being surrounded is primary and universal: the maternal womb, the room, the house, the valley, the canyon of the street, the final enclosure of the horizon and the hemisphere of the sky—they all belong together and are always with us. The primary awareness of being inside is directly reflected in the house as a surrounding shelter and in the semi-spherical sky of the architectural vault or cupola. It is supplemented secondarily by the experience of being outside of other things. Gaston Bachelard in his poetics of space, *La Poétique de l'espace,* points out that a metaphysics starting with the moment in which existence amounts to being "thrown into the world" is a metaphysics of a second position. It neglects the earlier state of being as well-being, symbolized by the maternity of the house.[2]

The primary world of the inside is complete. Regardless of whether it is limited or endless, nothing exists outside of it. Bachelard makes this point while discussing completeness and roundness: "Seen from the inside, without exteriority, being can only be round."[3] An architectural interior is the totality of what can be seen at the time. Hence its curious independence of size: it can be called large or small only by indirect comparison with things seen before or afterwards. The outside of a building, on the contrary, is inevitably dependent on the size of the surrounding space and the other objects contained in that space. Therefore, a building, seen from the outside, looks more clearly large or small.

If outside and inside cannot be seen together although the unity of the two is essential, how then is architecture possible? Obviously, either view must be supplemented by what is known about the other. But this knowledge cannot be purely intellectual, because intellectual knowledge and visual imagery do not fuse. Only images unite with images. Fortunately, a particular view of an object can also include aspects of the object that are not presently visible, although they are as visual as what is directly seen. I *see* the back of the vase I look at, and I *see* its hollow interior—which is fundamentally different from merely *knowing* that these aspects are there. Similarly, I see a building as containing an interior, and I see the inside as being fronted by an outside.

Here, another obstacle may seem to arise, deriving from a mistaken application of the theory of figure and ground. The textbooks of psychology have Edgar Rubin's figure of a goblet, whose outlines

can also be seen as two profile faces looking at each other. The figure demonstrates that one and the same contour looked at from the outside produces a shape (goblet) completely different from the shape seen from the inside (faces). The one cannot be recognized in the other, and the two cannot be seen simultaneously, only alternately. Both of these effects would seem to be fatal to architecture.

There are, in fact, architectural examples to bear out this predicament. When looked at from the inside, the Statue of Liberty, which is made of a thin sheet of metal supported by an armature, looks like a puzzling accumulation of hollows, senseless and without any resemblance to a human body. Attics, crawl spaces, and similar inside areas not intended to be "seen" often look like the back of a front—a front, however, unrecognizable from the inside because all concavities have turned into convexities and vice versa. This is so because the back of the front is seen as "figure," not as ground, and to the extent to which this is also true for some aspects of legitimate interiors a similar effect may be produced by them.

But it is only necessary to walk through a traditional church to realize that the walls and vaults and ceilings are not simply positive shapes, looked at from empty space, the way we look at a piece of sculpture. They are rather the shell of an air volume that fills the interior and in the midst of which we find ourselves. The internal shape corresponding to the external convexity of a cupola is not so much a concave hollow surface as it is a second, internal dome, made of air. Instead of two contradictory aspects created by the outer and the inner surfaces of the stone construction—one of them convex, the other concave—we perceive two volumes, fitted into each other, like the cores in the old flatirons or the foot inside the boot. Nested volumes can indeed be visualized as a unitary percept.[4]

The architect, then, keeps the interior of a building from being a mere backside residue of the outside by giving it the shape of a positive air volume. He thus expresses visually the fact that an interior is not empty space, as a geometrician would have it, but filled with a meaning of its own. This meaning of the interior is carried out spatially through the dynamics created by the axes and shapes of the air spaces. For example, there is horizontal movement through the nave and aisles toward the altar of a church and away from it; and there is a vertical ascension, gradually converging toward the center of the rib vault, the dome, or the ridge of the roof.

These dynamic air volumes bear out the role of the human beings in the building. They guide their minds in the proper directions and amplify their strivings to the large size of architectural dimensions. Hence the channeling and the heightening of our own being that we experience in a successful interior.

One of the fundamental differences to be noted, therefore, is that as we approach a building we are outside its stone volume, in open space. We are spectators. Rather than being elevated ourselves we are treated by the building to a spectacle of elevation. Indoors, however, we are an integral part of the interior. We are essentially, although not entirely, with and within the air volume filling a shell of stone. And here indeed is the strongest obstacle to the unified conception of a building. For although it is true that nested volumes can be visualized as a unitary percept, these volumes are not to be viewed from a common station point, as are the flatiron and its core or the boot and its foot. The outside must be viewed from the outside. But to look at the inside from the outside would mean to miss its nature; it must be viewed from its own inside. The unification of the two perspectives, produced by the two station points, has to overcome an antagonism. That is, the parallelism of exterior and interior shape is complicated by a counterpoint of views.

Windows and doors, large and transparent though they may be these days, do not commonly let us see the inside of a building. They let us peep at the inner core of the outside, which is quite another matter. A building may present itself as the container of a precious content, for example, of a statue of Athena; or it may appear as a center of radiation, for example, when the lights emerge from the windows at night. Henry Moore placed into his hollow sculpture a second solid, resembling a chrysalis in its cocoon. Compare these examples with what might be called the lantern type of modern building, which permits us indeed occasionally to get a glimpse of what it is like to be inside. Inversely, what a person in a building sees through the windows is the setting around the building, not its exterior. As I said before, one cannot see one's own face.

The architect's visual concept must unify these antagonistic aspects of the building. The task is further complicated by the obvious fact that outside and inside do not always parallel each other as strictly as do the outer and the inner surfaces of a ceramic bowl. Where such parallelism is approached, for example, in Romanesque

churches, the solid stone construction appears almost like a transparent shell, expressing a reassuring limpidity and simple frankness. The composition of the east front of St. Servin in Toulouse, where, in the words of Focillon, "the volumes build up gradually, from the apsidal chapels to the lantern spire, through the roofs of the chapels, the deambulatory, the choir, and the rectangular mass upon which the belfry rests,"[5] holds essentially for the inside as it does for the outside. It resembles a man's spontaneous facial expression and gestures, which reflect much of his soul with its complexities. The outsides of other buildings are more like a person's dress and deliberate conduct, displaying the way he or she wishes to appear. Nikolaus Pevsner, in his *European Architecture,* gives examples of buildings hiding the secret of the sacred, separating the secular from the transcendental, the modest from the splendid, or the rational from the irrational. But such discrepancy must observe certain rules. The contradictory aspects must add up to a meaningful whole. Also, less obviously, the outside as well as the inside must be complete and unified in itself—a rule violated, for example, in the façades of some English Gothic cathedrals, which are screens placed in front of the church proper and unrelated to what is on the sides, or John Wood's phony palace façade hiding thirty separate houses on the Royal Crescent at Bath.[6] In such a building, an outside that should be there but is not is in conflict with another outside which is there but does not fit.

So far I have dealt with the outside and the inside as separate realms. This dichotomy, however, is bridged by the mobility of people, who, more or less freely, pass from the one realm to the other. In early styles of architecture, this crossing of the threshold is a practical matter of piercing the walls with doors, but it is hardly acknowledged by a continuity of outside and inside in the form of the building. The impregnability of buildings spatially reflects an early conception of human existence: man surrounded by barriers and faced by closed entities, which must be cracked if they are to be penetrated. At the other extreme of our philosophy of space, we note the modern conception of the universe as a void, scantily populated by particles, which do not block continuous passage. Each work of architecture must locate itself somewhere on the scale between complete blockage and complete passage, and the particular ratio of closedness and openness it selects is a significant aspect of its style.

Given the intimate metaphoric relation between the house and its human inhabitant, we may even be tempted to connect this stylistic feature with a particular image of man, that is, with a corresponding ratio of closedness and openness in human nature. It may be admissible, for example, to point to the continuity between the inner workings of the mind and their outer manifestations and to find a similar continuity in a style of building of our time, which eliminates the wall and, in its more radical form, demolishes the outer envelope completely. In this latter case, the building presents itself as an arrangement of slabs and sticks to which the distinction of outside and inside is as inapplicable as it is to a bridge, a machine, or a Calder mobile.

Closed and open spaces act as a dynamic interplay of barriers and passages. Quite in general, architectural space must be viewed as an activity of forces, not as a static arrangement of objects and interstices. The geometrician sees solids, hollowed and surrounded by empty space. Space, however, is not empty. It is an invitation to transit, traversed by actual and potential trajectories and beset by barriers representing obstacles, promises, protection, and so forth. Space is created and made dynamic by objects, specifically by the dynamics of objects. Seen from the outside, the building is an expanding volume, reaching into space horizontally and vertically. A similar experience is provided by the inside.

In neither case, however, is this expansion an unlimited sprawling. Architectural dynamics acquire meaning only through the channeling of direction and through the antagonism of advance and containment. Focillon has distinguished between space as limit and space as an environment. "In the first case, space more or less weighs on form and rigorously confines its expansion, at the same time that form presses against space as the palm of the hand does on a table or against a sheet of glass. In the second case, space yields freely to the expansion of volumes that it does not already contain: these move out into space and there spread forth even as do the forms of life."[7] Now it is true that concavities in the outer envelope of a building are perceived as the effect of pressure exerted upon the building by the surrounding space. To a lesser extent this holds also for plane walls.[8] But since all visual dynamics are ambiguous, the retreat of the concavity and the restraint of the wall are experienced also as being due to a control exerted by the building itself. In successful architecture, the extent of an expansive movement is determined, first of all,

by the power of the available impulse. A mighty spire cannot derive its launching power from a small building, and a well-designed tower visibly consumes its resources until it stops where it has to; whereas some of our commercial high-risers disconcert us by growing out of bounds and finally stopping without reason.

In addition to the proper balance of effort and resource, a good building is an image of that self-discipline that makes the difference between thoughtful action and aimless thrust. Propulsive and restraining forces counterbalance each other visibly within the form of the building itself. As the air volume of an interior pushes upward toward the peak of a vault, the hollow reacts not only by receding under the impact of the thrust but also by reacting, like a pair of cupped hands, with a compression that holds together what is being expanded. Similarly, inside a house with an open pitched roof we find the slanting sides of the roof not only lifted but also counteracting the lift, like the folding up of a pair of wings. The thrust of elevation may be dominant as in a pointed arch, or neutralized as in a semicircular arch, or recessive as in a depressed vault. The particular ratio of expansion and contraction and the particular distribution of the expansive and constrictive forces help determine the character of an architectural style. It serves each generation of builders to locate its own position, the confinement of walls, and the infinity of space.

NOTES

1. Henri Focillon, *La Vie des formes* (Paris: F. Alcan, 1934). Transl. *The Life of Forms in Art* (New York: Zone Books, 1989), 74.

2. Gaston Bachelard, *La Poétique de l'espace* (Paris: Presses universitaires de France, 1964). Transl. *The Poetics of Space* (New York: Orion Press, 1964).

3. Ibid.

4. Steen Eiler Rasmussen, *Experiencing Architecture* (Cambridge, Mass.: MIT Press, 1959).

5. Focillon, *Life of Forms*, 71.

6. Nikolaus Pevsner, *European Architecture* (Harmondsworth: Penguin, 1957).

7. Focillon, *Life of Forms*, 79.

8. Rudolf Arnheim, "Negative Space in Architecture," in *To the Rescue of Art* (Berkeley and Los Angeles: University of California Press, 1992).

Drawings in Design

Drawings are a principal means used by designers, architects, painters, or sculptors to search for the shape they want to give to some work of theirs. The sense of vision relies on the artist's manual dexterity to give its images concreteness by stabilizing them on paper. The medium of drawing has properties of its own, and these interplay with the properties of vision. It is this interplay I will look at in the following.

The designer, making his drawing, uses the two means of vision, the direct perception by the eyes and the mental images relying on memory and imagination. How, for example, does an architect arrive at the shape of a building? At first, an overall image may appear in the mind, vague perhaps and quite preliminary. A sketch on paper may give it a shape that can be looked at and evaluated more tangibly. This, in turn, invites the imagination to work on the conception of the design. A dialogue continues between mental images and drawings.

Mental images differ from the optical recordings of the eyes by their reduced intensity. They are fugitive, easily wiped off the slate of memory, and they offer therefore a freedom not granted to optical percepts, especially in their dealing with space. Mental images can handle visual objects as though they were weightless. They can display them with ease from any angle or at any distance, as long as the person's visual imagination is sufficiently concrete. They can ignore gravity, if they so choose. Optical percepts, of course, can also skip from image to image. In this respect, they resemble computers and are even surpassed by them. Computers combine the concreteness of drawings with a lightfootedness letting them run through any number of variations. But they can also be accused of a seductive irresponsibility that allows them to ignore the tangible conditions of ma-

Derived from "Sketching and the Psychology of Design" in *Design Issues*, vol. 9, Spring 1993. Reprinted by permission of MIT Press.

terials as well as perceptual experience. Percepts, in turn, remain committed to the physical objects of which they are projections.

A telling difference between drawings made "from memory" and drawings made directly from the model is relevant here. Drawings done by artists from the model, regardless of whether they are intended to be faithful copies or not, show accidental features belonging to the particular appearance of the particular model. Drawings from mental images, on the other hand, rely on generalities, on the simplified shapes recalled in memory. They are always more abstract than what the artist's eyes observe directly. The drawings of architects also show the difference between sketches made from actual buildings and others done from memory.

Creative designing always involves the solution of a problem, the carrying out of a task, and therefore the conception unfolding in the mind always refers to a goal image. This final objective manifests itself at some degree of abstraction. Supplied by the designer himself or by the program imposed upon him, the goal image may be as intellectual as, say, the mere notion that the end product ought to be hierarchically structured rather than coordinative; or that it should depict the interconnection of two separate entities. But since all abstract thinking relies on some perceptual referent,[1] even the most abstract theme is tied from the beginning to concrete images. They supply the designer with the primary nucleus from which the actual structure develops.

As long as the guiding image is still developing, it remains tentative, generic, vague. This vagueness, however, is by no means a negative quality. It rather has the positive quality of a topological shape. As distinguished from geometrical shapes, a topological shape stands for a whole range of possibilities without being committed to any one of them. Being undefined in its specifics, it allows for deformations and deviations. Its pregnancy is what the designer requires in the search for a final shape.

This same vagueness is frequently apparent in the designer's sketches. "I like fuzzy stuff," said one of the designers quoted by Gabriela Goldschmidt in an excellent paper, on which I am relying in the following. "I can see things in it more than I can in the harder-lined things."[2] A sketch is a reflection of the guiding mental image; but it is not, and cannot be, identical with it, and this difference helps to make it a valuable instrument for the designer.

Since the goal is not given but only aimed at, it is only potentially present in the image at any particular stage of the process. The goal is perceived as inherent in the attained phase of the process; and this is the case in the mental image and in its reflection, the drawing. The dialectic process, rightly stressed by Goldschmidt, does not really take place, however, between the drawing and the mental image but more directly between the goal image and its realization—at both levels, the mental image and the optical percept, the imagination and the sketch.

In what way, exactly, does the design process come about? Does the work grow steadily like a plant or in some other fashion? Obviously, it should start with an analysis of the given task. In a most concrete case, the designer is asked to work from a given plan, such as in Goldschmidt's experiment from the outline of a building for a branch library. She asserts that the analysis consists in parsing the given form into its smallest items, thereby offering the designers a supply from which they can select and which they can arrange appropriately. Such a description, however, is psychologically insufficient. It resembles too much the way a computer operates when, for example, it goes about finding the best strategy for playing chess. In that case, the machine has been supplied with the largest possible number of moves permitted on the chess board and with the sequences to which they can lead. From this supply the computer extracts quite mechanically the one best suited for a particular constellation of the game to lead to victory. Such a method, however—even if it leads eventually to defeating the masters—is of purely practical value. As an image of what happens in the mind of the human player, it is a pitiful caricature of productive thinking. In design, such a procedure may be used occasionally. The designer quoted above reports that "sometimes I just get a lot of lines out of the whole assortment, and then I start to see things in it."[3] Such an assortment can be supplied by a computer, but there again it is essential to distinguish the instrument from the guiding mind. The procedure would be nothing better than a groping in the dark unless it were directed by the shape of the intended theme. What, then, is the nature of this theme?

Another of Goldschmidt's designers answers this question when he says that what is needed for the formal theme of an architectural solution is "a center, an axis, or a direction."[4] This is exactly what I have described as the structural skeleton, namely, the property that makes the pattern distinct, organized, identifiable.[5] Such a structural

skeleton constitutes the character of any meaningful design and in fact of any percept whatever. It is the sine qua non of all perception. In a sketch, a designer may indicate it by a pattern of axes or arrows.

Once such a structural skeleton has been arrived at in the mental image of the designer or on paper, it must be fleshed out; and here one can proceed by two methods, organization from below or organization from above. This difference often applies in architecture to that of proceeding from the inside out as opposed to proceeding from the outside in. In the first case, the architect may start with getting together all the components needed for the building and arranging them sensibly. In the second case, starting from the outside, he or she may design a compact, simple, and attractively shaped whole. If, however, one of these procedures is applied one-sidedly, the result may be either a mere agglomeration of units, unreadable as a visual whole, or a fortress or monument, whose inner components are awkwardly lumped and squeezed to make do with the available space. An ideal solution has been developed by nature in the human or animal body, where a suitable arrangement of organs is held together by a symmetrical, coherent, and well-balanced whole.

A tentative skeleton may require a radical restructuring. Such a "Copernican switch" occurred, for example, during the designing of Le Corbusier's Carpenter Center for the Visual Arts at Harvard, as can be traced from the architect's sketches.[6] The guiding idea was that of a building that would defy the fortresslike closedness of other buildings on the New England campus. The idea was to be symbolized visually by a building that, although of an overall cylindrical shape, consisted of two studio units, separated and traversed by an S-shaped ramp that allowed pedestrian traffic to flow through the building. A problem for the architect was how to unify the two components in a coherent whole. The structural skeleton, as tentatively drawn, foresaw two kidney-shaped units, facing each other like mirror images, which did look separate and did not congeal to a whole. By an ingenious act of restructuring, Le Corbusier turned one of the shapes upside-down, creating a windmill-like rotatory symmetry, which combined separation and unity. The students of the Carpenter Center nicknamed the result "two pianos copulating."

As this example shows, a building cannot be formed without its relations to the environment, unless it be completely self-contained. Here again, the relation runs in two directions. It radiates from the inside of the building toward the surroundings as a set of outlets, but it

is also determined by the outside through the various inputs converging toward the building. The building itself may demand no more than enough breathing space, such as the parvis of a cathedral, to let its visual powers exert themselves freely. Or it may have to adapt itself closely to the style and functional demands of its neighbors.

The function and nature of architectural drawings and sketches are inseparable from those of the design they serve. The creative process of designing, being an activity of the mind, cannot be directly observed. The drawings, done for the eyes and directed by them, make some of the design plans visible. They not only supply the designers themselves with tangible images of what their minds are trying out in the dimness of mental freedom, but they also permit observers or theorists to catch a few stop-motion glimpses of the flow of creation.

NOTES

1. Rudolf Arnheim, *Visual Thinking* (Berkeley and Los Angeles: University of California Press, 1969).

2. Gabriela Goldschmidt, "The Dialectics of Sketching," *Creativity Research Journal* 4 (1991).

3. Ibid., 129.

4. Ibid., 134.

5. Rudolf Arnheim, *Art and Visual Perception* (Berkeley and Los Angeles: University of California Press, 1974), 92.

6. Eduard F. Sekler and William Curtis, *Le Corbusier at Work* (Cambridge, Mass.: Harvard University Press, 1978).

Notes on Religious Architecture

All works of art worth the name are symbolic, and works of architecture are no exception. By symbolism, I mean that these works, in addition to their physical functions such as sheltering, protecting, and facilitating the activities of their users, convey through their visible appearance the spiritual and philosophical meaning of their functions. If a townhall, a hospital, or a private home is a work of good architecture, it proclaims its human calling by what its shape expresses. This symbolic meaning is not simply an attribution applied to the building "from the outside" as a kind of added interpretation, but it is of the very nature and essence of the design itself.

To do its job, the symbolism of a building has to be spontaneously apparent to the viewers' eyes through the various aspects of visual form, such as size, shape, and spatial relations.[1] The elements of this visual vocabulary are the geometrical shapes, by which a work speaks to us. It is useful, however, to distinguish open symbols from closed ones. Open symbols are freshly derived by designers when they draw on the qualities of their medium. In every culture, however, solutions once obtained tend to freeze into standards, replacing individual invention. Such closed symbols become semantic labels; they are reduced to mere tools of information. Their spontaneous meaning alerts the eyes no longer to evoke the building's meaning. The viewer understands, "this is a hotel" or "this is a church" and leaves it at that. But every time this convenience operates, architecture fades.

These thoughts were revived in me by the publication in Italian and French of an attractively designed book, *Project for a Church,* edited by Jean Petit for the Swiss architect Mario Botta.[2] The project describes a new church designed for the mountain village of Mogno in the Ticino near Locarno. In 1986, the seventeenth-century church

First published in *Languages of Design,* vol. 1, 1993. Reprinted by permission from Elsevier Science B.V., Amsterdam.

Figure 1. Mario Botta, groundplan of the church of Mogno, Switzerland.

of Mogno was destroyed by an avalanche. In designing a new church, Botta avoided the paralyzing effects of the closed symbols of traditional church architecture. His church is modern in style, shockingly different, but not struggling for sensational novelty. On the contrary, it aspires to meet the basic demands of a temple of worship by deriving them simply and directly from expressive traits of basic geometrical shapes (fig. 1).

Botta's church, although small, reaches for the sky and meets Leon Battista Alberti's demand that it be "isolated from, and raised above, the surrounding everyday life."[3] It is a simple stone cylinder, quite different from the shape to which the villagers had been accustomed. Not that starkly simple shapes are alien to rural living—Americans are reminded of the silos on our own farms—but to be presented with such a cylinder as the local church must be startling. More precisely, the cylinder of the building is elliptical in section; and somewhere above the height of the human body it begins to be cut off by an oblique plane. This harsh interruption of a perfect shape might remind the villagers of the ruins, several of which

Figure 2. Mario Botta, model for the church of Mogno,
Switzerland.

they saw after the avalanche struck. More essentially, however, the
oblique roof plane sharpens the upper part of the cylinder into a
kind of steeple, pointing to the sky in the manner of traditional
churches. At the same time, the tilted plane of the roof offers itself,
by its backward leaning, to the heights above like a worshiper, and
since the roof is covered with glass it orients the building and its
congregation to the sun, as churches have traditionally done by
their orientation toward the east.

Moreover, the tilted plane of the roof is given by the architect the
shape of a perfect circle (fig. 2). Since the internal space has a rectan-
gular base, its walls must adapt gradually to the circularity of the
roof, changing shape from layer to layer. This sophisticated transfor-
mation is by no means easy to visualize, especially since the longer
axis of the building's elliptical cylinder is oriented at right angles to
the midline of the roof. Once this is accomplished, however, the
minds of the congregation are presented with a sublimation of the

terrestrial living space, rising to the perfection of the circular oculus. Of course, the roof, being tilted, is seen by the congregation only in perspective. Its undiminished view is reserved to the location of the crucifix on the wall above the apse. The place where the figure is attached meets the perpendicular axis of the roof's circle.

The building as a whole plays on the symbolically evocative interplay of ellipse and circle. In a short contribution to Botta's book, Giovanni Pozzi alludes with good reason to the venerable tradition of this theme in the history of Western architecture and painting since the Renaissance.[4] In fact, Panofsky in his essay on Galileo as a critic of the arts has reminded us that Galileo refused to adopt his friend Kepler's discovery that our planetary system does not consist of a set of concentric circles but of elliptical trajectories, with the sun placed in one of the foci of these ellipses.[5] The perfect symmetry of the Copernican system was in keeping with the humanistic belief that the perfection of God was best expressed in the perfect geometrical shape of the sphere or circle and that therefore the appropriate shape of the sanctuary was centric and circular. In his book on the architectural principles in the age of Humanism, Wittkower discusses the philosophical and theological preference for centralized churches in the Renaissance and illustrates Leonardo da Vinci's designs for such churches.[6] Baptisteries, of course, were examples of such complete centric shape. For the purpose of churches, however, it was difficult to reconcile the location of the altar in the tradition of the basilica with a centralized ground plan.

It took the development toward Mannerism to introduce elliptical ground plans to architecture. As an earliest example, Panofsky cites Michelangelo's first project for the tomb of Julius II, and during the Baroque period of the seventeenth century the ellipse became a familiar shape. In his church of San Carlo alle Quattro Fontane, Borromini used the longer axis of the church, placing the entrance at one end and the apse with the altar at the other.

In designing his Mogno church, now under construction, Botta used the shorter diameter of his ellipse as the building's main axis, in keeping with the dominant symmetry axis imposed by the roof at right angles to the ground plan. His composition amounts to a modern synthesis of the traditional alternative between circle and ellipse by confronting the two in a contrapuntal relation. Philosophically and theologically, this is a confrontation of the more worldly ellipse

and the rectangular space it controls with the more sacred realm of the circular roof.

It will be evident that when buildings go beyond the closed symbols associated with their conventional function and rely instead on open symbols drawn from the spontaneous expression of visual shapes, their meaning also will be attributed primarily to the human vision and attitude they express rather than to their practical application. In church architecture, this means that the designer has his or her mind on the basic human qualities emerging from the particular ritual—in the case of the Mogno church that of Roman Catholicism. The designer may be a believer, visualizing in the doctrine the deeper human qualities with which artists are concerned, or may adhere to a different religion, or be an atheist. Not being a believer does not have to mean that one rejects or ignores a doctrine. It may mean respecting it as the carrier of underlying values one can indeed share.

This has been the case in Le Corbusier's chapel at Ronchamp, Matisse's decorations for the chapel of Vence, and the church of Assy, on which William Rubin has published an extensive monograph.[7] One of the artists contributing to Assy, Georges Rouault, was indeed a faithful believer. Not so the others, Bonnard, Lurçat, Léger, Chagall, Richier, and Lipchitz, among whom there were communists, atheists, and orthodox Jews. The most significant example is Jacques Lipchitz's altar statue of the Virgin, one of his finest and most profound works, on whose back he put the inscription: "Jacob Lipchitz, Jew, faithful to the religion of his ancestors, has made this Virgin to foster understanding between men on earth that the life of the spirit may prevail."[8]

All these artists and designers were modernists, in the sense that they abandoned stylistic conventions to refresh the expressive eloquence of their media. In religious architecture, this means that a good designer such as Mario Botta gave up most of the literal applications of tradition, not to ignore them but to probe once again the deeper core of human feeling and thought.

NOTES

1. Rudolf Arnheim, *The Dynamics of Architectural Form* (Berkeley and Los Angeles: University of California Press, 1977), chap. 7.
2. Mario Botta, *Progetto per una Chiesa a Mogno* (n.p., n.d.).

3. Ibid., 15.

4. Ibid., 36.

5. Erwin Panofsky, *Galileo as a Critic of the Arts* (The Hague: Nijhoff, 1954).

6. Rudolf Wittkower, *Architectural Principles in the Age of Humanism* (New York: Random House, 1962).

7. William S. Rubin, *Modern Sacred Art and the Church of Assy* (New York: Columbia University Press, 1961).

8. Ibid., 126–27.

III

What Is an Aesthetic Fact?

A good way of beginning this inquiry is by asking: Where are aesthetic facts located? Do we find them in the physical world? That may seem to be the case, because visual art is always found in physical objects or events, on walls, on canvas, in clay or wood or marble, in the bodies of dancers or in the sounds of music.

Yet all such objects become aesthetic facts only when they are perceived by our senses. And although the originals of works of art are always unique material objects, the best way of experiencing a work of art is not necessarily a privilege of the original. As an example, take the capitals carved by the sculptor Gislebertus in the twelfth century for the nave and choir of the cathedral in Autun. Not long ago fourteen of these capitals were removed to the chapter hall of the church and replaced by copies. Indisputably, only the originals possess the values of authenticity. Whenever a question about these sculptures comes down to their physical condition, the originals must be consulted. But aesthetically it is not so certain that the casts of the capitals, taken from the fairly tall piers in the place of worship, provide a less authentic experience than the originals. We are now able to examine the originals at reading distance but torn out of context and placed at the wrong height. Physically there is no problem, aesthetically there is.

More technically, suppose we look at a painting done five hundred years ago and we notice that one of the figures wears a green coat. Is that coat green? A colorimeter can establish that at a given illumination the picture area in question reflects light energy of a wavelength of 530 millimicrons. With different lighting, however, the physical stimulus may change drastically, and there is no reason to assume that the light at which or for which the picture was painted is identical with the light at which it is shown today. Also, five hundred years

Derived from *Studies in Art History,* vol. 2, published by the University of Maryland, 1976.

of varnishing, cleaning, and restoring may have changed the conditions of the pigment. Thus, if someone were to write the painting's history he would have to consider what the eyes of beholders received when they looked at the canvas in the fourteenth century and what they see today. The properties of the percept determine the aesthetic fact.

The perception of that coat's greenness also depends on whether in the painting it appears next to a dark yellow area or to a bright red. The interaction of color has been strikingly demonstrated by Josef Albers.[1] Shape, too, depends on the context in which it is presented. But quite apart from the context, significant differences show up between the physical dimensions of an object and its perceptual shape. In a study of optical illusions, the psychologist Edwin Rausch has spoken of the difference between ontogram and phenogram. Take the example of a square-shaped painting by Piet Mondrian. We call it a square, because those are its physical measurements. But experiments show and artists know that a geometrical square looks slightly too tall. And it is by its perceptual appearance that the artist and the observer deal with the work.

Of how many parts does an artistic composition consist? We have no trouble counting the fifteen white lambs surrounding St. Apollinaris in the apse of his church near Ravenna. But are we to group them aesthetically with the additional twelve lambs that emerge from Jerusalem and Bethlehem on the chancel arch? For another example, we have no trouble counting the number of figures on Edouard Manet's *Déjeuner sur l'herbe*. But when we group them for an aesthetic analysis, do we separate the three persons in the foreground from the woman gathering flowers farther back, or should we see the four figures united in a compositional triangle? It seems that the visual structure of the work calls for both readings in their interaction.

Percepts are always bound in relations. This places them on a higher level than does a mere accumulation of elements, but it also makes the task of discerning them properly or analyzing them adequately more difficult. Not with impunity can one interpret the structure of a work of art "against the grain." If, for example, one approaches Titian's painting *Sacred and Profane Love* by first connecting the red coat of the "profane" figure with the colors of the hills and shapes behind her rather than with the scene of the foreground, one tears the composition apart. This does not mean that these secondary connections may be neglected. A psychoanalyst, for example, would

seize upon the relation between the close-by story of the two women and what Erwin Panofsky has called the *paysage moralisé* of the background.[2] The fortified town with the peaceful rabbits behind the clothed woman contrasts symbolically with the open pond and the phallic steeple behind the naked one.

The sensory perceptions of the mind grasp the world not only relationally but also categorically, by which I mean, for example, that the sense of vision does not record shapes and colors mechanically in all details, as the photographic lens can do. Instead, it presents the raw material as general forms, which are primarily the ones resembling geometrical figures. It is true that in the history of art such styles as the French Impressionists aimed at the opposite, namely, a most faithful rendering of naturalistic detail, thereby neglecting the categorical "taxonomy" of objects. This, however, led to the countermovement of an emphasis on defined units, first in Cézanne and Seurat and eventually in Cubism.

The categorization of shape strengthens expression, that is, the dynamics inherent in the contours and proportions of visual units as well as in color. In fact, the visual forces carrying expression are the primary perceptual experience.[3] Examples from daily life will perhaps illustrate this fact. What happens, for instance, when a person falls out of love? One morning a man wakes up, and the beloved woman has become a physical body, its skin covering muscle, tendon, and bone; and he realizes that what she was to him visually until then was a pattern of expressive shapes, a grace of swinging contours, the subtle tension of vitality, the boldness of a sweeping cheekbone or brow. The carriers of these expressive qualities are still there but unemployed. The experience is like that of visiting a museum on an inauspicious day, when the shapes and colors keep silent, or like viewing paintings with the close housewifely look of the curator: the cracks across the panel, the peeling pigment, the underpainting, the signature in the corner. In such cases, the shapes are apprehended, but the visual forces they generate are not, and therefore the perceived object fails to speak.

Dealing with aesthetic facts means dealing with qualitative experiences. The artist and the observer face the same problem as scientists do when they want to understand the functioning of an organism or a social group or a physical phenomenon such as the weather. Works of art can be experienced perceptually, but if one wishes to understand them intellectually one must fit them into a conceptual

network, which may be quite adequate; but it never pretends to duplicate the phenomenon itself.

In no way does this mean that the interpretation of a qualitative phenomenon can only be subjective—if by "subjective" we mean an arbitrary response, depending entirely on the idiosyncrasies of the individual observer, something of no binding validity for anybody else. On the contrary, there are adequate and inadequate responses, whose truth value can be evaluated by comparing the observed facts with the statements somebody derives from the facts. Works of art take gladly to some responses and reject others.

A high order of complexity requires that all properties and contents of the structure be controlled by necessity. This condition is indispensable simply because the structure is supposed to fulfil a function, for example, as a statement of communication. The artist undertakes to communicate with himself or herself and mostly also with others. What a work is able to offer depends on its ability to make a comprehensible statement. To this end, it must avoid whatever is not required by its theme, and it must make its compositional structure an image of the theme. This is a decisive premise of the work's quality.

The judging of aesthetic quality calls for connoisseurship. It cannot rely on the convenient standards of number and measurement; it depends rather on perceptual intuition, on the discernment of harmonious coherence, order, simplicity at any level of complexity, and also on originality. All this presupposes a great deal of experience on the part of the historian or critic. A particular work is seen in the context of what the arts have produced at other times and places. But to make use of such knowledge involves a curious circularity. To evaluate a particular work, one relies on the standards one has derived from what one has found in the styles and principles of the arts elsewhere; but to obtain those standards and principles in the first place, one must have gathered them from what one has known. Human judgment is at best liable to correction, but one proceeds to the best of one's wisdom and honesty.

When the mind does good work, it invests all its resources. To create a work of visual art and to do it justice, one relies not only on what the eyes gather from sight. The understanding of representational art, in particular, becomes complete only when one knows what the content of a work signifies and what it meant to people at the time it

was created. Such knowledge is not merely added to the inventory of the experience, while otherwise the work remains unaffected. The very image of what is seen is altered by pertinent knowledge; and this knowledge should not be allowed to compete in the consciousness of the viewer as a rival presence, because this would make for an unmanageable combination of the two different realms of cognition: perceptual intuition and intellectual knowledge. Rather, for the purpose of making and absorbing a work of visual art, what is known is amalgamated as an ingredient of what is seen.

An unprepared visitor to the National Museum in Athens coming upon the sepulchral monument of Hegeso may receive a strong and legitimate impression of the formal beauty and touching human expression of the Greek marble relief, without knowing more than what he or she sees. Not knowing that the seated lady was holding a necklace, which was painted on the background, visitors may wonder about the meaning of her gesture and miss the connection with the jewel case, handed by the maidservant to her mistress (fig. 1). If visitors do not realize that they are looking at a funeral stela, they might wonder about the solemnity given by the sculptor to so homey an episode. And it would also help to know what death meant to the Greeks of the fifth century B.C.E.

It follows that the aesthetic comprehension of works of art takes place at levels of approximation, each of which offers its own gains, even though it remains partial. Understanding is also hampered by other factors, such as disorder or ambiguity in the work. There is a difference between unproductive and productive disorder. In artists, confusion may be due to a disturbed mind or other unproductive intrusions. But it may also be of the productive state of chaos, an uncoordinated potential of rich resources, from which a well-organized work might result.[4]

In viewers also, a productive disorder may accompany the initial encounter with a work whose complexity overwhelms them. Is this due to the inability of the artist to organize the multitude of components, so that the disorder comes from the work itself? Or does it come from the unpreparedness of viewers facing, for example, the interior space of a Baroque church or an abstract painting by Willem de Kooning? It takes patience and experience to make the distinction.

Ambiguity may serve as a final example of the problems to be faced when one explores aesthetic facts. Ambiguity, like disorder,

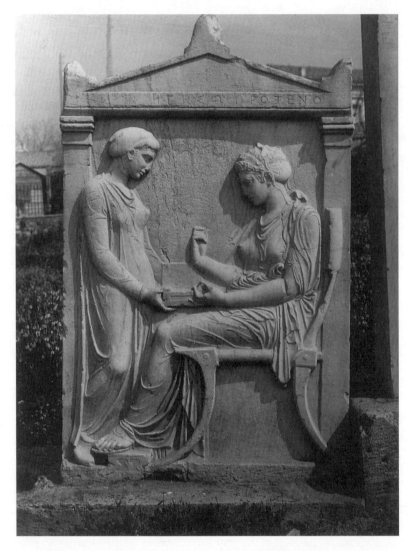

Figure 1. Sepulchral monument of Hegeso on the Dipylon Cemetery in Athens, fifth century B.C.E., now at the National Museum in Athens.

may be the fault of the maker. More interesting are instances inherent in the legitimate organization of the object. Visual perception offers examples of shapes inherently ambiguous, such as the line drawing of a Necker cube, which switches back and forth in space—an effect exploited by artists such as Maurits Cornelis Escher or Victor de Vasarely. The viewer is faced with the "multistability" of a struc-

ture whose figure and ground cannot be perceived at the same time. To quote William Empson, what happens "if what you took for a wall turns out to be the sea"? In such a case, says Empson, "you first see nothing, perhaps are for a short time puzzled as with a blur, and then see differently."[5] When such mutual exclusion is displayed in a work of art, it will fall apart, unless the split is bridged at a higher level by an overarching image that integrates them. The aesthetic difficulty to be overcome here is comparable to the one posed by the metaphor, where two distinct images, visual or verbal, must be integrated at a higher level of abstraction.[6]

In the foregoing examples, ambiguity is produced by distinct images that must be joined in a common experience. The opposite takes place when a single image suggests different meanings. One example may suffice. Meyer Schapiro has discussed the pictorial theme of Moses holding his arms raised during the battle with the Amalekites—a theme of which he says that it also evoked the traditional gesture of the orants, praying figures, which in turn represented the sign of the cross for the early Christians.[7] Here there is only one painted object, but the multiple connotations assigned to create a tension not found in a work in which various facets of meaning are united in an unambiguous though complex image. Ambiguity creates a tension that is observable in the visual image itself, in that the directly perceived dynamics of a figure varies depending on whether one sees the frail arms of an old man held up by an effort or a worshiper raising his arms in an upsurge of address and surrender. The multiple connotations of the ambiguous image can be unified, but in this case only as a comparison, a contrast, or a similar relation.

It will be apparent that when ambiguity is introduced by a skillful artist it does not abandon viewers to their own unlicensed fancies but is strictly rooted in the visual structure of the work. This is true for the cognitive aspects of works, to which I have limited this introductory essay. They, in turn, determine what is often described as the emotional nature of aesthetic responses. Together, the two aspects complete the fulness of a truly human experience.

NOTES

1. Josef Albers, *Interaction of Color* (New Haven: Yale University Press, 1963).

2. Erwin Panofsky, "The Neoplatonic Movement in Florence and North Italy," in *Studies in Iconology* (New York: Harper and Row, 1939).

3. Rudolf Arnheim, "Perceptual Abstraction and Art," in *Toward a Psychology of Art* (Berkeley and Los Angeles: University of California Press, 1969).

4. See "From Chaos to Wholeness," below, 156–62.

5. William Empson, *Seven Types of Ambiguity* (London: Chatto and Windus, 1949).

6. Rudolf Arnheim, "Abstract Language and the Metaphor," in *Toward a Psychology of Art.*

7. Meyer Schapiro, *Words and Pictures* (The Hague: Mouton, 1973).

From Pleasure to Contemplation

In book 10 of his *Nicomachean Ethics,* Aristotle draws a useful distinction between pleasure and happiness. By differentiating the two concepts and by defining and evaluating them, he succeeds in avoiding hedonism, which, ever since the time of the Cyrenaic school of Aristippus and later through the centuries to our own days, has remained the ruling theory of motivation. From the early days, philosophers cautioned that the impulses of sensuous pleasure must not be given free range but instead must be controlled by wisdom to avoid a self-defeating misuse of enjoyment. More recently, the conditions for making satisfaction acceptable were broadened. They included the happiness of society as a whole rather than just that of the individual. None of this, however, transcended the fundamental belief that the desire for pleasure is the ultimate motive of human behavior, as it is that of animals. This has been true in particular for the theory of aesthetics. Since many aestheticians were at a loss to discover any other specifically aesthetic motive, they accepted the traditional view that art is being produced and received to generate pleasure.

The persistence of this doctrine is all the more puzzling as it contradicts what actually goes on in people's minds when they yearn and decide to do something. To be sure, eating and drinking promise pleasure, as does the building of a boat, the exploring and solving of a scientific problem, or the painting of a picture. But when one looks at what is experienced as the foremost objective of any such undertaking, one finds that the person is intent on the target: the obtaining of nourishment, the completion of the object under construction, the solving of the problem, or the creation or reception of the work of art. Unless we are all badly mistaken about why we do things, it is the working at a task, the achieving of its completion, or, more generally, the full awareness of a significant experience that determines our motive—not the sensation of pleasure. In fact, in some cases the

First published in *Journal of Aesthetics and Art Criticism,* vol. 51, Spring 1993.

pleasure premium is all but undetectable. On the other hand, there is such a thing as pure entertainment, where feeling pleasure may be the only motive.

The hedonistic theory leaves us without a satisfactory answer also when we ask why pleasure is desirable. The question has an answer only in the physiologically based drives of instincts. The instincts of self-preservation—the urges to eat and drink and to procreate—have been built by evolution into the nervous systems of humans and animals because otherwise there would be no impulse to survive. But no instinct urges us to write poetry or to explore the universe, and none of the practical tasks, such as the work of physicians, educators, or politicians, are justified simply by reference to those basic bodily needs.

All this ought to be obvious to psychologists. Instead, they took to hedonism gratefully as an easy standard by which to measure motives that otherwise had no ready explanation. Answers to questions such as What do you like best? or Which do you prefer? were accepted as substitutes for explanations of what determines such preferences. I have said elsewhere that "just as in perceptual psychophysics the varying intensity of, say, a sensation of light provided the means for measuring thresholds, so the pleasure or unpleasantness of responses yielded the condition for a psychophysics of aesthetics."[1] In the meantime, the purpose of human activities, such as the pursuit of the arts, remained unexplained.

Aristotle describes pleasure as an immature means of controlling the conduct of life, suited only for the education of children, because children cannot be steered by anything but "the rudders of pleasure and pain." No one, though, "would choose to live with the intellect of a child throughout his life, however much he were to be pleased at the things that children are pleased at." Pleasure will suit the mature mind only as long "as both the intelligible or sensible object and the discriminating or contemplative faculty are as they should be."[2]

By meeting this condition, pleasure satisfies the requirements of happiness. But what is happiness? According to Aristotle, happiness is "the end of human nature"; it involves the human activity that is "in according with highest virtue." This virtue, he says, is contemplation. Contemplation is a divine element that humans have in common with the gods. The virtue of contemplation, then, is what

Aristotle means by happiness, and it is this term that will serve me in the following.

Aristotle describes the conditions that make pleasure meet the requirements of the contemplative life. Contemplation, he says, resembles the sense of sight in that it is a complete whole at any moment: "It does not lack anything which coming into being later will complete its form." This self-sufficient completeness of the contemplative experience, however, is attained only when it is activated by "the best-conditioned organ in relation to the finest of its objects." The optimal state is reached "when both the sense is at its best and it is active in reference to an object which corresponds." Highest quality, then, is the *conditio sine qua non*. "This is why when we enjoy anything very much we do not throw ourselves into anything else, and do one thing only when we are not much pleased by another; for example, in the theater the people who eat sweets do so most when the actors are poor."[3]

In sum, Aristotle states that complete happiness is achieved by "the activity of reason, which is contemplative, seems both to be superior in serious worth and to aim at no end beyond itself, and to have its pleasure proper to itself (and this augments the activity), and the self-sufficiency, leisureliness, and unweariedness (so far as this is possible for man), and all the other attributes ascribed to the supremely happy man are evidently those connected with this activity."[4]

I have quoted Aristotle at such length because what he says about the contemplative life reminds us of the aesthetic attitude. When he speaks about the self-sufficiency of such activity, he also leads us beyond a vexatious problem that has often troubled aesthetic discourse: what possible meaning could there be to saying that art exists only for art's sake? Are we not convinced that the basic condition distinguishing organisms from inorganic things is that all their activities are motivated by an ulterior purpose? Aristotle attributes self-sufficiency to contemplative behavior in general and calls it the final end of life. He reminds us that, while nature outside humankind knows of no meaning beyond its own physical existence, the human mind is privileged to explore the full awareness of what is reported by the senses and understood through thought. In other words, there is no meaning to human life other than the full experience of its existence, and the capacity to have such experience implies the moral duty to use it.

Obviously, philosophy has met this demand whenever it has adhered to its task. As a single reminder, I will refer to the saying of

Anaximander quoted by Nietzsche as a cornerstone of Greek philosophy: "Things must undergo their destruction where they originate, according to necessity; for they must pay penalty and be sentenced for their injustice according to the order of time."[5] The full awareness of coming and going, the full implications of life and death, are the human extensions of being in the world.

Since the arts make their contribution in practical life, I will give some examples of how the contemplative approach works in the practice of daily experience. The contemplative life calls for the utmost susceptibility to the daily occupations, which are so commonly reduced to thoughtless routine. The aesthetic attitude requires, as a kind of worldly preparation for its task, the very opposite of what William James recommends when he says, "The more of the details of our daily life we can hand over to the effortless custody of automatism, the more our higher powers of mind will be set free for their own proper work."[6] On the contrary, such automatism blunts the mind's preparedness for the conscious life. With deeper wisdom, Paul Valéry initiates his Socratic dialogue *L'Âme et la danse* with an apology for eating and drinking. "The man who eats," he makes Socrates say, "is the most righteous of men. . . . Every mouthful he feels dissolving and dispersing in him will carry new forces to his virtues and will do so indiscriminately to his vices. It feeds his torments as it fattens his hopes; and it divides its share between the passions and reasoning."[7]

The human body is one of the main instruments of art. Therefore, a constant awareness of its form and functions is a requirement of contemplative daily living. It is prescribed, for example, by various schools of transcendental meditation and is the mental attitude controlling yoga exercises. The person assuming a meditative stance concentrates, in systematic succession, on the levels of the body, building from the toes through the legs and the pelvis and chest all the way to the crowning seat of sensation and thought in the head. Instead of taking the body's being for granted, the mind acknowledges its significant nature and expression.

In the same spirit, the mind takes cognizance of the eloquent appearance of the objects and actions populating the natural and man-made environment. The shapes, the colors, and the motions, as well as the functions observed in daily experience, offer the raw material for the compositions of the dancers, the painters, and the sculptors,

the dynamics of music, and the perceptual referents of language in poetry, drama, and narrative.

What distinguishes the particular contribution of the arts is, first, that they present "the intelligible or sensible object," as Aristotle calls it, that is, the form that makes appearances accessible to the mind. It is, furthermore, the particular ability of art to go beyond mere cognizance. By animating the forces that make form expressive, it evokes a corresponding resonance in the mind of maker and recipient. By art, they are enabled consciously to experience the powers that carry the meaning of our existence.

NOTES

1. Rudolf Arnheim, "The Other Gustav Theodor Fechner," in *New Essays on the Psychology of Art* (Berkeley and Los Angeles: University of California Press, 1986).

2. Aristotle, *Nicomachean Ethics*, in *The Basic Works of Aristotle* (New York: Random House, 1941), 10.1.1172a21, 10.3.1174a1–3, 10.4.1174b35–36.

3. Ibid., 10.4.1174a15–16; 10.4.1174b18–19, 28–29; 10.5.1175b10–14.

4. Ibid., 10.7.1177b19–24.

5. Friedrich Nietzsche, *Die Philosophie im tragischen Zeitalter der Griechen* (Leipzig: Kröner, 1874), 277. My translation from Nietzsche's German text.

6. William James, *The Principles of Psychology* (New York: Dover, 1950), 122.

7. Paul Valéry, *L'Âme et la danse* (Paris: Gallimard, 1924).

The Symbolism of Light

Among the many symbols that religion and philosophy have drawn from nature, fire and the light it produces are the most universal and the most powerful. Religion is hardly conceivable without light as one of its agents. Fire is most prominent among the four elements that, according to pre-Socratic philosophers, constitute our world. It is an action rather than a mere being. When Plato ranked the elements by the degree of their mobility, he described the earth as the most stable, fire as the most mobile. Earth he called the primary substance, animated by air and water.[1] Fire enters the mythological scene as the great newcomer. By giving warmth, it protects life; and it offers the progress from raw to cooked food. Most important, light creates the sense of sight, which extends the world of living creatures beyond the range of touch. The presence of light alerts the mind to explore the universe. Also, the specifically human ability to watch oneself as an observer detached from the outer world could hardly have come about without the sense of sight distancing the subject from the object.

Fire is also the great destroyer, and both as a benefactor and a fearful enemy it identifies itself for the human senses as an impressive apparition to be thanked, worshiped, and propitiated. The campfires and the forest fires, the lightning, the volcano, and first and foremost the sun embody this supreme power. When the human mind looks around in search of the great creator, it can glorify him with the splendor of light.

To view life in the abstract, there is no better image than the flame. Fire is born, grows, and dies, and its darting shape retains its character even when an artist translates it into an unfiry medium, when a sculptor fashions flames of stone, or when a dancer turns them into the undulations of her body. So intimately is light connected with motion and action that it loses its character when it is deprived of this lively quality. When electricity produced pure, disembodied light, it killed the flame. The electric glass candle dispensed plenty of quiet illumination, but the sense of life had gone out of it, and it took all the

skill of modern artists to revive light by reinvesting electricity with motion and change. When we sit by the fireplace, warmed and end-lessly attracted, we watch the exhilarating dance of life, its grace and its voracious violence.

In an environment, light can be evenly spread as a pervasive lu-minescence. Although nothing can be seen without being lit, the vis-ibility of things can remain unrelated to any light source, as long as the eyes look at the world naively. The objects themselves seem to be endowed with luminosity. The book of Genesis reports on the cre-ation of day and night independent of that of the sun and the moon; and a child puts the sun and its rays in the upper corner of a picture without showing its effect on the creatures below. An environment can be raised to a state of splendor that it does not seem to owe to any source. Hence the medieval distinction between *lux* and *lumen*, the source of the radiation and the sheer luminosity created by it.[2] When we read that the walls of the temple of Solomon were covered inside with gold, we know that the sacred space as a whole was glo-rified by the omnipresence of light. In nineteenth-century painting, the Impressionists transformed realistic illumination into a perva-sive luminescence of sky and earth, stone and foliage, depriving mat-ter of its weight and texture and praising the sun as the spiritualizer of all things.

But light can derive symbolic significance also from its place of ori-gin and from the direction in which it moves. When fire is earth-bound, its shares the basic condition and aspirations of humankind. The flame of the lighted candle strives upward like human yearning, and the fires of joy and celebration and their artful offspring, the fire-works, all leap toward the sky, overcoming gravity in their tri-umphant ascent. When during the war we saw powerful searchlights moving across the night sky to converge on the tiny black insect of the enemy bomber, a new art was born, which eventually occupied the empty arena above the earth with gigantic choreographies of moving lights, visible to the crowds below as ceremonies for all.

Light stands also for the opposite action, namely, that performed by celestial powers dwelling above the human realm and exerting its awe-inspiring influences downward. An eternal lamp suspended in space presents us mortals with a reassuring promise. The lodestar guides the navigator, and lightning and erupting firestorms rain destruction upon the earth. Sun and moon, of course, are the great

protagonists of heavenly lights, and their dominance is recalled, if ever so modestly, by every lamp under a ceiling.

Illumination is by its nature an action from above. When light descends into a room, channeled by a window, it is first of all "functional light," as it is traditionally called, that is, a physical means of making things visible. In Western painting, illumination becomes an independent agent entering the scene of the picture as an active participant to interpret the visual shape of the human figures. The art historian Wolfgang Schöne has said of Caravaggio's characters that they are unaware of the strong light hitting them.[3] Such neglect, however, is rare, because the presence and symbolic resonance of propelled illumination is hard to overlook. Most obviously in Rembrandt, light streams into the darkness of the human abode, blessing and enlightening the persons exposed to it.

Since light is so powerfully visible but at the same time incorporeal and unspecific, it readily offers the image of a God devoid of material embodiment. As an emanation of divine spirit, light becomes an indispensable part of religious architecture. The ability of light to penetrate windows without having to break the glass was taken as a sign of its spirituality, and when the stained glass dispersed the purity of sunlight into the colorful variety of terrestrial pictures, it symbolized the neo-Platonic doctrine of the divine light gradually penetrating the darkness of the physical world. In the seventeenth century, the religious poet George Herbert begins his poem "The Windows" by saying

> Lord, how can man preach thy eternall word?
> He is a brittle crazie glasse:
> Yet in thy temple thou dost him afford
> This glorious and transcendent place,
> To be a window, through thy grace.[4]

Here also we meet darkness as the great antagonist of light. There can be no light without darkness, but the relationship between them makes for two mutually exclusive conceptions. To the physicist, darkness is nothing but the absence of light, and shadow falls where light is missing. To the eye, however, darkness is the active counterpower, from which light is born and which is combatted by light. Hence, in religion the world is either the monopoly of God with darkness as a mere remnant of evil, whose presence is not easily justified; or in a religious philosophy, such as that of the Gnostics, the world is

ruled by two coordinate agencies, the power of light and the power of darkness. The two fight each other in the battle of good against evil, or they complement each other, as in the Eastern image of the yin and yang. When light makes its entrance in the imagery of painting, either it shines in the darkness or light and darkness rule in cooperation, sharing the task of making things visible by articulating their shape. Leon Battista Alberti recommended that in the painting of an object light and shadow be applied with symmetrical equality.[5]

Light and the human mind need each other, because light is not visible without the mind, and the mind cannot see without light. It has always been taken for granted that the mind is not merely the passive recipient of what arrives from an outer and higher world. Mind has to be worthy of the gift. In fact, from antiquity all the way through the Renaissance, vision was conceived as being brought about by the cooperation of sender and receiver. Plato told in the *Timaeus* that vision is generated when a gentle fire from the eyes meets the light arriving from the objects: "When the light of day surrounds the stream of vision, then like falls upon like, and they coalesce, and one body is formed by natural affinity in the line of vision, wherever the light that falls from within meets with an external object."[6]

Hegel, in his *Lectures on Aesthetics,* saw a difference in the way the art media responded to light. "In sculpture and architecture, objects become visible by means of the external light. In painting, however, matter, which in itself is dark, contains light as its own interiority, its own ideal. It is pervaded by illumination, and because of this the light itself is darkened."[7] Goethe, in the introduction to his *Theory of Color,* returned to the ancient affinity between light and human vision when he put it in poetical form: "If the eye were not sunny, how could we perceive light? If God's own strength lived not in us, how could we delight in Divine things?"[8]

In our own days, we have learned to appreciate the interaction between light giving shape to the physical objects surrounding us and the sense of vision articulating what we see.

NOTES

1. Plato *Timaeus* 32.

2. Wolfgang Schöne, *Über das Licht in der Malerei* (Berlin: Mann, 1954), 55.

3. Ibid., 137.

4. Quoted in James Boyd White, *"This Book of Starres": Learning to Read George Herbert* (Ann Arbor: University of Michigan Press, 1994), 39.

5. Leon Battista Alberti, *On Painting* (New Haven: Yale University Press, 1966), 55.

6. Plato *Timaeus* 45C. (trans. B. Jowett).

7. Georg Wilhelm Friedrich Hegel, *Vorlesungen über die Aesthetik* (Berlin: Duncker und Humblot, 1837), 259.

8. Johann Wolfgang von Goethe, *Theory of Color* (Cambridge, Mass.: MIT Press, 1970), liii.

A God's Perfection

Perfection of body and mind comes with being a god. When Poseidon, the god of the seas, is shown imperfectly as a mortal entangled in much violence, as he often is on Baroque fountains, he forgoes this distinction. But presented as a trident-hurling ruler by a Greek bronze sculpture of the fifth century B.C.E., he is revealed as divinely perfect (frontispiece). Poseidon is still an attacker, but the throwing of the weapon is no longer the frantic effort of a capricious will. Although the weapon is not visible to us, we see a transfusion of energy from the man to the weapon by the rippling of the muscles pervading the god's body as a wavy rhythm of consonant forces; and this empowerment of the whole, this action by nonaction, makes the weapon fly off under its own impulse. It is an exemplary demonstration of what the Japanese master of archery taught the Western philosopher Eugen Herrigel, who wanted to understand the wisdom of Zen Buddhism.[1]

Action by nonaction, the formula for all sculpture that respects the timelessness of its medium, is also displayed by the symmetry prevailing in the figure. Poseidon's body has just emerged from the basic stance, so well known to us as the spread-eagle figure of the Vitruvian man, in which Leonardo gave us once and for all the prototype of male appearance. But this stance is also, and more relevantly, the root position for the yoga exercises, the basic *asana* from which one proceeds to the sideways position of directed action.

Without letting us forget the timeless symmetry from which it sprang, the body's turn to action differentiates the functions of the limbs. The left leg commits the weight of the body to displacement and advance, while the swiveling right leg lifts the whole figure beyond the human enslavement of gravity. Liberated from the load of matter, the god appears as the embodiment of pure energy. We see spiritualized action.

First published in *Michigan Quarterly Review,* vol. 32, Fall 1993.

The body is here under the command of the head, which faces the goal. The right arm activates the hurl, the left arm keeps the body steady and steers its direction. Total concentration defines the goal, but the goal remains in the infinite as a target never reached. It is an endless quest, which—as we think of the human species—transcends even the completion of masculinity by femininity in human love. Beyond such human finality of union, the divine figure's sexual organ remains confined to the symmetry of nonaction, while the spirit of Poseidon's glance knows of no such limitation.

Only when the body is nude can it reveal the interaction of all its parts, the universal dynamics that alone displays the spirituality of the image. Slightly superhuman in size, Poseidon's statue was presented as a votive offering to a temple devoted to him. Only recently, about seventy years ago, the bronze statue was recovered from the Aegean sea, approximately near Cape Artemision, where according to the Greeks' belief Poseidon had come to their help by shipwrecking the Persian attackers. I thought of him when I sat among the marble columns of his temple remaining on the Sunion promontory south of Athens. High above the waters, I sensed the endlessness of the god's realm and the quiet ubiquity of his power.

NOTE

1. Eugen Herrigel, *Zen in der Kunst des Bogenschiessens* (Konstanz: Weller, 1948).

Gauguin's Homage to Honesty

Some of the works of Paul Gauguin differ from the rest of his oeuvre in that they contain spatial and compositional features not found in the others, features that depart from a tradition obeyed by other leading painters of his time and derived from the Renaissance.

Those works attracted me particularly because they seemed to retrieve an elementary immediacy of pictorial expression—the effect one experiences in works that rely most directly on the medium's most authentic formal means. I knew of no immediate precedent or explanation for this deviation from the more direct tradition, but I happened to come across a passage in Gauguin's autobiographical diary, *Avant et après*, in which he reports on having been greatly inspired by a reproduction of a fresco in the Magdalen Chapel of the Lower Church of San Francesco in Assisi.[1] And indeed, the picture in question, a work of the early fourteenth century, reveals a striking affinity to the very compositional traits observable in the Gauguin works here under discussion.

In *Avant et après,* Gauguin refers to an album of reproductions, Japanese prints, and lithographs by Daumier and Forain, grouped together "not by chance but by my own deliberate will."[2] To this little display he added as its principal item a photograph of a wall painting that he attributed to Giotto but is now believed to be by one of Giotto's collaborators, the Master of the Chapel of St. Nicholas.[3] It is one of the scenes decorating the Magdalen Chapel in the Lower Church of San Francesco in Assisi. The painting differs from the work of Giotto and his major contemporaries by its primitivism. I owe to a personal communication by Marvin Eisenberg the observation that this difference may be due to an archaizing tendency of the artist, that is, an attempt to imitate an earlier style. If the Assisi artist was a maverick by refusing to join the growing trend toward naturalism,

First published in *Leonardo,* vol. 25, no. 2, 1992.

Figure 1. Master of the Chapel of St. Nicholas, *Arrival of the Magdalen in Marseille* (ca. 1315–1320). Church of San Francesco in Assisi.

his having been picked by Gauguin is surely significant, even though the photograph of the *Arrival of the Magdalen in Marseille* (fig. 1) may have been in his possession merely by accident.

"Certainly," writes Gauguin, "in this picture, the laws of beauty do not reside in the verities of nature; let us look elsewhere." He comments on the disproportion in size between the fugitives in the gourdlike boat, the woman lying on the rock, and the figures approaching the town. There is no relation, he says, between the occupants of the boat, the angels in the sky, and the small tower entered by the tiny arrivals. What, then, attracted Gauguin, in spite or because of the obvious defects of this particular picture? "Before this canvas," he confesses, "I have seen Him, always Him, modern man, who reasons out his emotions as he reasons the laws of nature, smiling that smile of a satisfied person and saying to me: You understand that!" He concluded, "And I would like to pass my life in such honest company."[4]

What exactly was it that led Gauguin to welcome the medieval painter as a companion in arms, an early representative of modern man, as someone guided by the same spirit as he was himself? What, in particular, did he experience as honesty, this decisive virtue he hoped to share?

What made the modern painter discover a paragon in an artist who lacked so obviously the perfection to which Gauguin and his fellow artists owed so much of their professional standard and success? Clearly, this very imperfection was what had attracted him. With regard to strictly pictorial balance, the Master of St. Nicholas was an accomplished artist. In his painting, the floating boat is held in the center by visual masses marking the four corners: the rocks and the island on the left, the architectural gate and the landscape on the right. But the spatial and temporal coherence of the geographical setting and of the narrated story, indispensable to the conventions of the later Renaissance art, is neglected. The painter does not hesitate to present in the same picture two different scenes of the Magdalen legend, separate from each other in time and space, namely, the arrival of the saint and her companions in the harbor of Marseille and the miracle of the pilgrim's wife revived by the saint on the desolate island and holding her child wrapped in her coat.[5] Connected by nothing but the stormy ocean as the background, the two episodes are free to convey their stories in naive isolation. The dominion of naturalistic coherence is replaced by the very different dominion of visual immediacy. The components of the subject matter are exhibited in frontal coordination, and the occupants of the boat are enumerated in neat detachment from one another. Spatial depth is reduced to a straight confrontation in the surface. Narrative interaction is replaced by the didactic clarity of visual coordination, as though arranged on a blackboard for the convenience of an interpreter or teacher, who indicates item by item with a pointer. It is indeed an honesty of presentation that eschews the spatial interrelations and the perspective distortions of an outer world in favor of the elementary requirements of the pictorial medium—a medium attentive to the flatness of the chapel wall.

I will now compare two paintings of Gauguin, both beautiful, but one in the Renaissance tradition of spatial composition and the other boldly modern, as it harks back to the elementary persuasiveness of the pictorial medium. *The Seaweed Gatherers* (1889; fig. 2) conveys a sense of flowing unity that extends diagonally from the distance with the line of the approaching carrier women. The viewer must transcend the frontal plane to enter an outer, three-dimensional world. A heap of brown kelp, furnishing the center around which the composition is organized, is located in the middle of the pictorial space. The painting conforms to what I have described elsewhere as the typical combination of centric and eccentric composition.[6]

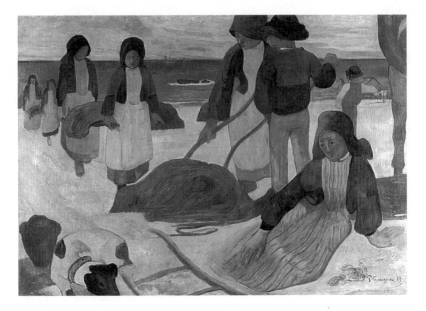

Figure 2. Paul Gauguin, *The Seaweed Gatherers* (1889). Museum Folkwang, Essen.

Most characteristically traditional in this work is the interaction of all its components. They all respond to one another, adding up to the reassuring unity of a social context that reflects a shared way of life. It is the sort of communion to which the style of pictorial representation has accustomed us, in spite of all the changes from the early Renaissance to well into the twentieth century.

Moving to a Gauguin painting of the preceding year, the *Old Women at Arles* (1888; fig. 3), we notice that its compositional unit is obtained not by a pervasive interaction but, on the contrary, by the staccato effect of elements arranged in juxtaposition. The procession of the Arlésiennes is not brought about by the flow that unites the seaweed gatherers but by the mere parallelism of two separate groups, arrested in their motion by their frontality. The human figures touch each other, but they communicate no more closely than the two starkly detached yellow cones of the wrapped shrubs or even the pilings of the fence, which blocks the scene so abruptly. The painting is no less sensitively balanced than other competent work of the century, but each of its components attracts unusual attention to its self-contained, individual completeness. The composition is like an as-

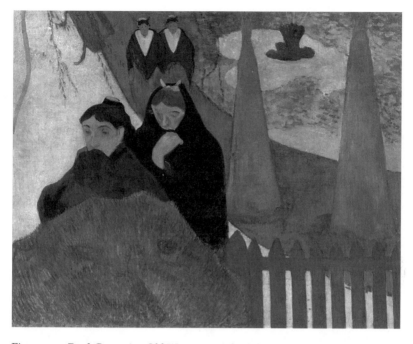

Figure 3. Paul Gauguin, *Old Women at Arles* (1888), oil on canvas, 77 ×
92 cm, Mr. and Mrs. Lewis Larned Coburn Memorial Collection, 1934.391.
Photograph © 1995, The Art Institute of Chicago. All rights reserved.

sembly of exclamation points, refusing to soothe us by the illusion of
a traditional story. Rather, like the fresco of the Assisi painter, Gau-
guin's scene offers a frontal display, spreading its components across
the plane and attentive to its task of informing the viewer's eyes.

If one looks further through Gauguin's oeuvre, one comes across
other aspects of a similar conception. There are groups of figures ran-
domly aligned in bunches and held apart by gaps, and there are con-
trapuntal correspondences between detached units in the plane as
well as props, such as dogs and cats, scattered across it. In certain
works, the organizing function of the frame is deliberately overruled.
A landscape spreads abroad in carefree abundance, or one partner of
a pair of figures is awkwardly curtailed by a corner while the other
holds the center. There are inserts, interrupting the spatial unity of
the presentation, similar to the ones in Byzantine mosaics. An ex-
treme example is a late woodcut, probably meant to be combined
with another of the same series (fig. 4). Crouching women and

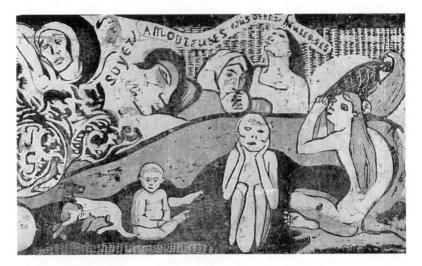

Figure 4. Paul Gauguin, *Love, and You Will Be Happy* (Soyez amoureuses, vous serez heureuses), Guérin 58, woodcut, 16.2 × 27.6 cm, Joseph Brooks Fair Collection, 1949.932. Photograph © 1990, The Art Institute of Chicago. All rights reserved.

children, intermingled with heads and busts, are distributed over the surface, all but unrelated like the elements of a collage. There is no coherent spatial scene but, once again, an arrangement of significant items, illustrating in this case the title message, *Love, and You Will Be Happy* (1898/1899).

Searching for similar tendencies in other painters of the century, one finds only a few special traits of the same stylistic syndrome. The spreading of isolated figures reminds one of Degas; but Degas obtained his social discrepancy not by the detachment of his components in space but, on the contrary, by contrasting it with strict compositional coherence and bodily closeness. Something similar holds for Edvard Munch's desolate mourners who populate his *Death Chamber* of 1894 like lonely statues, or for the couples in his *Dance of Life* of 1899–1900.

Gauguin's diary, *Avant et après*, was written in January and February 1903, the year of his death. The *Old Women at Arles* was painted fifteen years earlier. There is no historical proof that this or other paintings of the kind discussed here were directly influenced by the pledge to honesty expressed in the diary. Gauguin never saw the original of the Assisi painting, which in fact is in a poor condition of

conservation. In his Marquesas studio, he could only have had a small black-and-white reproduction. His pledge, however, and his admiration of the Assisi fresco spell out Gauguin's motive for an innovative style, which represented an audacious step beyond the naturalistic tradition of the Renaissance. He anticipated the liberation from narrative space in the depth dimension carried out by the Fauves, the Cubists, and the Expressionists. But, in an apparent paradox, he did so by returning to the elementary immediacy of the pictorial image he found in the primitivism of the Assisi fresco.

Primitivism is in fact the key concept relating an early naïveté of artistic styles to the revolution of modernism. In the Museum of Modern Art's monograph on *"Primitivism" in Twentieth-Century Art*, Kirk Varnedoe begins his essay on Gauguin as follows: "Paul Gauguin is the *primitif* of modernist primitivism, its original, seminal figure. Other artists before him may have known of the arts of Primitive societies, but Gauguin was the first to appreciate in such forms a significant potentially transforming challenge to Western ways of depicting the world."[7]

Here, then, is the meaning of what Gauguin admired and wished to share as the "honesty" of the Assisi painter. As an early pioneer of modern art, Gauguin spotted a dishonesty in the violation of the pictorial plane, perpetrated by the Renaissance tradition when it undertook its excursion into the depth of the outer world rather than defining its task as the creation of a pictorial equivalent of that world. That tradition had conquered the third dimension of space, but by doing so it distorted pictorial shape into a compressed optical projection. To straighten out this distortion, Gauguin acted as a forerunner of the art of our time.

NOTES

1. Paul Gauguin, *Avant et après* (Paris: Editions Crès, 1923), 97–99.
2. Ibid, 97.
3. Giuseppe Palumbo, *Giotto e i Giotteschi in Assisi* (Rome: Canesi, 1969).
4. Gauguin, *Avant et après*, 98–99.
5. Granger Ryan and Helmut Ripperger, eds., *The Golden Legend of Jacobus de Voragine* (New York: Arno, 1969).
6. Rudolf Arnheim, *The Power of the Center*, new version (Berkeley and Los Angeles: University of California Press, 1988).
7. William S. Rubin, ed., *"Primitivism" in Twentieth-Century Art* (New York: Museum of Modern Art, 1984).

The Echo of the Mountain

When psychologists approach the slippery subject of creativity, they need first to decide whether they think of creativity more as an instinct or a reflex. To call it an instinct means to group it with the inborn urges to survive, to protect oneself, to assuage hunger and thirst, to procreate. The prime impulses for such behavior are physiological, bred by evolution into all living creatures to make them strive for staying alive.

There are people who think about creativity in just this way. Although they do not deny that such behavior is stimulated by what is observed in the surroundings, they consider it essentially a gift of the gods, for which we can be grateful but on whose roots not much more can be said. They suggest that the creative person feels impelled to search the world for subjects about which to be inventive, formative, scientific, or poetical. Because this approach neglects asking about the motives of creativity, in the belief that they are hidden in the machinations of the hormones or otherwise unfathomable, much of what is speculated nowadays on the subject is disappointingly vague.

The alternative approach, which I will pursue here, considers creativity more like a reflex and argue as follows: Living creatures are born into a world full of invitations to act. It is a world of mysteries and problems, challenges, threats, and opportunities. In our own interest, we are driven to explore, to understand, to describe, to praise, and to complain. The outcome of all these strivings is called creativity. Therefore, to understand what creative creatures are doing, one must explore the challenges provided to them by their experiences. The most interesting creatures, at least to us, are the humans, and among their various ways of coping with their task I will concentrate on the arts.

Speaking of the world in which "les parfums, les couleurs et les sons se répondent," Charles Baudelaire says in his poem "Correspondances":

La nature est un temple où de vivants piliers
Laissent parfois sortir de confuses paroles;
L'homme y passe à travers des forêts de symboles
Qui l'observent avec des regards familiers.[1]

Why is nature a forest of symbols and why do these symbols watch the poet with familiar regard? Baudelaire alerts us to the insight that to see the things and happenings of the world as symbolic is artists' particular way of viewing their experiences, instead of taking them simply as what they *are*. To be sure, artists—whether they are poets, painters, or musicians—have a particularly acute sensitivity in observing the behavior of what surrounds them. They experience this behavior as an interplay of forces, because that is precisely what we call life. But the artists' way of seeing these forces as symbolic means that they are responding to the dynamic events not merely as what they are but as images reflecting the inner forces of the human mind—the strivings, the attractions and repulsions that are the central concern of our existence.

Forces, by their very nature, are abstract. They can be felt but can neither be seen nor heard nor touched. In the world surrounding us, however, these forces are embodied and therefore can be perceived. We see the birds fly, we hear the sirens scream, we touch the warmth of a human body. To perceive the forces of the world embodied is the invaluable privilege of the senses. Our mind's inner experience, however, is deprived of this privilege. Since forces are felt but are as abstract as electricity or gravitation, it is the artists' task to make the strivings of the mind perceivable by seeing them symbolized in the behavior of the environment. The artists' world is indeed a forest of symbols.

Among the arts, poetry is the one that makes this way of perceiving most explicit. I will quote from two poems by Denise Levertov, in which she talks about grief. One of them, "Human Being," begins like this:

Human being—walking
in doubt from childhood on: walking

a ledge of slippery stone in the world's woods
deep-layered with wet leaves—rich or sad: on one
side of the path, ecstasy, on the other
dull grief.[2]

Later on, in "Talking to Grief," she says:

> Ah, grief, I should not treat you
> like a homeless dog
> who comes to the back door
> for a crust, for a meatless bone.
> I should trust you.
>
> I should coax you
> into the house and give you
> your own corner,
> a worn mat to lie on,
> your own water dish.[3]

Grief is strongly felt but not easily described. It has no shape or visible action. By contrast, a person stumbling on a slippery path between a joyful and a saddening side does not only capture us as a tangible image but also displays immediately understandable properties: striving toward a goal under precarious conditions. It does not take a poet to see such a situation as the reflection of analogous states of mind; but it does take a poet to evoke the image compellingly and as a symbolic concretization of an inner happening that concerns us.

Similarly, shunning or welcoming grief is an abstract feeling, but our way of responding to a homeless dog is not. Using the dog as an enlightening analogy of grief exemplifies a most common way of benefiting from the concreteness of the perceivable world. This device is the main tool of the artist. One may refer to it as symbolism, allegory, or metaphor when one discusses creativity. Or one may speculate on the resemblances between things, about which Michel Foucault fantasizes so freely in the manner of medieval mystics, saying that all the shapes of the world can "approach" one another but that man is in the center of all these analogies. "Man is in proportion with the sky as well as with the animals and the plants, with the earth, the metals, the stalactites, the tempest."[4] But no matter which theoretical approach one prefers, what counts is the realization that we are dealing here with the very core of the artistic response to the world of the senses.

Artists' creative dialogue with nature becomes even more impressive when their statements reach beyond the individual's aspiration, to deal with the striving for perfection and the recognition of the aspiration's weakness. There, the world of nature offers the vast spatial scope of up and down, peak and valley. Physical gravity also acts its

part in the interplay of body and mind, the burden of matter as against the soaring flight of the psyche.

A ready example of this interplay is the letter written in Latin by the poet Francesco Petrarca to his spiritual guide, the Augustinian father Dionigi de' Roberti. It describes his ascent of Mount Ventoux near Avignon in the year 1336. High mountains have played their symbolic role through history and all over the world. Dominating its environment and being visible from all sides, the mountain offers from its peak a survey of the world and detachment from it, and as such it has a symbolic affinity to the divine. The gods ruled from Olympus, and Hokusai's thirty-six views of Mount Fuji show the many human occupations united in their common dependence on a higher power.

Petrarca describes graphically the laborious struggle of his ascent, the temptation to avoid the steep directness in favor of easier routes, and a final exhaustion calling for a respite. The suspension of physical effort affords the chance of meditating about the nature of his undertaking. He realizes that "nature is not overcome by man's devices; a corporeal thing cannot reach the heights by descending." But what the body has trouble attaining, the spirit can attempt, and it is the analogy of the mountaineer's struggle with the striving for human perfection that leads the mind from the material to the spiritual.

> What you have so often experienced today while climbing this mountain happens to you, you must know, and to many others who are making their way toward the blessed life. This is not easily understood by us men, because the motions of the body lie open, while those of the mind are invisible and hidden. The life we call blessed is located on a high peak. "A narrow way," they say, leads up to it. Many hilltops intervene, and we must proceed "from virtue to virtue" with exalted steps. On the highest summit is set the end of all, the goal toward which our pilgrimage is directed.[5]

Comfort can be derived from a comparison between the impediments of the body and the ease of the mind's mobility. Petrarca now comes to wonder whether it would not be far easier for the nimble and immortal mind to obtain "by a flick of the eye" without any motion in space what the mortal and frail body is trying to accomplish under the heavy burden of the limbs.

The foregoing examples are meant to show that when the perception of our world is practiced at all intelligently, things and happen-

ings can be seen symbolically; that is, they are taken to be concretized images of what moves the human mind. This analogy refers to any level of the mind. It may depict a mere clash of antagonistic forces or the deepest struggle for salvation or happiness. Such intelligent dealing with the world involves creative responses in several ways. First, as I have said, it involves grasping the behavior of the forces acting in what confronts the senses: the dialogue of pine trees with the wind blowing across the ocean; or the way an assortment of fruit arranges itself on a table; or the majestic rising of a drawbridge that lets a boat pursue its course on the river. Such cognition is creative because it is much more than looking, hearing, or feeling. It explores the nature of things quite actively.

Second, such dealing with the world is creative also as it takes what is perceived as problems calling for solution. How can we understand what presents itself as a puzzling disorder? How can we profit from the given conditions to improve the situation? How can we create an image that clarifies what is given and shows the performing forces organized in a coherent structure?

In its most particularly human applications, the material world and our ways of handling it are used as analogies of the abstract forces that activate our minds. This symbolism serves the psychologist to use mental images of forces as metaphors, as Sigmund Freud, for example, did. It equally serves the artist to use the world as an interpreter of our experience. We have noted it in the writers' creative mirroring of human strivings, but it is just as apparent in Leonardo da Vinci's drawings of fantastic vortices or in the thunderstorm of a Beethoven symphony. Endowed with the ability to scrutinize the enigmatic world in which they grow up, human beings profit from their consciousness by puzzling, understanding, discovering, and inventing.

NOTES

1. Charles Baudelaire, *Oeuvres complètes* (Paris: Pléiade, 1961).

2. Denise Levertov, *Life in the Forest* (New York: New Directions, 1975).

3. Ibid., 43.

4. Michel Foucault, *Les Mots et les choses* (Paris: Gallimard, 1966), 37. My translation.

5. Ernst Cassirer, Paul Oskar Kristeller, and John H. Randall, Jr., eds., *The Renaissance Philosophy of Man* (Chicago: University of Chicago Press, 1948), 39.

Deus ex Machina

As I reread Molière's *Le Tartuffe*, it occurred to me that, by the way the play ends, it fails to unravel the plot to which it is committed. It cancels the final development by the fiat of a superior power, external to the forces that generated the play. As Molière misuses his play to pay homage to his patron, the king, he disobeys Aristotle's rule that "the unravelling of the plot, no less than the complication, must arise out of the plot itself, it must not be brought about by the Deus ex Machina. . . . The Deus ex Machina should be employed only for events external to the drama—for antecedent or subsequent events which lie beyond the range of human knowledge and which require to be reported or foretold; for to the gods we ascribe the power of seeing all things."[1]

Aristotle does not deny that in the drama superior powers may legitimately occupy the kind of function that only they can meet, as distinguished from the limited resources of humans. He implies that the human mind deserves the privilege of discerning, within its range of understanding, the good from evil and of resisting, within the range of its power, the irrational forces of passion. The question raised by Molière's handling of his plot comes down to asking what interferences by superior powers disturb the compelling logic of drama. Those interfering powers may be supernatural if, for the purpose of fiction, they are admitted as agents in human affairs. They also may be terrestrial, cutting the Gordian knot by wilful decree.

In *Le Tartuffe*, Molière presents a good-hearted but ingenuous man, exploited by a hypocritical *faux dévot* to the extreme of being robbed of all his possessions and even threatened with imprisonment. He is rescued only by the supreme wisdom and justice of the king, who unmasks and punishes the villain. Molière deprives his characters thereby of their right and duty to resolve the predicament in which they are caught. The king is not a legitimate agent of the plot in that

First published in *British Journal of Aesthetics*, vol. 32, no. 3, 1992. Reprinted by permission of Oxford University Press.

he does not share the spiritual problem imposed upon the characters by their encounter with the faux dévot.

What exactly are the characters' rights and duties? Since they are brought to life by a work of art, not by the real world, they are not primarily charged with the practical task of defeating the villain. The conflict of forces, of which the play consists, cannot be a purely physical one, otherwise it might as well be a boxing match or a duel of animals. Nor does the play call for an inquiry into the nature of evil. The faux dévot is not the center of the plot but only its external cause. The center is held by the innocent victims, who must face the problem of evil. How are Orgon and his family going to find in their minds a way of persisting in the good life by reconciling from now on the needed caution with the equally needed trust in human nature? The answer to this question should be given by the unraveling of the plot, but the intrusion of the deus ex machina deprives the characters of their right and duty.

A performance of the play on the stage would focus on the external events, the undoing of violence and injustice, but those events are only the visible manifestations of what the play is truly about, if it is to qualify as a creation of the human spirit. In another play, written in the same century as that of Molière, Corneille in *Le Cid* uses figuratively the forces of the "arm" versus those of the "head" to indicate what matters in human action. "Sire, j'en suis la tête, il n'en est que le bras," says Don Diègue during the discussion of the cause to be judged by the king. He, the king's aged general, has been gravely offended by a rival, who has slapped his face. His valiant son, Don Rodrigue, restores his father's honor by killing the offender; but he also incurs the death penalty for the murder he has committed. Don Rodrigue, however, is precious to the king as the heroic leader of his army. Therefore, he is spared the penalty and will be permitted to redeem himself by further service to his country. The tragic conflict between the demands of honor and the demands of the law leaves the protagonist petrified, with no other way out but his own death. "Je demeure immobile, et mon âme abattue cède au coup qui me tue." The knot is cut, however, by the discretion of an opportunistic ruler. The happy ending turns the tragedy into what Corneille in fact called first a tragicomedy. The king decrees that time as well as Rodrigue's valiance and the help of his king will take care of overcoming a point of honor that operates against the hero. "Pour vaincre un point

d'honneur qui combat contre toi, laisse faire le temps, ta vaillance et ton roi."

In the examples I have cited, the interference by a superior power can be described as a flaw due to a weakness of the dramatist. The problem becomes more significant when the action of the superior power does not concern the denouement but the cause of the dramatic conflict. Aristotle has instructed us that the deus ex machina can be employed legitimately to introduce information about events that need to be reported or foretold, "for to the gods we ascribe the power of seeing all things." This divine power is represented in Sophocles's *King Oedipus* by "Bright, Shining Apollo," the god of light. Phoebus Apollo symbolizes the enlightenment of universal knowledge. It is he who, by the Pythian oracle, discloses Oedipus's crimes, and by implication he must have foreseen them and perhaps brought them about. Even so, as his punishment Oedipus deprives himself of the privilege of sight, which by being unaware of committing crimes he has been shown not to deserve.

Oedipus's guilt, then, does not consist in having committed his crimes consciously. This led in the history of Western thought to the attempts of proving that nevertheless he is responsible—attempts of which the Freudian theory is the most recent and conspicuous example. If Oedipus strove unconsciously to kill his father as a rival and to possess his mother, he was indeed the initiator of his crimes, although he was neither aware of his motives nor their deliberate generator. Even so, Oedipus and his people charge him with the responsibility for what has happened. The task of drama is revealed, therefore, as describing how the human mind copes with the fate of bearing the responsibility for sins not wilfully incurred by it.

In *Oedipus at Colonus*, the gods are charged more explicitly with having engineered the unfortunate coincidence that made the king of Thebes an incestuous patricide. Oedipus accuses them: "I did not know the way I went. *They* knew; they, who devised this trap for me, they knew!" The connection is more compelling in another Greek play, the *Hippolytus* of Euripides. There the deus ex machina is lowered quite literally to the stage by a crane, and the action is presented as a power struggle between Aphrodite and Artemis. It is Aphrodite, "powerful among mortals," who imposes Phaedra's frenetic passion for her stepson upon her. At the same time, the drama is made more clearly a human concern by being fought out in the mind of the

protagonist. In queen Phaedra "reason struggled to subdue passion." The irrationality of the sexual drive is set against the equally human but rational demands of morality. Hippolytus, in turn, is guided by his devotion to the virgin goddess Artemis but not coerced by her. He opts freely for a life of chaste virtue. Hippolytus, in fact, is not a dramatic figure but the mere cause and victim of Phaedra's conflict.

If one compares the Greek *Hippolytus* with Racine's version of the same theme, now more properly entitled *Phèdre*, one finds that the focus is shifted even more explicitly from the divine rulers to the human agents of the plot. This is so even though Venus is still the initiator of Phèdre's adulterous passion. Now, however, the imposition of criminal guilt is characterized more strongly as a punishment meted out unto her as the last descendant of a race tainted by erotic misdeeds. Phèdre condemns herself as "the sad dregs of all nature" (le triste rebut de la nature entière), because the goddess of love acts as a defender of the laws of nature more in general—laws that have been violated by generations of a single clan.

The supernatural agents are yielding the stage to terrestrial ones. Nevertheless, superior powers continue to exert their function in the drama. Like the gods, forces beyond the control of an individual's rationality bring to bear their influence, and the responsibility for the effects continues to be accepted by the protagonist. This fact makes it possible for the play to remain a drama. Phèdre assumes the guilt for her sinful strivings fully as her own. She accepts the sins of her forefathers the way a modern dramatic victim might accept a burden of heredity. The deus ex machina has been replaced to a considerable extent with a force of human origin. The battle between passion and morality is internalized as a dynamic struggle within the protagonist, and Phèdre's suicide is the inevitable outcome of an insoluble tragic conflict.

The role of heredity as a superior power interfering with the moral conduct of human life reminds one, of course, of Henrik Ibsen's *Ghosts*, where again the intrusion of an external agent is shown to be motivated by human wickedness. The depraved Captain Alving has caused his son Oswald's deadly illness. Oswald explains to his mother that he is "not really ill, not what people usually call ill. Mother, I am spiritually broken—my will is gone—I shall never be able to work any more!" The true culprit, however, is not the human dissipation, which is revealed as a mere response to pernicious social constraints. It is they that have turned society into

an assembly of "ghosts." Mrs. Alving says accusingly to Pastor Manders, "It isn't just what we have inherited from our father and mother that walks in us. It is all kinds of dead ideas and all sorts of old and obsolete beliefs." The superior powers causing the tragic conflict in Ibsen's play act within the protagonist, Mrs. Alving, as the struggle between oppressive forces burdening her and her own sense of rightness and freedom. It is no longer the might of passion that inveighs against morality but a fight of one moral force against another—one evil, the other good.

"All this talk about law and order," says Mrs. Alving, "I often think that is what causes all the unhappiness in the world." The rebellion in Ibsen's *Ghosts* against the interference of powerful social constraints is anticipated in one more play I will cite here, Heinrich von Kleist's *Prinz Friedrich von Homburg*. By disobeying the military order of the ruler, the protagonist has incurred the death penalty, and he feels that it is his duty to abide. He asserts that, witnessed by the army, he has violated the holy law of war, which he wants to glorify by his freely chosen death. ("Ich will das heilige Gesetz des Krieges, das ich verletzt, im Angesicht des Heers, durch einen freien Tod verherrlichen.") By the time this play was written, in 1811, the obedience to authoritarian tyranny had begun to yield, and the Prince von Homburg himself objects in the end to what he compares with the rigidity of antiquity ("wie die Antike starr") and appeals instead to "Edelmut und Liebe." The seventeenth-century ruler's verdict of mercy was seconded by the Prussian king of Kleist's own time, Frederic II, who in his memoirs makes his predecessor, the elector of Brandenburg, say, "If I judged you by the severity of the laws of war, you would deserve to die. But God cannot wish that I darken the splendour of so happy a day by spilling the blood of a prince who was one of the instruments of my victory."[2] In the play, the decision is no longer the individual act of a supreme ruler, as it was in Corneille's *Le Cid*, it is rebelliously demanded by the entire military command of the army. This change of attitude indicates, for the morality of European drama, the erosion of the supreme power's intrusion into the conduct of human affairs.

Even so, the basic nature of drama does not change. It remains the conflict between forces beyond the individual's control—whether generated within the mind or exerted from outside it—and the strivings of rationality within the range of human freedom. Free will, however, considered psychologically and aesthetically, is subject to

constraints of its own. The will is not free to conceive or enact deeds out of nowhere. Psychologically, all behavior derives from drives, attitudes, and beliefs preceding it. Aesthetically, behavior violates the demand of necessity if it is not dictated by its antecedents. It deprives the plot of its logic and makes it arbitrary and meaningless. The dramatic conflict excludes such arbitrariness. In its pure form, it is fought out within the mind between the impulses imposed upon it and others controlled with equal necessity by its own reasoning.

The lawful determination of all forces at play in the drama was and is beclouded, however, by the long philosophical and theological tradition of a will free of any lawful determination. At the time from which most of the preceding examples of plays were taken, this predicament is clearly expressed in the writings of René Descartes.[3] Descartes asserts that the human mind is endowed with a large share of God's infinite and unlimited freedom of will. God himself has "not only known from all eternity what exists and can exist but he has also willed it to happen." In the human mind, however, the power of cognition is set against that of free judgement, "mon libre arbitre." Human cognition is coerced by what the mind perceives clearly and distinctly, but it is entirely free in the broad area of circumstances in which it is incapable of such clear distinction.

This conservative notion of the human privilege to will and act gratuitously left a large psychological and aesthetic gap—a gap closed by Baruch Spinoza when he identified God with nature and thereby subjected all forces, mental and physical, secular and divine, to the same unitary set of natural laws. In what I have described elsewhere as the Magna Carta of psychology as a science,[4] Spinoza objected to the tradition of exempting the human mind from the laws of nature. "Most of those who have written about the affects and the human conduct of life have done so as though they were not dealing with natural things obeying the common laws of nature but with things outside of nature. They seem to conceive of man in nature as a kingdom within a kingdom." Instead, Spinoza asserts: "There exists in the mind no absolute or free will, but the mind is determined to will this or that by a cause that is determined by another cause and that one in turn by others, and so *in infinitum.*"[5]

When the interaction of mental forces is freed of arbitrary intrusion, psychological as well as aesthetic theory can obtain a consistent image of the inherent logic by which human beings act and are acted upon.

NOTES

1. Aristotle *Poetics* 15.1454b1–6.

2. Heinrich von Kleist, *Prinz Friedrich von Homburg,* ed. Alexander von Bormann (Munich: Goldmann Verlag, 1983).

3. René Descartes, *Les Principes de la philosophie,* pt. 1, 37–43, and *Les Méditations,* meditation 4.

4. Rudolf Arnheim, "Beyond the Double Truth," in *To the Rescue of Art* (Berkeley and Los Angeles: University of California Press, 1992).

5. Baruch Spinoza, *The Ethics,* pt. 3, "Preface"; pt. 4, 48.

A Maverick in Art History

When in the 1920s one wanted to study psychology at the University of Berlin, one had to tackle two "majors," philosophy and psychology, because at that time psychology had not yet cut the umbilical cord from its mother discipline. In addition, for the Ph.D. one needed two minor fields, for which I chose the history of art and that of music.

Connections between the arts and psychology, which were my guiding interest even then, had barely begun to exist. At the University of Berlin, there was the usual separation of locations. The philosophers were housed in the main building "Unter den Linden." The psychologists conducted their experiments on two floors of the Imperial Palace, abandoned by its occupant after the revolution of 1918. The art historians were located in a classicistic building we called "die Kommode," because it looked like a chest of drawers. Every department minded its own business, and, as usual, a student who wanted to explore the relations between disciplines was left to his or her own devices.

In art history, there were three professors, the most famous of whom was Adolph Goldschmidt, the authority on medieval book illustrations. As a teacher, he was the very opposite of a flamboyant performer, but he captured the attention of his students by the wealth of his material. He was a small man, his nose buried in the papers from which he had lectured for decades. He had no need to raise his eyes to the screen, because his assistant had run the slides for him forever, and when the professor said, "In the lower left corner we see the figure of the Evangelist," it would have amounted to the unthinkable collapse of preestablished harmony if the Evangelist had not held his appointed place on the screen at that exact moment.

Derived from a lecture at the convention of Midwestern Art History in Ann Arbor, 1987.

The name of the professor who examined me in the orals was, I believe, Edmund Hildebrandt. He was a specialist in the Quattrocento and had agoraphobia, so that for his lectures the students had to squeeze into a small auditorium, where people fainted for lack of oxygen. He remains in my memory because in the orals he asked me to describe, without the benefit of illustrations, the stylistic differences between the tails of the horses on the two equestrian figures of Donatello's *Gattamelata* and Verrocchio's *Colleoni*.

The third professor was Hans Kauffmann, a young lecturer, pale and intense, who had just published a study on what he called the style ornament in the portraits of Rembrandt. Those portraits, he asserted, were composed on the basis of a rosette or star pattern of rays, issuing from the lap of the figure in all directions.[1] In those days, however, the discoveries of Sigmund Freud were fresh in our minds. We bought the first editions of his writings for a few marks; and if someone insisted on the sexual area as the generative center of the human figure, we youngsters looked at one another with a knowing smile. (Many decades later, when I had come to appreciate the compositional "power of the center," I acknowledged him as a forerunner of my own observations.)[2]

The Freudians, of course, were among the early psychologists who tried to apply their theories to the arts, but their relation to art history has always remained precarious. When they asserted, for example, that Leonardo da Vinci had trouble sorting out his mothers or that Picasso reflected in his *Guernica* catastrophic events of his childhood, it seemed clear that such early experiences, if they survived in fact in the mind of the artist, were subordinated to his mature conception of the deeper meaning he found in his subject. Besides, the psychoanalytic claim that art is nothing better than a secondary sublimation, a substitute for the instinctual satisfaction actually desired, or that artistic creation consists in the regression of the ego to a more primitive mental level, were unlikely to endear the prophets of that doctrine to friends of the arts.

Nor was psychoanalysis a favorite of the gestalt psychologists, by whom I was trained at the Psychological Institute of Berlin. The founders of that approach welcomed works of art and music as the perfect embodiment of highly organized and unified patterns, in which the structure of the whole interacted with that of the parts. No other school of psychology could have prepared me better for

my work on the formal resources of visual perception, on the organization of composition, and on the symbolic expression of shape and color.

Even so, between art history and the psychology of art there was a gap not easily bridged. Historians, by their very nature, are interested in variety and difference. They are fascinated by the inexhaustible wealth of appearances that distinguish one culture from the next. They are challenged by the ways in which manifestations of such diversity grow from one another, and they would like to understand our own period's particular style and outlook as the unique product of many roots.

Psychologists, too, are interested in development. They have been studying the artwork of children, as it develops from simple beginnings to more complex achievements. And there have been recent attempts to show that the stages of mental development in the child, as described by Jean Piaget, are paralleled by the course of art history. The problem there, however, is that the growth of a person's mind can be considered a unitary, coherent process, leading from early beginnings to full functioning, whereas in the history of the arts there is at best here and there the gradual perfection of a particular feature within a limited span of time. This was the case, for example, when Greek art changed from archaic beginnings to Hellenistic impressionism. But since the development traced by child psychologists involves a qualitative improvement from the poor resources of the infant to the full command of mental powers, the historians pursuing this analogy have a hard time avoiding the embarrassing impression that they want us to admire the steady ascent from the immature fumblings of Egypt and Greece to the glorious climax in the works of our own contemporaries.

Less broadly conceived studies of development offer a better promise. I made a detailed analysis of the many sketches and stages that led Picasso from the first drawing for *Guernica* to the completed painting. Pursuing Picasso on his twisted path, I came to admire the wealth of the completed work.[3] Its offerings seemed almost inexhaustible; and I confess that after staring at it for a year and concluding my survey, one day I had to make the frustrating discovery that in the right corner of the canvas there was an open door I had never noticed. Other such doors have been opened by other researchers since that time.

Investigations such as the one on the creative process in *Guernica* concern a sequence of events in time and therefore have an affinity to the approach of art historians. I believe, however, that another way of dealing with art psychologically will prove to be at least as fruitful in the long run. I said that historians, by their very nature, are attracted by variety and difference. The natural sciences, on the other hand, concentrate mostly on what things have in common, and psychologists are somewhere in the middle between the two attitudes. From this point of view, history can be considered synchronically as the unfolding of the endless aspects of human nature, revealed by the varying conditions of social, physical, and psychological circumstances. In that way, history is seen as a reservoir from which to draw examples of how the basically invariable components of the human mind manifest themselves. In the arts, the set of human responses can be investigated through examples that associate Cycladic figurines with sculptures by Henry Moore or the wall paintings of Pompeii with the canvases of French Impressionists. Such an approach gives prominence to the image as such rather than the particular place and time of its appearance.

The realization that the two approaches complement each other has been slow in coming, even though the principal achievement of one of the most prominent art historians has been precisely this rapprochement. When Heinrich Wölfflin in his *Principles of Art History* compared the Renaissance and the Baroque by such visual categories as the linear and the painterly, flatness and depth, openness and closedness, the elementary perceptual categories occupied the foreground of interest.

It is less well known that Wölfflin initiated his approach in an even more radically psychological fashion. In his dissertation of 1886, entitled "Prolegomena to a Psychology of Architecture," he attempted, under the influence of the psychologist Theodor Lipps, to apply the theory of empathy to architecture. "How is it possible," he asked, "that architectural shapes can be the expression of something mental, of a mood?" Quoting psychologists such as Wilhelm Wundt and aestheticians such as Johannes Volkelt and Robert Vischer, he answered that it is the awareness of our own body, the kinesthetic sensations of load and weight, the muscular extension and constriction of the lungs, and the visual qualities of proportions and physiognomy that make us experience architectural expression by empathic resonance.[4]

Although by now the original theory of empathy has gone through many transformations, it seems to me worthwhile to translate a passage from the conclusion of the great historian's early work. What Wölfflin wanted to show in his dissertation, he says, was that "an organic understanding of the history of form will become possible only when one knows what fibers of human nature connect with the sense of form." Thus far, he says, "the historian who has to judge a style possesses no system for characterizing it—he has to rely on instinctive sensing." Therefore, an ideal of scientific exactness tempts historians to talk only about how things follow one another, and not a word more than that. He concludes:

> I am not inclined to overlook the virtues of this tendency, but I cannot but believe that it is not sufficient to attain the highest scientific level. A history that wishes to acknowledge nothing but the sequence of things in time cannot last. In particular, it would deceive itself if it believed it had attained "exactness" in this manner. One's work becomes exact only when one is able to capture the flow of appearances in solid forms. In physics, such solid forms are provided by mechanics. In the humanities, this foundation is still lacking. One can look for it only in psychology. This would make art history, too, capable of referring the particular back to the general, that is, to laws.[5]

Wölfflin did add that thus far psychology had not reached the state of perfection needed to meet the demands of a historical morphology. This was true in 1886, and it cannot be gainsaid entirely today. Nevertheless, some progress has been made, and my own work has been devoted almost entirely to this end. In the 1920s, I collected much material on the film as an art.[6] What interested me was not so much the individual works then produced but rather the medium of the silent film as a great experiment of representing our world by means of mobile images alone. The photographic medium had been rejected as being nothing but mechanical reproduction and therefore incapable of artistic expression. My strategy was to compare systematically the visual experience of looking at the actual world with the viewing of the film image on the screen and to show that the very deficiency of the early screen image, its lack of sound, its flatness, its confined space, its reduction to black and white, was its means of interpreting the sensory world, including by indirection the sounds.

A few years later, I used the same approach to analyze in another book the perceptual resources of radio as an art.[7] As the countermedium of the silent film, radio offered ways of interpreting the

world by sound alone. In a key chapter, called "In Praise of Blindness," I described the unique virtues of disembodied voices and noises in such radio plays as Bertolt Brecht and Kurt Weill's *The Flight of the Lindberghs*.

When the silent film was replaced by the talkies and radio had to defend itself against television, I clung to those early media with a zoologist's love for endangered species. Trying to capture, as Wölfflin had demanded, the flow of appearances in solid forms, I used the early media to illustrate the properties of perceptual categories. But it took my emigration to America and my entrance into its academic world to relate my observations of the art media more directly to my training as a psychologist.

Let me mention here that like many expatriates of those years I looked forward to a new life in America with the mixed feelings reflected, for example, in the diaries of the painter Max Beckmann. I was accustomed to thinking of the United States as an awesome blend of skyscrapers and cowboys, and here I remember with much gratitude a visit by the art historian Horst W. Janson, then probably still a graduate student, who on a return trip to the old continent visited me in Italy, where I had been working at an Institute of the League of Nations. We were sitting on the roof terrace of our little house in a suburb of Rome, with the profile of the Monte Cavo and the Renaissance villas of Frascati on the horizon and the white oxen with their lyre-shaped horns grazing in the Campagna. How could one bear to leave all this behind? It was then that Janson told me about America, its many universities and libraries, its museums and art galleries, its heroic landscapes, and the international flavor of its cultural life. That conversation changed my entire outlook, and when I did arrive in New York in 1940 I was lucky enough to find my expectations richly confirmed.

When the Guggenheim Foundation gave me two years of carefree time, I decided to sit down and write my book on the application of the gestalt psychology of perception to the visual arts. Soon enough, however, I discovered that there was a gulf between the two disciplines, which had still to be bridged. It was in the nature of a psychological experimentation to limit itself to the simplest visual shapes, single lines or triangles or circles, whose variables were easily surveyed. No such convenience was offered by the complexities of works of art; and it was works of art I was after. Thus, instead of writing my book, I settled for a number of special investigations

dealing with depth perception in pictorial space, with visual ab-
straction, color relations, and so forth. Only some years later was I
ready to apply what I knew about perception to what I knew about
art in a systematic book, trying to steer a watchful course between
scientific exploration and a decent respect for the intangibles of indi-
vidual creation.[8]

Forty years have passed since that first undertaking, and as I
glance back at the many studies occupying me since then, I find the
main difference to be a change of observation point. While in those
early years I came equipped with the generalizations of experimen-
tal research to explore the arts for convenient illustrations, I gradu-
ally moved my venue to the territory of the arts themselves. I took off
from what artists and designers had given us, and I employed the
analysis of formal means of perception and expression to answer the
question: What is it that makes the arts speak to the eyes?

NOTES

1. Hans Kauffmann, *Rembrandts Bildgestaltung* (Stuttgart: Vohlhammer,
1922).

2. Rudolf Arnheim, *The Power of the Center,* new version (Berkeley and Los
Angeles: University of California Press, 1988).

3. Rudolf Arnheim, *Picasso's "Guernica": The Genesis of a Painting* (Berke-
ley and Los Angeles: University of California Press, 1963).

4. Heinrich Wölfflin, "Psychologische und formale Analyse der Ar-
chitektur," in *Kleine Schriften* (Basel: Benno Schwabe, 1946).

5. Ibid., 45.

6. Rudolf Arnheim, *Film as Art* (Berkeley and Los Angeles: University of
California Press, 1957).

7. Rudolf Arnheim, *Radio: An Art of Sound* (New York: De Capo Press,
1971).

8. Rudolf Arnheim, *Art and Visual Perception* (Berkeley and Los Angeles:
University of California Press, 1974).

IV

Learning by Looking and Thinking

Educators have many targets, and they try to do justice to all of them, as best they can. Among the goals they want their pupils to attain, there is at least one on which they can all agree, and it is the one to which I will limit myself in the following. More attention, I will insist, should be paid to the interdependence of thinking and the senses, especially the sense of vision.

Everybody is grateful for the benefits of vision. By its eyesight, the human mind reaches beyond the confines of the body. By reaching beyond the objects our hands can touch, we contact the stars with the speed of light. Sight is distinguished among the senses by telling us about the innumerable shapes of things, their sizes and places. A mere inventory of these facts, however, would not be sufficient for what we need to know. Beyond the mere facts, we need to take hold of life in action; for life is what we want to understand. An entomologist, for example, is curious about butterflies. So the first thing he needs is the "facts." He collects lots of the insects in his net. But the facts are not yet in a comprehensible order; they are a mere accumulation of specimens.

All too much learning is still like a net full of insects. What some teachers have collected in their net is numbers, dates, lists of famous persons, lists of events. But to children, the world does not look like that. When their eyes explore the world, they see happenings, people, and things acting upon each other. There is attraction and repulsion, helping and fighting, mutual influence in innumerable ways. This is what children see, and this is what they need to learn about.

Now there are two ways of responding to action. One can simply watch it and be entertained by the variety of stimulations. It is a passive way of keeping the mind busy, and children as well as adults are tempted to spend their time that way. Many popular television programs treat their audience to such passive distraction. But human

Derived from "Learning by Thinking and Doing," *Educational Horizons,* Winter 1993.

minds are spurred also by another equally powerful need. It is a sense of curiosity, a sense of wonder, the wish to find out how things work, how they act upon each other, why they are the way they are, and how one manages to participate. This more comprehensive need to know impels children from their youngest age, and it activates two basic abilities of the mind: the ability to observe and the ability to think about what one perceives.

In education, we have been burdened by a tradition that separates perceiving and thinking, as though they were entirely different activities. Many of us have been made to believe that we have to feed the sense of sight in one way and to train reasoning in quite another. Supposedly, there is one aspect of learning that supplies the mind with useful pictures of the wonders of nature and the achievements of mankind, the sights of foreign countries, and the scenes of historical events. Quite apart from that, in other hours of the day we are supposed to train the intellect by treating it to theories and formulas, statistics and concepts. The senses are supposed to be limited to the raw material of individual specimens, whereas the intellect deals abstractly with generalized concepts. The two are expected to serve each other, but they engage different faculties of the mind and have to be trained separately.

This separation seems to me psychologically incorrect and educationally pernicious. One needs only to look at what happens in any act of productive learning to realize that it consists in an intimate interaction of observation and reasoning. This is evident already when a young child takes an object apart and fits it together to find out how it works. The fascination of such a task is brought about by the cooperation of what is seen and what is figured out. The handling of the plaything is controlled by the inseparable union of watching, handling, and thinking. And what is true for the child holds equally for the way the brains and eyes and hands of great scientists operate. I will try to illustrate this cooperation of sense and thought by the example of a very abstract concept, namely, the principle of causality. This concept has recently produced a crisis in scientific thinking, because physicists discovered that causality does not seem to hold for the observation of how particles behave in quantum mechanics. But the way we ascertain the place and momentum of any object at any instant of time in ordinary life is not applicable to the microworld of particles, because the tiny quantum of x-rays or other radiation media needed to contact an electron is sufficiently strong to disturb the

Figure 1. Albert Michotte, demonstration of visual causality.

object we want to observe. This important discovery has had a double effect. It has taught us that, far removed from our daily experience, there are areas of our physical world that our sense of causality cannot penetrate. But in no way has it shown that causality does not hold. What the discovery of the physicists has told us is that the instruments of our knowledge—our minds, our senses, our means of reading the world—are indispensable parts of the causal process. What we see, what we learn, depends on who is looking and who is learning.

Causality in action is always a captivating sight, whether we watch the eruption of a volcano threatening a village or billiard balls pushing each other in a game. A boxing match or an argument in a discussion is alive because it shows causality in action. But how exactly does causality work?

Psychologists have demonstrated that causality is more than an abstract concept to be studied from a textbook. The energy transmitted from an agent to a suffering recipient can be made alive in the visual experience of a person watching the event. Around the middle of our century, the Belgian psychologist Albert Michotte studied what happens, for example, when in an animated scene a black square appears on the screen and begins to move sideways (fig. 1.)[1] After a while, the black square stops exactly on top of a red square, which has been waiting at the middle of the screen and is now in contact with its partner. The moment the black square stops, the red square beneath it starts to move. What happens in the minds of viewers, who may be students of any age? What they see is not the purely mechanical displacement of geometrical figures. They see a small dramatic spectacle, not unlike what happens when cartoon characters push each other around. The viewers get involved, as though it were a sports event, particularly when now the teacher, instructed by Professor Michotte, asks what will happen if we vary the conditions of the event. What will happen if the black square moves either more slowly or faster than the red one? Or if the red square starts moving

only a while after it has been touched by the black one; or if it is either smaller or larger than its opponent? What is the difference between being pushed and receiving only the cue to move under one's own power?

Before you know it, a whole world of different possibilities challenges the inquisitive mind of the child. Seeing the forces of give and take in action, the human imagination can explore questions that can be answered by simple experiments. These are prime examples of thinking by observing. Without separating the intellect from sensory experience, visual thinking makes the mind work as a whole. It gives intelligence to vision and enriches the abstract concepts with the colors and shapes of visual experience.

Now this may be all right for fields of learning where visual images are directly involved. Geometry, for example, begins and ends with the examination of figures; but what about arithmetic, the most abstract of the disciplines? Here also the good teacher relies on the sensory counterpart of the numbers, because what numbers stand for is nothing but quantities, and the quantities of weight, size, and mass are entirely sensory. We do not need to resort to practical applications like pounds of apples or numbers of chickens. For some children, such illustrations are more distracting than helpful. No, the mere abstract qualities themselves call up all sorts of lifelike connotations. What, for example, are equations? They are comparisons of equal quantities, like weighings on a pair of scales. Quantities may be put together in innumerable different ratios and yet be equal in their total amount. Our daily lives are full of such comparative weighings, and to study them "in the pure" challenges and entertains the mind.

Then again, there are fields of learning that seem to be populated by nothing but practical facts: crowds of people, outstanding individuals, exploits and battles. In the study of history, there seems to be little space for conceptual thought. And yet, here again thinking is indispensable for vision, because all those noisy events are underlaid by forces that must be comprehended in their direction and strength—physical forces, military, social, economic forces, to be compared and weighed. Just as in the causality demonstration and the arithmetical examples, abstract shapes and numbers conjure up the facts of life in all their visible and tangible concreteness, so, conversely, the facts of life reveal their understandable meaning only when they are seen as the play of abstract forces explored by our intellect.

What we admire as intelligence can be understood as excellence of perceptual thinking. This is true for all the different activities in which intelligence manifests itself. The ways in which a skillful cabinetmaker uses the virtues of his tools to deal with the properties of his materials is not different in principle from the ways in which an intelligent head of a company or institution handles the abilities of his employees to obtain the desired results and products. The same is true for the different levels at which students apply their intelligence to learning. To deal intelligently with a geometrical problem requires the same basic abilities as to handle a question of economics or ethics. One has to search for the pertinent underlying principles and apply them to the particular conditions offered by the given situation.

Even so, it is all too obvious that not all students do equally well in all areas.[2] To learn how to deal with people in social situations will fit the intelligence of some students better than to fix a motor or to dissect the body of an animal. To do justice to each individual, we must evaluate the person's functioning in relation to how much of an affinity he or she has to a particular competence of body and mind.

Visual learning relies not only on how much ability and willingness pupils bring to their studies. Much depends also on how well the materials and conditions offered in the learning situation are suited to a ready grasp of the things to be seen and understood.

When we prepare visual aids, we are all too often satisfied with material that somehow contains the subject to be studied. To give a sensible idea of the geography and social conditions of, say, Haiti, it is not sufficient to show any kind of travelogue material, as long as it presents the objects to be discussed. Instead, the visual material must be selected in such a way that it demonstrates the relevant facts and relations as visual symbols of the underlying concepts; for without grasping these concepts one receives the visual material as nothing better than a pleasant tickle of the eyes. The same is true for visual aids intended to explain the function of a machine or an organic mechanism.

I have referred elsewhere to an investigation by a German psychology student, Werner Korb, who found that in the teaching of chemistry the student's understanding is often impaired by a cluttering up of the table where the teacher keeps all his bottles, tubes, and burners in full sight, even though for the eyes of the students it

is not obvious what belongs to the experiment they are expected to watch and consider.[3] Equally distracting is it when the demonstration is set up in the cheapest and technically simplest way, regardless of whether or not the setup clearly reflects the decisive features and relations of what is to be understood.

A similar kind of task faces teachers every day in the classroom when they try to clarify a problem by a diagram on the blackboard. There are enlightening diagrams and confusing ones. Some focus on the decisive aspects of the problem, others distract by ambiguous shapes or irrelevant detail. But teachers must also cope with the opposite task of how to make a general idea, such as freedom or submission, obvious by turning it into a significant visual image. It takes skill to handle this interrelation of thought and visual imagery successfully, and this skill has to be learned and practiced. The professional expert in this field is the artist, and art education is a training ground for visual thinking. Art education faces the teacher with two tasks. Students must learn to look at pictures attentively and congenially, and they need training in doing artwork themselves.

When we are dealing with pictures representing stories, it matters once again whether or not the pictures succeed in drawing attention clearly to the underlying theme. A biblical story such as that of the sacrifice of Isaac has been illustrated by many artists more or less well. When we see it presented in an etching by Rembrandt, it becomes the dramatic story of a father, driven by the duty to obey his superhuman master and the resistance to slaughtering his beloved son. Nothing disturbs the powerful realization of the theme.

Many pictures, however, present no narrative subject at all. Abstractions make valuable statements without referring to familiar objects. This is true not only for the abstract paintings of our century but also for the "designs" made spontaneously by young children. Although many people visiting art exhibitions protest that they do not understand what the modern works are about, they have little trouble producing abstractions themselves. I have often asked students to represent concepts such as democracy or the difference between a good marriage and a bad marriage in an abstract drawing, and I have found that they take to the task quite readily and that it is an excellent pedagogical tool for analyzing and interpreting concepts.[4]

Here again, of course, we are reminded of the diagrams on the blackboard, used by teachers in every field of knowledge to enliven

concepts with visual concreteness. Visual thinking is the ability of the mind to unite observing and reasoning in every field of learning. Whether people spend their days on using the physical forces of their bodies as garage mechanics or surgeons or dancers or whether they labor quietly at their desks as mathematicians or poets, the principal instrument on which their minds rely will always be the same.

NOTES

1. Albert Michotte, *La Perception de la causalité* (Louvain: Institut Supérieur de Philosphie, 1946).

2. Howard Gardner, *Frames of Mind* (New York: Basic Books, 1983).

3. Rudolf Arnheim, "A Plea for Visual Thinking," in *New Essays on the Psychology of Art* (Berkeley and Los Angeles: University of California Press, 1986).

4. Rudolf Arnheim, *Visual Thinking* (Berkeley and Los Angeles: University of California Press, 1969), chap. 7.

As I Saw Children's Art

The artwork of children has helped us to realize that the trend toward naturalistic representation, which has dominated Western art for more than the last five centuries, does not give us the whole story. It is true that all through human history there have been periods whose style of imagery deviated conspicuously from lifelikeness and that nevertheless they reflected the spirit and meaning of life in ways that we had good reasons to envy. But it was always possible to dismiss all those many deviations from what was considered normal as being the immature products of primitive people or as being due to unfortunate impediments of one kind or the other.

Powerful influences in our own time have helped to remove these blinders from our eyes. One of the influences is the emergence of modern education and of child psychology. It was recognized that the childhood years should be spent not only on training the young in the skills of adulthood. The early years, one came to understand, are crucial for the development of all the essential abilities of the mind and the body. A child is a person from the first day of its life and begins right away to discover, to respond, to learn. Doing artwork turns out to be one of the best helpers in this development.

The monopoly of naturalistic art suffered another upset when painters and sculptors of the twentieth century overrode its canons quite recklessly. Cubism, Expressionism, and Nonobjective Abstractionism showed that reality can be revealed in new and equally valid ways. Although the lifelike depiction of nature maintained a place, it was known from then on as just one among other equally valid ways of accounting for human experience. Child art was acknowledged by painters such as Paul Klee as one of the models to be followed.

Quite generally, the human mind acquires its knowledge in two ways that run in opposite directions but complement each other. On

Derived from "A Look at a Century of Growth" in *Child Development* in *Art Anthology,* National Art Education Association, 1995.

the one hand, comprehension of the world around us starts with broadly generic notions and becomes only gradually more specific. A child grasps first the difference between humans and animals and only later the difference between cats and squirrels. On the other hand, however, exploration takes off from local details, which only later come to occupy their place in the broader context of the environment. Other landscapes, other people's homes and possessions come as surprises. The intricate give and take between the two approaches to reality is reflected in the artwork of children.

Traditional psychology, however, tended to take this second approach to be the first and only one in early experience. The senses of vision, hearing, and touch were supposed to start out recording the elements of the outer world piece by piece and more or less faithfully. Then, a second, higher level took over to extract generalities from the raw material that had been gathered. But this, psychologists believed, came later.

This prejudice created a puzzle, when theorists looked at children's drawings and found that, as soon as those simple pictures showed recognizable subjects they obviously were not attempts to copy what is recorded through the lenses of children's eyes. Instead, they were generalities, made up of simple geometrical shapes such as lines or circles. Of course, these shapes were not perfectly executed. Especially the earliest drawings were crude approximations, and there were wild scribbles and splotches.

But the predicament was clear. The pictures did not show what the theorists expected, and so they helped themselves with the absurd claim that children skip the early experience of perception and begin instead with grasping what they see by means of intellectual concepts. "Children draw what they know, not what they see." The general acceptance of this misguided notion was what I had to contend with when I wrote a chapter on "growth" in *Art and Visual Perception*.[1] It was the first strike in my lifelong battle for the priority of the senses in human cognition.

Equally revealing, however, was to me the realization that the artwork of children shows an unfailing respect for the demands of the medium they are employing. When one makes pictures on a surface, one must obey different rules than when one makes figures of clay.[2] In this respect, children can serve as a model for the visual arts in general. One cannot violate the conditions of the medium with impunity.

This led me to show more recently that certain common deviations from the geometrical rules of central perspective are misinterpreted by art historians as errors.[3] By making things converge toward depth, central perspective hides their sidefaces and thereby neglects the task of showing what needs to be seen. The so-called inverted perspective reveals it, in keeping with the conditions of the two-dimensional medium. Children know this intuitively; and so do the practitioners of other early styles of painting.

I had to conclude that visual perception does not consist in copying or extracting or selecting from the images that the projections of the eye lenses have to offer. This meant that perception operates by forming concepts—a disturbing contradiction in terms of traditional psychology.[4] There were perceptual concepts, and there were intellectual concepts. Perceptual concepts had to organize the raw material of vision and to cope with the conditions of the medium. Intellectual concepts, although derived from perceptual concepts, were another matter.[5] Children did not lack them, but, as I have pointed out, they do not rely on them for forming the style of their artwork.

It has always seemed pointless to me to distinguish between art and nonart. On no scale dealing with the understanding of art is there a cut-off level, separating what deserves to be called art and what does not. Art, in my opinion, is not a category of objects but a quality or property of things and objects.[6] Art is the ability to express the nature and meaning of something through its sensory appearance. Whenever a child's product exhibits this representational virtue, it has the quality of art. Simple or complex, conscious or unconscious, this precious ability begins to show in early childhood.

Art is not the privilege of a few gifted people. We are only beginning to understand the particular conditions needed for talent to come to fruition, but it is already evident that the early formal principles in the development of gifted children are those of all normal children.[7] Typical of them seems to be a keen sense of observation and an eagerness to reflect these observations in their artwork. Frequently, there is also a strong visual imagination, the invention of rich shape and color patterns. The originality of composition may show up quite early, although in our particular culture the precocity of gifted children may manifest itself mainly in an early ability to handle the devices of naturalistic representation, such as foreshortening and other aspects of spatial depth.

I need to mention here that my own concern with children's art—as indeed with the arts in general—has been mostly with its cognitive function. Not that I underrate in any way the psychological importance of the work's content or the personal attitudes it may reveal; see, for example, the drawings done by children during the Spanish Civil War.[8] I just happen to be mostly absorbed by the human mind's coping with the complexity and mysteriousness of the world we face, the problems raised by this confrontation, and the efforts of the mind to recognize and resolve these problems.

Any successful coping with this fundamental problem presupposes an intimate cooperation of perception and thinking. I have referred already to the unfortunate separation in theory of these two components of the cognitive mind. The distinction is all the harder to handle when language does not provide terms to refer to their unity, as is the case in English. The German language luckily provides the word *Anschauung,* which stands for sensory experience, as it comprises understanding and conceptualization. Henry Schaefer-Simmern in his pioneering book on the unfolding of artistic activity helped himself with terms such as "visual conceiving," and I had to limit myself to speaking in English of "visual thinking," even though such thinking amounts to much more than applying the purely optical recording of percepts to thought.[9]

In his work on multiple intelligences, Howard Gardner refers to the arts in defining seven principal skills such as the musical, the bodily-kinesthetic, and the spatial; and from the days of Viktor Lowenfeld art educators are acquainted with the difference between more visually and more haptically inclined individuals.[10] Gardner's theory is exerting a wholesome influence on early education by pointing out that from the beginning children are disposed to learn most readily in particular areas of functioning and will profit from being educated with individual emphasis on their special dispositions. I am hesitant to agree that these different dispositions are best called intelligences. I am inclined to believe that the notion of intelligence should not be split up into a variety of different manifestations. Gardner recognizes the ability to solve problems as a central virtue of intelligence, and it seems to me that the ability to group essentials, to see particulars in their broader context, to discover relations between distant areas and thereby to view things in new ways is a central, supreme distinction of intelligent persons. It is the same quality

in a good painter, mathematician, or garage mechanic, even though it does not appear equally in all aspects of a person's mind. The cleverness of an intelligent child shows up early.

What I find particularly challenging in Gardner's work is the need for educators to discover ways of teaching different subjects in the perspective of a particular mental disposition. It is easy to teach a visual youngster art or geometry, but how does one give him or her a fitting access to prose or physics or history? Good teachers find ways of doing it, but it takes imagination.

In dealing with children's artwork, I have concentrated on the preschool years because in early childhood the root principles of the work show up most purely. The steps of development from the simplest to more complex shapes have been analyzed by Schaefer-Simmern, on whose approach I was able to base much of my own, and it has been usefully illustrated by Sylvia Fein.[11] To Fein we also owe the case study on the development of a gifted child's artwork, and hers was preceded by Gertrude Hildreth's monograph on a boy drawing trains.[12]

The natural growth of children's development in the arts can be interfered with by prejudices held by educators. One of these prejudices has been spread by the producers of television, who believe that the span of attention of people, and particularly of children, is quite short. Supposedly, the only way of keeping the attention of an audience is to feed it potpourris of various short bits. This mischievous strategy has trickled into art education, inducing teachers to confuse children by a bombardment of different techniques, materials, and assignments. Nothing could be more adverse to the natural behavior of an undisturbed child. Left alone, it will spend endless time on a task that has caught its attention, just the way adult artists do. A task has a power of taking over and dictating how much time will be needed and what needs to be done.

Another cultural artifact seems to me to be the cause of the slackening of the creative impulse and the decline of artistic quality, which has been observed in early teenagers. It has been attributed to the onset of puberty, but it seems to me due to our particular social situation. There is little true affection for the arts in the general population, a neglect supported by the mass media, which promote the prestige of sports. A youngster interested in the arts is likely to be taken for a sissy, and his reputation with his classmates will suffer.

Under favorable conditions, however, when parents and teachers support the arts and show an interest in the artwork of the young, the work grows without interruption in accordance with its inherent impulses, and it may do so for the rest of the person's life. The trust in these impulses, born with the child and nourished by the delight and stimulation of experience, is what keeps art educators struggling along in the face of all obstacles.

NOTES

1. Rudolf Arnheim, *Art and Visual Perception* (Berkeley and Los Angeles: University of California Press, 1974), chap. 4.

2. Claire Golomb, *Young Children's Sculpture and Drawing* (Cambridge, Mass.: Harvard University Press, 1974); idem, *The Child's Creation of a Pictorial World* (Berkeley and Los Angeles: University of California Press, 1992), chap. 4.

3. Rudolf Arnheim, "Inverted Perspective and the Axiom of Realism," in *New Essays on the Psychology of Art* (Berkeley and Los Angeles: University of California Press, 1986).

4. Rudolf Arnheim, "Perceptual Abstraction and Art," in *Toward a Psychology of Art* (Berkeley and Los Angeles: University of California Press, 1966).

5. Rudolf Arnheim, "The Double-Edged Mind: Intuition and the Intellect," in *New Essays*.

6. Rudolf Arnheim, "Art as an Attribute, Not a Noun," *Arts in Society* 9 (1972).

7. Claire Golomb, *The Development of Artistically Gifted Children* (Hillsdale, N.J.: Erlbaum, 1995); Ellen Winner, *Gifted Children: Myths and Realities* (New York: Basic Books, 1996).

8. Aldous Huxley, ed., *They Still Draw Pictures* (New York: Spanish Child Welfare Association of America, 1938).

9. Henry Schaefer-Simmern, *The Unfolding of Artistic Activity* (Berkeley and Los Angeles: University of California Press, 1948); Rudolf Arnheim, *Visual Thinking* (Berkeley and Los Angeles: University of California Press, 1969).

10. Howard Gardner, *Multiple Intelligences* (New York: Basic Books, 1993); Viktor Lowenfeld, *Your Child and His Art* (New York: Macmillan, 1954).

11. Arnheim, *Art and Visual Perception*; Sylvia Fein, *First Drawings* (Pleasant Hill: Exelrod, 1993).

12. Sylvia Fein, *Heidi's Horse* (Pleasant Hill: Exelrod, 1976); Gertrude Hildreth, *The Child's Mind in Evolution* (New York: King's Crown Press, 1941).

Artistry in Retardation

Among the natural resources that are still being discovered are not only those of the physical world, such as the minerals of the earth, the nutrimental and medicinal resources of plants, or the ingenious structural devices functioning in the anatomy and physiology of animal bodies. We have also begun to explore untested cognitive and artistic resources of the human mind.

Such mental resources were overlooked, because they involved deviations from the standards. Among them were, first of all, the minds of people disturbed by violent passions or distorted worldviews. They were considered the refuse of society to be put away in insane asylums. But they also came to be the first to be thought of as salvageable. Psychiatry, which had its beginnings in the nineteenth century, became acceptable because many of the minds it undertook to deal with seemed potentially normal and therefore curable. Eventually, in 1922, this led also to the pioneering publication of the psychiatrist Hans Prinzhorn's *Artistry of the Mentally Ill*, in which the author acknowledged not only the high artistic quality of the work of untrained patients but also its affinity to the style of contemporary art.[1]

A different story was that of human beings who fell short of the standards of normalcy by being either immature or by being stopped in their mental development. Even children were treated for a long time as the mere potential of society but not as valuable and useful in their present state. They had to be taught the basic skills, but their way of thinking was dismissed with a tolerant smile; and we own hardly any examples of the artwork of children from periods preceding our century. Art education developed from the mechanical copying of model objects, and only very gradually and hesitantly have we begun to stimulate the inherent capacities of children to spontaneously observe, invent, and shape.

First published in *The Arts in Psychotherapy*, vol. 21, no. 5, 1994.

All this leads me to the potential resources of persons who are stopped at some early level of mental development by the physiological handicap of Down's syndrome. For lack of a better term, these people are spoken of as retarded, and they, too, are generally still denied an early chance to unfold their creative potential. By now it is recognized, however, that retardation comes at different levels, and while even the least educable persons can be given the chance of some cognitive, linguistic, and motor improvement, the real eye opener has come from the achievements of individuals who, favored by relatively good neurological conditions and by a helpful environment, have astonished us by their unexpected abilities. In 1979, I reported on a case study dealing with a Canadian woman, Jane Cameron, by the German art educator and therapist Max Kläger.[2] As one of the craftworkers at the excellent Montreal workshop Le Fil d'Ariane, Ms. Cameron not only designed and executed tapestries of exquisite artistic quality but also was motivated to make thoughtful poetical comments on her work.

Two other books have been published by Kläger, a professor at the Pädagogische Hochschule of Heidelberg. One of them is another case study on a Down's syndrome artist, Willibald Lassenberger; the other, edited by Kläger, is a selection of single works by twenty-two artists at different institutions in Germany and Austria.[3] Both books, not yet available in English, greatly enrich our knowledge of the field. The Lassenberger study presents an individual whose personality and social background differ greatly from those of Jane Cameron. It suggests, however, that certain characteristics of high artistic quality may be shared across the board. The book also adds much to a systematic psychological theory of the subject. The other book demonstrates the impressive variety of personal styles and worldviews to be found in Down's syndrome artists at different places. Here also the artistic level of the examples is consistently high, and certain formal qualities are shared by all. The short analyses of the paintings, written by educators, art historians, and psychologists at academic institutions all over the world, refrain deliberately from considering the works as the products of retarded persons but discuss them instead strictly as works of art. By treating their makers like any other professional artists, they make a powerful statement on how completely these special artists deserve to be taken as full-fledged and successful members of society.

It is evident from these publications that a favorable social setting is indispensable even for the most gifted among these neurologically impaired persons to let their work bear fruit. A home environment offering no encouragement to artwork constitutes a formidable obstacle, which can be overcome only by timely help elsewhere. The technical facilities of a workshop have proved to be especially productive when it also makes for the right attitude. "It provides a sense of competence, of professionalism," says Kläger; "it also convinces a person that work in the arts is at the same level of craftsmanship as work with wood, metal, or ceramics. The contact with other impeded persons and the exchange of observations and creative suggestions convey security and self-confidence."[4] A workshop of this kind should not insist on a wide range of technical facilities, which will cause "a superficial and finally frustrating attitude." It should rather concentrate on "a deepening and enduring experience."[5]

Instruction also ought to be limited to purely technical assistance or to such general suggestions as subjects to select for artwork. The artists presented in Kläger's case studies have had no training in art, and the work in the collection of examples looks as though these artists have received no such instruction. They demonstrate the enjoyable results of modern education, which endeavors to cultivate the growth of spontaneous creativity rather than impose rules on how to do things. To be sure, these people, like everybody else, have been exposed to the taste and the models of popular culture, some of which show up in the subject matter of their work. That they absorbed these influences without being deflected from the beautiful purity of their own pictorial style is to the credit of the persons who supervise their lives.

Although there are limits to how closely Down's syndrome persons can approach the standards of normalcy, their early development seems to be essentially that of other human beings. Their capacities do not seem to be limited to special abilities like those of the idiots savants, but, with sufficient stimulation, their intellectual, cognitive, and perceptual development and that of their motivational strivings seems to be like that of normal children, except that it works more slowly, takes longer, and stops earlier. The beauty of their best artwork rivals that of normal children. In fact, it often attains a thoughtfulness and symbolical depth reflecting the maturity of adult age.

Kläger's work is guided by the principle that art is indivisible. This keeps him and ought to keep us from trying to distinguish art

from nonart. Not that we should accept as art everything anybody chooses to call that. But we should acknowledge aesthetic quality at all degrees of perfection. Discussions on whether or not the work of children or retarded persons should be called art are an obstructive waste of time. We should be warned here by what happened to a similar problem in the psychology of thinking. The pioneer anthropologist Lucien Lévy-Bruhl introduced the notion of a "pre-logical" mentality of primitives, which he saw as different in principle from the logical thinking of more advanced cultures. "We are unable to share a way of thinking," he wrote, "for which logic and pre-logic exist together."[6] By now we know instead that logical thinking begins to operate at an early age, in cultures as well as in individuals, and that we can understand its nature only if we consider its entire range.

Similarly, the artwork of Down's syndrome persons can be adequately seen only if one realizes that in its undisturbed form it shares the traits of all early art, notably that of children. We have learned by now to evaluate such art not negatively by what it lacks but positively by its remarkable qualities.

The eyes of the viewer are impressed with an incorruptible lucidity of statement that has moved and inspired good artists of our time. It is unfortunate, therefore, that under the influence of the psychoanalyst Ernst Kris early art has sometimes been considered regressive, as though it represented a step backward in the development of the human mind.[7] But there is nothing regressive about these early achievements. The artistry of Down's syndrome persons should be appreciated at its own level.

I mentioned that although the pictorial style of these artists is like that of normal children's art, it often reflects the imagery and the reasoning of a more adult mind, especially in its use of symbolism. By symbolism I am referring to a property of works not limited to the strict representation of the environment but enriched by features pointing to the deeper significance of the depicted scene. I will not indulge here in the kind of interpretation by which Freudian and Jungian analysts commonly transcend what is actually perceivable; they speculate on the unconscious thoughts and images reflected in what they see. I find it safer and equally rewarding to stick to the facts given to the eyes, especially when little additional information is available.

I will limit myself to two examples whose shape shows up in black-and-white reproduction, even though in these works, as in

Figure 1. Dietmar Geppert, *Untitled* (1988). Kunstwerkstätte Lienz, Austria.

most of those of the others, the colors contribute greatly to the composition and meaning. Figure 1 was done in oil crayon by Dietmar Geppert, a twenty-eight-year-old resident of the Kunstwerkstätte Lienz in Austria. We see a family portrait in frontal symmetry, which reminds professor Igor Zhor of Brno University, the commentator on this work, of the style of Byzantine icons. We know it also as a char-

Figure 2. Willibald Lassenberger, *Amerika* (1991). Evangelische
Stiftung de La Tour. Treffen/Kärnten, Austria.

acteristic of all early art. To complete the symmetry of the picture, a
piece of fabric held by the father is added below the small child. The
bearded father dominates the center of the group. The small scenes
at the bottom, like the predella of a Renaissance painting, add lively
action to the family story. Of particular interest are the purely sym-
bolical strands of tentacles on top of the heads, which unite the mem-
bers of the family by giving visible shape to the concern of the par-
ents for their child.

Quite different in personal style although equally comforming to
that of all early art is figure 2, a tempera painting by Willibald Lassen-
berger, a resident of the Austrian Evangelische Stiftung de La Tour.
As distinguished from the favorable conditions from which Jane
Cameron profited, Lassenberger, born in a working-class family, was
declared unsuitable for attending school and grew up analphabetic.
He owes the opportunity to become a successful artist entirely to the
workshop for the retarded of the Austrian institution.

Lassenberger's painting, discussed by Kläger, shows the popular
clichés of an uneducated person richly translated by the imagination
of a gifted painter. The rectangular surface is divided into four quad-
rants, showing on the upper left the Statue of Liberty and below it a
man surrounded by the coins of his fortune. Equally in the money is

the emperor of America on the upper right, who lords it over the symbolic figure of a triumphant woman. She owes her joyfulness to the star-spangled banner, of which she is shown to be a part.

These two examples will have to suffice as representatives of the rich harvest of pictorial work made available by Max Kläger. His books come as a reminder of the artistic treasures still to be uncovered from the minds of a neglected minority.

NOTES

1. Hans Prinzhorn, *Artistry of the Mentally Ill* (New York: Springer, 1972).

2. Rudolf Arnheim, "Art, Poetry, and Retardation," *Art Psychology* 6 (1979): 205–11.

3. Max Kläger, *Krampus: Die Bilderwelt des Willibald Lassenberger* (Hohengehren: Schneider, 1992); idem, ed., *Die Vielfalt der Bilder* (Stuttgart: Wittwer, 1993).

4. Kläger, ed., *Die Vielfalt der Bilder*, 7.

5. Kläger, *Krampus*, 70.

6. Lucien Lévy-Bruhl, *How Natives Think* (Princeton: Princeton University Press, 1985), chap. 3.

7. Ernst Kris, *Psychoanalytic Explorations in Art* (New York: International Universities Press, 1957).

A System of Expressive Movement

The human body needs movement to feel alive and to keep alive. An infant moves even before it leaves the mother's womb, and all through life the pleasure of physical action is the helper of growth and efficiency. Exercise is practiced in the old-fashioned gymnastics of training muscle by muscle with military exactness. But in the arts of yoga or the Chinese *tai chi*, a sensitive awareness of the subtle and harmonious cooperation in the body as a whole has given us a new respect for the body's way of acting as a truly human companion of the mind.

Physical therapy has greatly refined its techniques of rehabilitation, and psychotherapy is developing the healing power of movement as a helper of the ailing mind. This has led quite naturally to a companionship with dance, because dancing has always been intimately associated with the mind, its expression of elation or dejection, its need for rhythm, precise statement, and synergy. On an earlier occasion, I have referred to the broad perspective on the universal benefits of movement by the choreographer Rudolf Laban.[1] His work has been followed up in a systematic presentation by Irmgard Bartenieff with Dori Lewis in a book that "describes what the body can do, how it does it, how it relates to space, and how the quality of its movement affects function and communication—coping."[2] The book deserves more general attention than it has been given so far.

Bartenieff was trained as a dancer and never lost contact with dance as a modern art. Thoroughly familiar also with the anatomy and physiology of the human body, she approached her work in therapy with principles derived from her early contact with her teacher Laban.

Laban had based his approach on the triad of body, space, and what came to be known as the effort/shape system. By effort is meant

Derived from "A Turning Point in Movement Therapy" in *The Arts in Psychotherapy*, vol. 8, Winter 1981.

the impulse that exerts itself in the dimensions of space, weight, time, and flow. The effort of space determines the directions toward which movement is oriented.

Weight refers to the heavy or light pressure given by the movement. The time dimension varies from a leisurely reach to a determined push; and the flow describes the difference between a free, uninhibited swing and a controlled, perhaps staccato, movement.

More geometrically, the dynamic range of bodily movement can be described as the kinesphere, which is the spherical volume of space within which the body operates. It is confined by the reach of the limbs, but within this space the limbs can swing through any of the 360 degrees. Any dance composition, however, is organized on a system of eight spatial directions. They can be described schematically as forming a diamond-shaped octahedron, whose corners are the target points of the eight basic movements. In her chapter "Carving Shapes in Space," Bartenieff shows how this fundamental theme is further developed in a more complex system.

The term "effort" is not the best translation of the original German *Antrieb*, which means impulse. The dynamic quality of movement Bartenieff had in mind does not typically refer to the sudden mobilization of a strong amount of energy. The dynamics of movement is, first, a visual quality, perceived by observers, such as the audience of a dance performance. It distinguishes, for example, the appearance of a limp, poorly directed stretch of the arm from a vigorous push. But the dynamics of movement is also felt as kinesthetic perception of the muscle tensions in the body of the performer. Most important, dynamics carries expression, and expression is the conveyor of meaning. Expression makes a determined gesture be seen as a display of the mind's quality of courage, as distinguished from helpless fumbling.

The four aspects of movement are discussed separately by Bartenieff for the sake of theoretical analysis. But she insists that only a totally integrated performance of the whole organism makes for an aesthetically successful and therapeutically wholesome result. Such integrated movement requires that the body be organized around a center within the body, and this center is established dynamically by a constant, flexible search for balance, not by rigid restraint. An upright posture, for example, should not be obtained by stiffening and bracing. Instead, "the whole body slightly sways while 'standing still' in a figure-of-eight distribution of weight (center, forward, right

side, backward, center, forward, left side, backward, center) in con-
tinuous subtle fluctuation between stability and mobility to maintain
balance. The Fundamentals' concern with centering as the sources of
support is crucial here."[3]

When the norm position of the living body is a state of constant,
subtle readjustment, it adapts itself more easily to a restructuring, re-
quired when some functions are impaired by paralysis or injury. In
studies carried out many years ago, the psychologist David Katz de-
scribed the almost immediate rearrangement of the body's total func-
tioning in animals deprived of one or several of their limbs.[4]
Similarly, Bartenieff has the example of a four-year-old polio patient,
whom she gave exercises that made him "struggle for balance" to
reestablish verticality. This, she says, was in contrast to the traditional
focus on local muscular activity "without spatial reference."[5]

In the well-integrated body, movement is activated by a group of
centers, which are hierarchically organized in such a way that the im-
pulses from secondary centers subordinate themselves to the main
direction given by the dominant center. The location of the dominant
center can vary. Thus, in the Japanese kabuki dancers the center of
their weight is in the pelvic area, which conveys a sense of earth-
bound grounding, whereas the Western ballet dancer centers his
weight on the diaphragm area of the torso, thereby obtaining a sense
of uplifting lightness.

Only in the simplest cases, for example, when a boxer gives his
thrust a maximum intensity by marshaling the energies of his total
body in support of it, are the subcenters of activation mere executives
of the dominant movement. More often, actions and counteractions
cooperate to enrich the performance. This, however, must not lead to
fragmentation. A good dancer shows how the harmonious coopera-
tion of the various motives is obtained by his limbs, as though they
were the members of a chamber music group.

Bartenieff refers here, for example, to a study of the expressive be-
havior of business executives carried out by Warren Lamb, a col-
league of the late Rudolf Laban.[6] Lamb showed that an isolated ges-
ture, not supported by the rest of the speaker's body, may reveal a
lack of true engagement and is likely not to produce the desired ef-
fect in onlookers and listeners. The expressive aspects of motor dy-
namics are amply documented by Bartenieff. She reports, for exam-
ple, how she came to suspect suicidal destructiveness in a young
woman who in a dance therapy session abruptly ended every phrase

of her movements. In another instance, she analyzed the motor patterns of two presidential candidates in a television debate, indicating the difference of attitude in the incumbent and the challenger.

Bartenieff's book abounds in revealing analyses of bits of everyday behavior observed in railway stations or during professional activities. They remind me of similarly incisive, although purely intuitive, analyses in the writings of Honoré de Balzac, who was interested in the expression of people's gait. In his *Théorie de la démarche*, he gives the example of a husband who suspects his wife of infidelity. From the window he watches the "particulier," an unattached male, as he leaves the house after visiting the wife. He wants to guess from the expression of the suitor's way of walking whether or not he had success with the lady.

I have confined myself here to the basic system to which Bartenieff has developed Laban's analysis. There is no limit, of course, to the applications that have been derived from it in the practice and pedagogy of the dance, as well as in the teaching of gymnastics and in dance therapy.

NOTES

1. Rudolf Arnheim, "The Melody of Motion," in *To the Rescue of Art* (Berkeley and Los Angeles: University of California Press, 1992).

2. Irmgard Bartenieff and Dori Lewis, *Body Movement* (New York: Gordon and Breach, 1980), xiii.

3. Ibid., 21.

4. David Katz, *Animals and Men* (London: Longmans, Green, 1937).

5. Bartenieff and Lewis, *Body Movement*, 7.

6. Pamela Ramsden, *Top Team Planning* (London: Cassell, 1973).

V

The Face and the Mind behind It

An interest in the eloquent expression of the human body has accompanied and almost haunted me since my student days. My dissertation in psychology dealt with visual expression, particularly that of the human face. My approach, however, was not aimed at the problem that concerned the physiognomists and phrenologists in the past, researchers such as Johann Kaspar Lavater, Franz Joseph Gall, or Cesare Lombroso. They wanted to prove that the character and capacities of the human mind are faithfully reflected in the shape of the face and the skull and indeed in the body and its behavior in general. They could rely on the practice we all share of responding to a person—and that means also to a person's mind—by what strikes us as the outer manifestation of intelligence or dullness, forthrightness or slyness, warmth or coldness. Although Shakespeare's *Macbeth* (act 1, scene 4) warns us that "there's no art to find the mind's construction in the face," our trust in what we see is not unjustified; but the genuine appearance of the body is so heavily overlaid by the contingencies of convention, misinterpretation, and even anatomical accidentals that it must be judged with much caution.

My own concern has not been with visual expression as a clue to what lurks behind it but with what it conveys in and by itself as a prime quality of all perception of shape. Which perceptual factors account for our compelling image of personality in the human face? What is it we see, regardless of whether or not what we see is reliable? The spontaneity of appearance is what occupies the artist and the actor on stage. It is also the criterion directing much of the work of the plastic surgeon. When he is not concerned with the reconstruction of physical function, the surgeon shares the problems of the artist and the actor. What does the body look like? What should it look like?

First published in *Esthetics and the Treatment of Facial Form,* Center for Human Growth and Development, University of Michigan, 1993.

Bodily expression is always seen as a vehicle of the mind. Have you ever tried seriously to see the parts of the human face as nothing but instruments of the physical functions for which they were developed in evolution—the eyes as nothing but glassy balls for the focusing of light, the nose as a tube with its openings as a mere conduit for air and chemical particles, the mouth as a mechanical gobbler of foodstuff and liquids? This image of the face, although physically correct and sufficient, is dehumanized to the point of being unobtainable in perception. Yet for the theorist there remains a puzzling discrepancy between the mind, an immaterial universe of sensations, thoughts, strivings, and feelings, and the purely physical structure of bones, tissues, muscles, and tendons. What bridge enables the body to serve as the visible equivalent of the mind? How can something as invisible as affection or repulsion be perceived by the eyes? I shall come back to this question at the end.

The more elementary method of physiognomics relied on the geometrical shapes of the body. As a radical example of this approach, I will mention Ottmar Rutz's "textbook," in which he distinguished four body types, the spherical, the parabolic, the pyramidal, and the polygonal, applied to the body as a whole as well as to its parts, such as the head.[1] These types were meant to describe the body and also, in a vaguely symbolic fashion, the corresponding characteristics of the mind. Spherical individuals display roundness in their physical shapes as well as in their mental traits. Parabolic types tend toward elongation, the pyramidal ones toward angular straightness, and the polygonal ones account for the more or less chaotic mixtures of them all.

A more professional approach, which has been widely applied in psychiatric and characterological practice, is the psychiatrist Ernst Kretschmer's attempt to relate basic body types to corresponding mental pathologies.[2] He distinguished the asthenic type (with its slim body and angular profile, found in schizophrenic patients, but also in some great artists, thinkers, and political leaders, who tend toward speculative abstraction and dogmatism) from the pyknic type, characterized by roundness and found more often in manic-depressive patients but also in normal artists or scientists inclined toward a descriptive, practical, empirical approach.

While such systems are based on predominant geometrical traits of the body, another approach deals with proportion. Proportion is related to expression when, for example, the body as a whole and

the face in particular are subdivided into a "higher" region of the mental functions, that is, the region of the senses, cerebral cognition, and the will, as against the "lower" region of the more physical functions of digestion and reproduction. The relative size and dominance of these regions has been influential in the representation of the human figure in the arts and also in our practical judgment of people's bodily appearance, because of the moral and aesthetic distinctions between the human and the bestial, the spiritual and the material, the superior and the inferior.[3] The proportions of the classical face tend to favor a subdivision into three equal parts, the forehead, the nose, and the mouth and the chin, associated with such mental functions as the imagination, the will power, and the activity drive.[4] This ideal balance derives from the Caucasian tradition and makes for prejudicial discrimination against other racial types such as the Asian or the African.

In general, one can say that people prefer a regular, average proportion, because it meets the norm of what is popularly considered beautiful. In commenting on this fact, however, Immanuel Kant observes in his *Anthropology* (pt. 2, sec. A3) that too much regularity makes for the appearance of a very ordinary person, because beauty requires more than what he calls the *Mittelmass*, that is, the medium measurements.[5] Beauty also requires character. I have found in my own experiments that when college students were asked to select from a group of their photographs the one most like themselves, they opted for the closest to an average type of person, whereas a friend of each student's, when asked to select the one most like their friend, chose the photo most characteristic of her.

Physiognomists such as Lavater had enough intuitive sense to judge faces by their overall appearance, but they also thought it more scientific to investigate each part of the face separately, for instance, by describing the various types of noses. In my dissertation, I showed, however, that the same part, for example, the same contour line of the chin, is judged quite differently when it appears in two different faces.[6] Parts need to be considered in the context of the whole.

To deal with the measurements and shapes of the human form, however, is not sufficient. What really accounts for the perception and evaluation of the body's appearance is not its shapes as such but the expressive dynamics carried by the shapes. Perception refers mainly to the forces made visible in the outer appearance of the body. The physical forces, the originators of the forces perceived by the eyes

of the viewer, are hidden, of course, under the skin. The elastic leo-
tard of the skin smoothes and thereby unifies the assemblage of or-
gans, but it also levels the articulate distinctions in that assemblage
and thereby makes the shapes of the body more difficult to under-
stand and to depict in sculpture and painting. When artists study
anatomy, they do so to better understand what the model displays
only in an approximate, noncommittal fashion. A good artist does not
look for the shapes as such but for the forces manifest in the relief of
bones, muscles, tendons, and tissue. These forces carry the expres-
sion and therefore the meaning of what we see. They serve the artist
as the true "model" for his own conception. "Form is for us the de-
sign of a movement," observes Henri Bergson.[7]

That the expression of the face is what we perceive primarily, not
its shape as such, is shown most strikingly in a popular scribble, the
ultimate abstraction of its features: two dots for the eyes, a vertical
line for the nose, and a horizontal for the mouth. Although it reduces
facial features to a minimum, its human expression is immediate and
powerful. It has been used by theorists to study the variations of fa-
cial expression. In the nineteenth century, the physiognomist, physi-
cian, and painter Carl Gustav Carus showed in his book *The Symbol-
ism of Human Form* that by simply narrowing the distance between
the eye dots, the rudimentary face can be made to intensify the
glance, piercing the viewer.[8] Carus referred to Rodolphe Toepffer's
Essai de physiognomie of 1840. This Swiss artist asserted that all facial
expressions could be obtained by varying systematically a simple
line drawing of the face.[9]

When one tries to describe what is meant by physical beauty, one
discovers again that beauty does not depend on shape as such but on
the dynamic expression conveyed by it. Dominant among the dy-
namic features is the sense of physical and mental vitality, which
manifests itself, for example, in the body's response to the force of
gravity. Giving in to gravity, which pulls us to the ground, expresses
a lack of vitality, a lack of initiative, a listlessness and weakness. Grav-
ity is overcome by striving upward, which stands for energy, youth-
fulness, action. Therefore, beauty is impeded by anything that sags—
a sagging cheek or shoulder, a sagging breast. The attractiveness of an
arm's or a leg's contour depends on the dynamics of its curve.

A raised eyebrow conveys alert energy and vitalizes the face. The
features of an intelligent, mentally active person express themselves

most directly through the dominance of tight muscular tension on the bones of the face. The expression of the protruding nose relates rarely to the sense of smell but acts by its visual dynamics as the prow of boldness and mastery. When of excessive size, the nose becomes the standard tool of cartoonists and caricaturists by displaying an undeserved, inappropriate pretense of intrusion into the affairs of the world.

The dynamics of facial expression is observed not only when we look at another person; it also reverberates in our own inner experience, in the kinesthetic sensations of our own face, the tensions in our muscles, when we make a physical or mental effort. The relaxation around our eyes and mouth may indicate that we let attention lapse and suspend alertness. This inner awareness does not refer to shapes but reflects forces inside the body. It lets an infant smile in response to the mother's smile, even though its response is kinesthetic.

This observation makes me return to a question I posed in the beginning. How is it possible for us to perceive in the configuration of bodily shape the entirely immaterial sensations of elation or depression, friendly openness or hostile coldness? The answer is that *the discrepancy between shapes and feelings is bridgeable by the dynamic tensions shared by the physical and the mental realms.* The same intensity that animates us when our mind tries hard tenses our faces visibly, and the relaxed surrender of happy tranquillity loosens both the mind and the body.

NOTES

1. Ottmar Rutz, *Vom Ausdruck des Menschen* (Celle: Kampmann, 1925).

2. Ernst Kretschmer, *Körperbau und Charakter* (Berlin: Springer, 1921), 126.

3. Rudolf Arnheim, *The Power of the Center,* new version (Berkeley and Los Angeles: University of California Press, 1988), 126.

4. Rudolf Arnheim, "Caricature: The Rationale of Deformation," in *To the Rescue of Art* (Berkeley and Los Angeles: University of California Press, 1992).

5. Immanuel Kant, *Anthropologie in praktischer Hinsicht.*

6. Rudolf Arnheim, "Experimentell-psychologische Untersuchungen zum Ausdrucksproblem," *Psychologische Forschung* 11 (1928).

7. Henri Bergson, *Le Rire: Essai sur la signification du comique* (Paris: Presses Universitaires, 1947).

8. Carl Gustav Carus, *Symbolik der menschlichen Gestalt* (Celle: Kampmann, 1925).

9. E. H. Gombrich, *Art and Illusion* (New York: Pantheon, 1960).

Consciousness—
an Island of Images

In 1886, the physicist Ernst Mach published *The Analysis of Sensations*, a book that continues to be a standard presentation of the psychology of perception. He had realized that the only facts directly available to physicists for the exploration of the material world are our sensory percepts. Therefore, it was essential for physicists to know what exactly were the data offered by perception and how they were affected by their interrelation. The world of perceptual shape, color, and movement supplied information about physical as well as psychical facts, and these in turn were interrelated by the principle of complete psycho-physical parallelism.[1] The psychical facts were images or reflections of corresponding physical facts.

At the same time, however, Mach subscribed to the monistic view that these two realms constitute one unitary universe of discourse. Because all physical facts are given to us as percepts, they belong to the world of sensations, and there is no break between the two realms. Mach chose to overlook the fundamental fact that there exists a second universe, from which all perception is excluded and which we know only by conjecture or inference, namely, the physical world. To the best of our knowledge, no conscious awareness exists in and for the world of physical objects. Stones, planets, or oceans do not know that they exist. Some plants or primitive animals show us by their behavior that they respond to light. Some unicellular creatures have eyespots enabling them to distinguish between darkness and light. There is no reason, however, to assume that these early responses are accompanied with any conscious awareness. A purely physiological process within the organism leads from the stimulating light effect to the motor response. Aristotle says in *De Anima* (428a) that ants or bees or grubs have sensations but no imagination.

First published in *Journal of Theoretical and Philosophical Psychology*, vol. 14, Fall 1994.

Early responses to the outer world are very elementary, which impels the evolution of animals to strive for more distinctive information. Gradually, on the scale of evolution, there develops the ability to discern shape, color, and movement. At some time during this process, consciousness arises and begins to accompany the activity of the senses, but we have no way of knowing when this happens. All we can observe from the behavior of organisms is that the ability to discriminate, to remember, and to solve problems increases, until at the human level we become directly aware of consciousness by our own experience and indirectly by what other people tell us. The usefulness of such cognitive experience is obvious. Why it exists, however, is by no means obvious, because conscious activity is a reflection of the physiological processes in the nervous system. We must assume that there are physiological counterparts to every aspect of conscious activity, unless we are willing to believe that some conscious events are images of a nonexistent physical agent. But if the physiological mechanism is so complete, why is it duplicated by consciousness?

The answer to this perennial question is perhaps beyond human comprehension; but we need not transcend the realm of consciousness to realize that we are dealing with more than one universe. As we trace, for example, the generation of sound, we note a consistent causal process from the vibrations of a body such as a drum to its reverberations in the ear and the transduction of the mechanical waves into electromagnetic impulses projected upon the receptive centers in the brain. But that is where our exploration stops. Nowhere on this level of causally connected events does it meet the generation of the conscious experience of hearing noise or music. Consciousness dwells in a totally different second universe. It is an island of images, reflections of what happens in the physical world.

We must add right away that the neural processes, of which the conscious ones are a function, are not the ones directly observable with scientific instruments or tests available now or in the future. These observations, too, are but images of the physical events here under discussion. They are all that is available to us, but their actual physical basis is as much beyond our direct experience as the rest of the physical world.

Even so, it remains tempting to think of conscious awareness as being different merely in amount rather than in kind. To consider the

relation as merely quantitative is suggested by the smooth and constant shift from one level to the other in our daily experience. Much of what we do routinely has been automatized to such an extent that it neither requires consciousness nor relies on it. We are alerted to the need to watch, to remember, and to decide when some unusual circumstances confront us; but once the emergency has been tackled, we are likely to switch back to a state of unawareness.

At the same time, impressive happenings in our conscious life alert us to influential impulses of whose origins we find no trace in our conscious experience. This led in the nineteenth century to the notion of the unconscious, a term introduced by the philosopher Eduard von Hartmann.[2] The idea of unconscious mental events was suggested in particular by the motivational force of the will, which influences manifestly what people do consciously. The theory was given a more solid foundation by Freudian psychoanalysis. The very term "unconscious" implied a direct causal bridge between the two areas of conscious and unconscious events in a monistic universe. But to call something unconscious was, of course, a purely negative localization of what and where the thing was *not*. Positively, there was only one universe to which such phenomena could be assigned, namely, the nervous system. Freud, trained as a medical man, remained aware of this fact. In *Beyond the Pleasure Principle*, he spoke of difficulties created by the "specific picture language" of depth psychology: "The shortcomings of our description would probably vanish if we were already able to replace the psychological terms with the physiological or chemical ones. To be sure, these, too, belong only to a picture language, with which, however, we have been familiar for some time and which perhaps are simpler."[3]

This Freudian caution, however, is commonly overlooked. When physicists speak about the relation between the physical world and the mind, they often seem to take interaction literally, in the cavalier manner all too common nowadays among psychologists or medical men. Some physicists, however, assert quite clearly that physics deals directly with nothing but images. Thus, Sir Arthur Stanley Eddington, after referring to the material substance of water, says:

> But, of course, this solid substance of things is also a figment. It, too, is a product of the imagination, projected upon the external world by the mind. We have chased the liquid of the water to the atom and from the atom to the electron, where we have lost it. But at least, one

might retort, we have found something real at the end of our chase, namely, the protons and electrons.

A little later on, addressing his readers, Eddington asserts:

> The physical object in my perceptual world exists also in your perceptual world. There exists an external world that is neither a part of you nor of me. It is rather a neutral ground, the foundation of the experience that is our shared possession.[4]

Eddington reminds us that when we are considering the relation between physical and mental facts, we are dealing with levels of conscious images. This leaves physicists with the task of exploring, by inference, the nature of the physical world beyond that of imagery. One way of solving the problem is to simply deny its existence. Thus, Heisenberg in an important early paper observes that "all perception is a selection from an abundance of possibilities and a limitation of what may happen in the future. Because the statistical character of quantum theory is so intimately tied to the imprecision of all perception one might be tempted to conjecture that behind the perceived statistical world there is hidden another, 'real' world, in which the law of causality holds. We assert explicitly that such speculations seem to us fruitless and meaningless."[5] This was the positivistic attitude proclaimed by Mach.

If, however, perception is selective, as it certainly is, there must exist something from which it selects; and if perceptual sensations are the only data at the disposal of our cognition, the selection must be an excerpt from a world beyond our experience. This was realized by physicists such as Eddington, as shown by the statement I quoted above. Historically, the problem has attracted the attention of philosophers, mostly in the simpler version of what they called the relation between body and mind. The story is too well known to need rehearsal here. I will limit myself to mention that according to Descartes nothing "acts more directly on our soul than the body, to which it is joined, and consequently we have to think that what is a passion in the soul is usually an action in the body, so that there is no better road to arrive at the knowledge of our passions than that of examining the difference existing between the soul and the body."[6]

Descartes stated that all existing "substances" are either body or mind, either spatial or conscious; the substances of the body were *res*

extensae, those of the mind were *res cogitantes*. Spinoza accepted this distinction but asserted that everything we can perceive belongs to a single substance "comprehended sometimes by the one and some-times by the other attribute."[7]

Of more direct concern to me here are Descartes's more explicit references to ideas

> that seem to me to come from some objects outside of me; they are the reasons obliging me to believe that they are similar to those objects . . . I experience in myself that those ideas do not depend on my will, for they often present themselves to me in spite of myself, so that, for instance, now, whether I want it or not, I feel warmth, which persuades me that this sensation or this idea of warmth is produced in me by something different from me, namely, by the heat of the fire next to which I happen to be. And nothing seems to be more rea-sonable than the conclusion that this foreign thing conveys and impresses upon me its resemblance rather than any other thing.[8]

In fact, if reality consisted of nothing but our own perceptions, every aspect of them should be generated by us. That this is not the case is obvious to everybody. In his *Traité des sensations*, Condillac points out that the sense of touch is the first to inform us about the existence of external objects.[9] We learn to distinguish between activi-ties that depend on us and others that do not. The visual world van-ishes when we close our eyes, but it does not cease to exist, and it be-longs to a realm outside our direct experience. Thus, within the very world of our consciousness we are made aware of messages reaching us from another world, beyond our own making.

Since we are dealing with conscious experience as the only uni-verse to which we have direct access, it is useful to enquire what ex-actly we mean by conscious perception. The question arose at the spectacular crisis that troubled physicists when during the develop-ment of quantum mechanics the situation began to look as though the theoretical constructs could no longer be grasped by explanatory images.[10] The controversy focused on the German term *Anschau-lichkeit*, insufficiently translatable as "visualization." A fact or state-ment is "anschaulich" when it is represented by images that not only are visible as percepts or memory images but also reveal the essen-tials of the referent, as it is made visible. The problem arose in quan-tum physics when the apparent incompatibility of wave and particle seemed to block any perceptual representation.

Heisenberg suggested that the difficulty could be overcome when, as he stated at the beginning of his paper of 1927, "we believe we understand a physical theory in an *anschaulichen* fashion when in all simple examples we can grasp its experimental consequences qualitatively and when we have also recognized that the application of the theory never involves inner contradictions."[11] This definition obviously goes beyond perception in its usual sense and in fact may seem to contradict it. (By using the term "qualitative," Heisenberg referred to the difference between anschaulich and quantitative or measurable, but he did not refer specifically to perception.)

In a paper on the concept of complementarity, I have argued that perception need not be limited to the coherent presentation of a seen or imagined scene of life, as is the case, for example, in Einstein's famous thought experiment of a man in a box that is pulled at a constant speed and therefore gives him the impression of his body being attracted by gravitation. "Such images, however," I observed, "lead by degrees of abstraction to others, limited to spatial diagrams of theoretical situations," for instance, when Freud compared the psychic life to an apparatus composed of several pieces.[12] Freud used a metaphor to make a mental situation more directly perceivable because it was less suited to visualization; but to do so he had to raise his image, taken from mechanics, to a level of abstraction at which the disparate realms of reality, the apparatus of mental life and a technical instrument, became relatable. In fact, the perceptual concreteness of metaphors quite in general derives from analogies established at a raised level of abstraction between images located in different realms.[13] It follows that when a fact of experience, such as the juxtaposition of wave and particle, does not fit the primary level of perception, it may well yield to a more abstract level.

The present paper is based on the axiomatic assumption that we are faced with two different universes, the physical and the mental. Both are empowered by dynamic forces, so that in physics one used to speak of the difference between matter and energy. Physical forces, mechanical and electromagnetic ones, move the events of the physical world, including the physiology of organisms. They are accessible to us indirectly by inference. Mental forces are at play when we observe the perceptual images of objects acting upon one another; they are also mobilized by the psychological events of motivation and cognition. But just as objects and happenings are known

to us only as images, so are forces. Mach mentions that the psychologists Stumpf and Ostwald have referred to a specifically mental energy, but such assertions derive from the confusion between the phenomenal world and the physical world and would be hard to reconcile with the law of the conservation of energy.[14]

This leaves our consciousness with an island of images informing us in an indirect and incomplete fashion about the world in which we live. The world of our experiences is a reflection of some of the processes occurring in our nervous system. The picture we receive is by no means complete, given the automatic reflexes, physiological steering devices, or the "unconscious" processes, some of which show up indirectly in our behavior. The images of the physical world, of which our nervous system is a part, offer data available to us for our dealing with the transcendental world. These images teach the carpenters, the engineers, the physicists, the surgeons, and indeed all the rest of us what laws of nature govern the behavior of material objects—what they will let us do and what is beyond our powers. Because consciousness tells us so much, we willingly put up with its limitations.

NOTES

1. Ernst Mach, *The Analysis of Sensations* (New York: Dover, 1959), 60.

2. Eduard von Hartmann, *Philosophie des Unbewussten* (Berlin: Carl Duncker's Verlag, 1869).

3. Sigmund Freud, *Jenseits des Lustprinzips* (Vienna: Internationaler Psychoanalytischer Verlag, 1921), sec. 6. My translation.

4. Sir Arthur Stanley Eddington, quoted in Hans-Peter Dürr, *Physik und Transzendenz* (Bern: Scherz, 1986), 99, 34. My translations.

5. Werner Heisenberg, "Über den anschaulichen Inhalt der quantentheoretischen Kinematik," *Zeitschrifte für Physik* 43 (1927): 197.

6. René Descartes, *Les Passions de l'âme*, pt. 1, art. 1.

7. Baruch Spinoza, *The Ethics*, pt. 2, prop. 7.

8. René Descartes, *Méditations*, pt. 3.

9. Étienne Bonnot de Condillac, *Traité des sensations* (Paris, 1921).

10. Arthur Miller, *Imagery in Scientific Thought* (Boston: Birkhäuser, 1984).

11. Heisenberg, "Über den anschaulichen Inhalt," 172.

12. Rudolf Arnheim, "Complementarity from the Outside," in *To the Rescue of Art* (Berkeley and Los Angeles: University of California Press, 1992), 188.

13. Rudolf Arnheim, "Abstract Language and the Metaphor," in *Toward a Psychology of Art* (Berkeley and Los Angeles: University of California Press, 1967), 266.

14. Ernst Mach, *Die Analyse der Empfindungen* (Darmstadt: Wissenschaftliche Buchgesellschaft, 1985), 304.

Form as Creation

An essential difference needs to be recognized between form and mere shape. Any object at all has shape, whether it be physical or mental, natural or constructed, complete or incomplete, accidental or planned. When "form" is used in the strict sense of the concept, it does not refer to any physically existing thing. Form is an abstraction. It applies to the conceptual properties of objects, whether the concept be intellectual or perceptual, measurable or intuitive, geometrical or topological. Form always permits a description, and no actually existing thing can ever be fully described by an abstraction. It can only be approximated by formal description. A cube is a form, but a cubic shape, built from any material, can never be quite cleansed of its accidental impurities. "But," says Erwin Schrödinger, "without an absolutely precise model thinking itself becomes imprecise, and the consequences to be derived from the model become ambiguous."[1]

Form can cover all three dimensions of space. It can be limited to immobile entities such as lines, surfaces, and solids. Its complexity can vary from Euclid's five regular polygons to a bewildering multiformity. It can also synthesize a sequence of locations in space and time.

Forms, then, are creations of the mind. Taken just by themselves, they are devoid of forces. Such are the forms that populate geometry. This does not mean, however, that static forms are primary in human experience. On the contrary, what mobilizes the human mind first of all are not simply bodies as such but things that move and change, things that approach as helpers or enemies, things that perform. Their actions are more impelling than their thingness. Before you know what hit you, you know that you are being hit.

Correspondingly, in the sciences and in philosophy, the elementary primary model of static forms is supplemented by a less simple and more adequate worldview that combines bodies and forces. In

First published as "The Completeness of Physical and Artistic Form" in *British Journal of Aesthetics*, vol. 34, no. 2, 1994. Reprinted by permission of Oxford University Press.

this more complex view, bodies in and by themselves still remain as static as before, but now they are seen as inhabited by forces, that move them and let them act on other bodies. This duality of matter and energy prevailed through the ages until Einstein discovered in 1905 that mass and energy are the same thing. This more unified notion abandons matter as a separate concept and leaves organized energy as the only and sufficient substrate of the universe. What looks like bodies is an agglomeration of forces.

The new dynamic worldview not only dominates the science of physics, but it revolutionizes also our insight into how the mind works and what it produces. For both purposes, however, it is necessary to make a distinction to which the present paper is addressed. This distinction refers to the principles by which the forms of the dynamic world are organized. What are these principles?

The answer to this question was unduly simplified when it was reduced to a single principle. In psychology, it was assumed that the organization of form is ruled only by the tendency toward equilibrium. The gestalt psychologist Wolfgang Köhler, for example, focused on what he called the law of dynamic direction. He found it in statements by the physicists Pierre Curie and Ernst Mach, who had pointed out that the approach to equilibrium is "characterized by growing regularity, symmetry, and simplicity in the distribution of the material and the forces within the system."[2]

The dominant role of this principle cannot be doubted. It refers to a general law of nature governing all physical processes and, by the corresponding physiological processes, the functioning of the mind as well. The general tendency of striving toward the simplest available structure is an aspect of the more comprehensive tendency toward equilibrium. To mention just one example, any form of symmetry makes for a simplification of structure. It does so because symmetry promotes the equilibrium of any system.

The principle of equilibrium, however, is not sufficient to describe the organization of form.[3] Equilibrium is lost in empty space unless it is related to an equally important counterforce supplying the medium upon which equilibration can act. This is most evident when equilibrium is viewed as an application of the second law of thermodynamics. The entropy principle states that the amount of energy active in a system diminishes as it approaches equilibrium. Now the second law is praised in textbooks as the driving motive of all natural events. Beyond this, Arthur Eddington has related entropy to beauty

and melody: "Entropy is only found when the parts are viewed in association, and it is by viewing or hearing the parts in association that beauty and melody are discerned."[4] The trouble with this all-too-broad statement is that thermodynamics in its general sense, as Max Planck has reminded us, "knows nothing of an atomic structure and regards all substances as absolutely continuous."[5] The law of entropy, being purely statistical, ignores precisely the characteristics of structure which creates form.[6]

Equilibrium, to repeat, operates in a void unless there is something to be equilibrated. To create form, the forces constituting the universe must, therefore, fulfil a double task. They must promote equilibrium and they must supply what I call the structural theme or, with a term borrowed from the biology of metabolism, the anabolic structure.[7] As a simple example, one may think of periodic crystals, whose geometrical order is so strongly determined by equilibrium. Clearly, however, this ordering power works on the particular interaction of electromagnetic attraction and repulsion by which the lattice structure of crystals differs from other kinds of objects. For a more general formulation, we can rely once more on Planck, who says in a discussion of entropy, "every system of objects possesses in any state a definite entropy, and this entropy indicates the preference of nature for that particular state."[8] This means that an object comes about when the entropic tendency toward equilibrium is stopped in a certain phase of its development. What accounts for this stopping, this "preference of nature," is obviously the forces of the structural theme, so that *form can be defined as the interaction between equilibrium and structural theme*. The result will be determined in each case by the relative strength of the two powers. R. H. Francé, in a study of organic growth, has spoken of the "optimum law," by which growth is halted when the processes of development have reached an optimum state.[9]

The structural theme of forms reveals itself most clearly in the organic bodies of animals and plants. It takes shape in the physical forces determining their growth and controlling their actions. D'Arcy Thompson states: "The form, then, of any portion of matter, whether it be living or dead, and the changes of form which are apparent in its movements and in its growth, may in all cases alike be described as due to the action of force. In short, the form of an object is a 'diagram of forces.'"[10]

The structural theme of a tree takes shape in the axis of the rising trunk, in the tree's striving upward and sideways in all directions,

ramifying with increasing detail to the smallest twigs. At the same time, it is controlled by equilibrium centered on the verticality of the axis and displayed by the symmetrical spread of its skeleton and foliage. Similarly in the arts, the organic body of the dancer gives shape to the theme of a choreographic work. The body itself has been brought about by the forces of growth, regulated here again in its symmetry by the counterforce of equilibrium. In the performance, the dancer's movements derive from the vocabulary of his body's muscular forces. This vocabulary articulates itself in actions, such as reaching and withdrawing, rising and dropping, rotating and surrounding—a system of visual symbols by which the artist describes human strivings. Order is imposed on this theme by the control of spatial proportions and directions, the balancing of distances, and the ordering of locations among the members of the group on the stage.

The interaction of the two components of form prevails also in the arts of painting and sculpture, even though they do not use physical forces to represent the structural theme. In the "immobile" media, the dynamic character of the physical world expresses itself indirectly through perception, because perception mirrors the physiological forces of the nervous system. Neither a tree in a painting nor a human body in a sculpture is driven by physical forces, but their visual images are experienced as configurations of forces.[11]

Since painting and sculpture are not limited to the representation of organic bodies, their shapes do not have to conform to the uninterrupted flow reflecting the interaction of organic muscles and tendons. They are free to resemble, if they wish, the lattices of periodic crystals when equilibrium monopolizes their form, as it does in the repetitious patterns of ornaments or in the overall homogeneity of Abstract-Expressionist paintings. Not for that, however, are they less coherent, that is, less dynamic in their structure.

By its very nature, the structural theme manifests itself in a much more complex fashion than does its counterforce, equilibration. This is so because the structural theme comprises the multitude of empirical actions of which organic and inorganic bodies as well as invented shapes are capable. By contrast, equilibrium derives from an elementary law of nature, manifest in such basic phenomena of order as simplicity, economy, or symmetry.

Form, then, comes about by the interaction of its two components. It creates what gestalt psychologists have called *prägnanz*, which is

by no means limited to the one-sided effect of simplification. It comes about when a structural theme, invented by nature or the human mind, is given its optimal appearance by the controlling law of equilibrium. This cooperation makes form become complete. It lets it do its work, become understandable and beautiful.

NOTES

1. Erwin Schrödinger, *Science and Humanism* (Cambridge: Cambridge University Press, 1969), 25.

2. Wolfgang Köhler, *The Task of Gestalt Psychology* (Princeton: Princeton University Press, 1951), 59.

3. Rudolf Arnheim, "The Two Faces of Gestalt Psychology," in *To the Rescue of Art* (Berkeley and Los Angeles: University of California Press, 1992), 206.

4. Arthur Eddington, *The Nature of the Physical World* (Ann Arbor: University of Michigan Press, 1958), 105.

5. Max Planck, *Eight Lectures on Theoretical Physics* (New York: Columbia University Press, 1915), 41.

6. Wolfgang Köhler, *The Place of Value in a World of Facts* (New York: New American Library, 1966), chap. 8; Rudolf Arnheim, *Entropy and Art* (Berkeley and Los Angeles: University of California Press, 1971).

7. Arnheim, *Entropy and Art*, 32.

8. Max Planck, "Die Einheit des physischen Weltbildes," in *Vorträge und Erinnerungen* (Darmstadt: Wissenschaftliche Buchgesellschaft, 1969), 37.

9. Robert H. Francé, *Bios, die Gesetze der Welt* (Munich: Hanfstaengl, 1921), 142.

10. D'Arcy Thompson, *On Growth and Form* (Cambridge: Cambridge University Press, 1969), 11.

11. Rudolf Arnheim, *Art and Visual Perception* (Berkeley and Los Angeles: University of California Press, 1974), 437.

From Chaos to Wholeness

We live at a time in which every statement of fact seeming to confirm destructiveness is eagerly seized upon, not only by the popular culture but all the way up to the thoughts of theoretical thinkers. Whatever seems to show a dominance of shapelessness in our world and to deny the validity of order and understanding is welcomed, and the ability to define existing structures is questioned.

This has been happening recently to the scientific observations and theories of chaos. They have been misleadingly taken to prove that we live in a world of hopeless confusion, which drowns whatever attempts are made to establish order. Perhaps the very name of the theory contributes to the misunderstanding. This happened early in our century to the theory of relativity, which has been misused from the beginning to proclaim that "everything is relative" and that there are no objective facts. Much of this might have been avoided if Einstein's original preference for the name *Invariantentheorie* had remained in use.[1] Similarly, the proper emphasis of the theory of chaos would be evident if its name reflected the notion "order out of chaos"—this being the title of the pioneer publication in the field, Ilya Prigogine and Isabelle Stengers's book first published in 1984.[2]

An inveterate gestalt theorist cannot but prick up his ears when he learns that any study of chaos requires us to return to a consideration of wholeness. For centuries, it was taken for granted that to be scientific meant to deal with any phenomenon as the sum of its parts. Gestalt psychologists had spent their lifetimes fighting this approach and were therefore dismissed as unscientific. But they had recognized that the only adequate way to deal with the organism, the life of the mind, and therefore also with the arts, was to overcome the traditional dogma.

Now we are told that the very nature of a science can require the rejection of "reductionism," "a watchmaker's view of nature."[3] Re-

First published in *Journal of Aesthetics and Art Criticism*, vol. 54, 1996.

ductionism reduces wholeness to an assemblage of elements. Chaos, however, comes about through the interaction of incompatible forces, and such conflict cannot be grasped as long as one conceives of entities as the mere sum of self-contained wholes. This has been obvious to aestheticians: If in viewing a painting one ignores the forces that act upon one another in the organization of the whole, one misses the very composition of the work. Nor does such an approach tell us what is the matter when a composition looks wrong. Thus, it is most welcome, for example, to hear the physicist David Bohm maintain that "parts" such as "particles" or "waves" are forms of abstraction from flowing wholeness.[4]

A forerunner of the present term "chaos" came into the scientific language as "disorder." The second law of thermodynamics can be defined as saying that the material world moves from orderly states to ever-increasing disorder and that this process ends up in a state of total disorder. Order is defined here as organized structure. When this structure is gradually destroyed—for instance, by erosion—it gets to be more and more shapeless, unless it reaches an even distribution of matter. This is the law of entropy, stated in 1865 by Rudolf Julius Clausius as saying that the entropy of the world strives toward a maximum.[5]

Maximum entropy, however, can also be described as a state of equilibrium—an elementary state of order, although, one might say, a disappointing one, because it is empty. It is the primary and also final order.[6] It is the "ground state of the field—also called the vacuum state of the universe."[7]

When cosmologists assume that the universe was originally in this primary state, they must also assume that some disturbing element arose from the inside or outside of the system and initiated the formation of organized units, constituting the world as we know it. In the household of the mind, a similar disturbing element is needed to make organization proceed. We say that it takes a discord in the system to generate a problem; and problem solving is the very nature of creativity.

In the arts, some discord in the artist's inner or outer environment produces the disequilibrium serving as the impulse to do something about it. The artist may undertake to denounce the flaw, or he may describe a state devoid of it and thereby present a flawless equilibrium.

A local generator of structure is now called an attractor by scien-

tists. An attractor is a local focus of energy. It is a region in a system that exerts a "magnetic" appeal seemingly pulling the system toward it.[8] In a painting, for instance, some distinct spot of color or shape will create a local system of forces around itself. In the simplest case, a single attractor will organize the entire field around itself. More often, there are more centers than one, say, in one of the crowded village scenes by Peter Breughel. In the extreme case, we reach again the maximal distribution of energy, which can be described as an assemblage of coordinated attractors.[9]

What, then, is chaos? I said above that forces operating in different directions are the prerequisite of most structures. Although in a system these forces act upon one another, they can make for functioning wholes, for example, in the spiraling vortices of galaxies or typhoons. Even turbulence derives from this kind of order. "Turbulence arises because all the pieces of a movement are connected to each other, any piece of the action depending on the other pieces, and the feedback between the pieces producing still more pieces."[10] When a vortex is stretched beyond a certain limit, it subdivides into ever smaller vortices, until the whole bursts into chaos.

Chaos arises when the components of a system do not coordinate but fight one another. In the maximal version of chaos, remnants of order are barely or not at all discernible. Scientists limit themselves to studying how such a system comes about or how it can develop into structured order; but the phenomenon itself defies any definition beyond the mere statement of its particular existence. An artist may undertake to present chaos as a portrait of the world or of our civilization, but since chaos is by its nature unstructured it cannot offer anything but the monotony of shapelessness; and whatever changes occur in it will make no difference.

In the inorganic world, chaos is observed in meteorology or the behavior of bodies of water. In organisms such as humans, chaos tends to be limited to rare occasions of panic. Normally, the functioning of organisms is dominated by more regular, more predictable patterns of behavior, from which chaotic episodes deviate as pathological exceptions.

Within the dominant pattern of behavior, imperfect functioning can be distinguished from chaos by being called disorder—when this term is reserved for levels of a system whose components are definable. For instance, when in an architectural design the shapes are

discernible, one may also be able to see that something in its composition does not work. Disorder, as distinguished from chaos, is definable and may suggest ways of remedying the trouble.

Being able to analyze a work means that one can subject it to a conceptual network. In such a network, every unit is stably defined, and each of the relations between them is also firmly established. Such a neat distinction, however, does not operate in gestalten. In a gestalt, each unit is affected and modified by its relations to other units of the system. Each relation, in turn, is affected by the agent generating it. It is an interaction that operates within every level of the structure, from the whole to its subordinates and between the various levels as well. Given the three-dimensional complexity of such a structure, it can be conceptualized only in approximation, which is what scientists are equipped to do when they describe the functioning of organisms or the nature of sensory perception. The same is true for aestheticians analyzing works of art.

The pioneer researchers of gestalt psychology traced linear relations from top down and from bottom up, that is, from the whole to the parts and from the parts to the whole. This kind of limited approach has the disadvantage of exposing thinkers to the accusation that they proclaim totalitarianism or that they ignore the forest for the trees. But such linear dynamics was and is the only approach available to theoretical thinking. Intellectual analysis can handle hierarchic sequences, such as those of nested boxes or the mathematical models of fractals that lead from the largest size to ever smaller ones, but they necessarily remain abstractions.

The intellect does not aspire to duplicating the gestalten of nature or art, and it would not gain anything by copying what we possess anyway.[11] Our eyes and ears profit from being parts of organisms. They are thereby enabled to perceive actual whole-structures and to control the creation of such structures. The human mind happily combines the two resources of cognition by experiencing the presence of actual structures in interaction with the analytic exercise of the intellect.

Chaotic disturbances occur in the perception of artworks when viewers or listeners cannot detect any unitary functioning in a composition. Unable to find comprehensible order, the perceiver's sense of sight or hearing bounces around hectically in search of something to hold on to.

Trouble arises more locally when elements are not clearly identi-

Figure 1. Henri Matisse, *La Danse* (first version; March 1909). Museum of Modern Art, New York. ©1995 Succession H. Matisse, Paris/Artists Rights Society (ARS), New York.

fied as belonging either apart or together or when they interfere with one another. I will limit myself to a single example. Henri Matisse has devoted two pictures to a round dance of five figures holding hands (fig. 1). One of them, done early in 1909, is at the Museum of Modern Art in New York; the other, done a few months later, is at the Hermitage in St. Petersburg. As happens with all patterns extending in depth when they are projected on a surface, the front overlaps the back, so that in this case the frontal figures overlap those behind them. This makes for crossings at which the beholder's eyes are not clearly led one way or the other, and areas of chaotic disorientation result. In this case, the hands of the frontal figures are interfered in their reaching for each other by the knee of the figure behind them, and a similar ambiguity disturbs the path of the glance at the other side of the painting. Such disorientations occur also on highways, when the constellation of roads does not clearly indicate which way to turn. Of course, one can intend to create confusion, but that may be dangerous or at least unproductive.

All natural systems are open to outer influences. A work of art, taken by itself, is necessarily closed if it aims at making a definitive

statement. When, however, such a defined statement is exposed to its reception by the mind of the viewer, it is put in the context of the work's environment and that of the mind's own range of experiences, knowledge, and attitudes. The work is a kind of monad, in that it mirrors the nature of the world, although unlike Leibniz's monads it is not without windows. More appropriately, it can be compared with what in modern science is called solitons. A soliton is a closed, coherent entity within the flow of events. In nature, for example, it takes the form of vortices, as we know them from the shape of galaxies or typhoons. Its components are held together by internal feedback, but they are capable of "maintaining their identity only by remaining continually open to the flux and flow of their environment."[12]

Chaos, from a Greek word referring to the "yawning" abyss of the beginning, is described in the ancient myths as the original darkness, either empty or filled with shapeless matter. Ovid calls it a crude, unformed mass, nothing but an inert weight, the "not well-joined" discord of the seeds of things.[13] This original raw material, either by its own initiative or by that of a creator, splits up in a first division, such as day and night or sky and earth. Our own scientists are eloquent on how order dissolves into disorder, but they are only beginning to find out how chaos turns into order. It is an endeavor in which we all have a stake.

NOTES

1. Gerald Holton, *The Advancement of Science and Its Burdens* (Cambridge: Cambridge University Press, 1986), 69.

2. Ilya Prigogine and Isabelle Stengers, *Order out of Chaos* (Toronto: Bantam Books, 1984).

3. John Briggs and F. David Peat, *Turbulent Mirror* (New York: Harper and Row, 1989), 21.

4. David Bohm and F. David Peat, *Science, Order, and Creativity* (New York: Bantam), quoted in Briggs and Peat, *Turbulent Mirror*, 29.

5. Rudolf Julius Clausius, *Abhandlungen über die mechanische Wärmetheorie.*

6. Rudolf Arnheim, *Entropy and Art* (Berkeley and Los Angeles: University of California Press, 1971), 30.

7. Briggs and Peat, *Turbulent Mirror*, 132.

8. Ibid., 36.

9. Rudolf Arnheim, *The Power of the Center*, new version (Berkeley and Los Angeles: University of California Press, 1988).

10. Briggs and Peat, *Turbulent Mirror*, 52.

11. Rudolf Arnheim, "The Double-Edged Mind: Intuition and the Intellect," in *New Essays on the Psychology of Art* (Berkeley and Los Angeles: University of California Press, 1986).

12. Briggs and Peat, *Turbulent Mirror*, 139.

13. Ovid, *Metamorphoses* 1.7.

VI

Two Ways of Being Human

It has taken the human mind quite some time to realize that nature is ruled by laws. Early experience suggests that the world is run by the power of individual impulses. Human beings feel they are free to want to do what they please and to try to get away with it. All one has to reckon with are the equally free powers of others, some of which are very strong. The gods and the demons act by their unpredictable whims. One can win their graces by gifts or prayers. Nothing happens in this world without somebody having willed it. Illness or death is sent as a punishment by someone. So are earthquakes and droughts. Rain and shine are decreed by somebody. This is the primitive version of causality.

The regular course of heavenly bodies was the first to suggest the lawfulness of nature. But this made for a split in the worldview. While the heavens were recognized to be governed by the stern regularity of the planetary paths, the sublunar world was still thought of as a conglomerate of unpredictable impulses. Mankind, in particular, remained an exception. I have pointed out before that it was Baruch Spinoza to whom we own the revolutionary insight that the human mind fits the order of the universe by behaving in accord with the laws of nature.[1] Rather than demeaning humanity's dignity, this admittance to the supreme order of the universe endowed it with its due rank.

This decisive progress of wisdom is still far from conquering our reasoning today. Toward the end of the nineteenth century, the split between nature and humanity was applied to a separation within cognitive philosophy and psychology. Wilhelm Dilthey introduced the distinction between *Naturwissenschaften* and *Geisteswissenschaften*, the former dealing with quantitative laws, the latter with human individuality. It is true that Dilthey already envisioned, at

Derived from "The Struggle for Law and Order" in *Michigan Quarterly Review*, vol. 24, Spring 1985.

least in principle, a synthesis of the two approaches, when he wrote in 1883: "The purpose of the *Geisteswissenschaften* is to grasp the singular, individual quality of the historical and social reality. It recognizes the uniformities effective in its formation, and it establishes the aims and rules of its development. This can be obtained only by means of the devices of thinking, namely, analysis and abstraction."[2]

But the usual desire to simplify conceptualization by dissecting a whole into neat opposites soon turned this duality (renamed by Wilhelm Windelband the nomothetic and the idiographic sciences) into the mutually exclusive difference between the descriptive and the explanatory approaches. The natural sciences are supposed to be limited to description, whereas the humanistic sciences are able to explain. This misleading and unfruitful conflict is still with us.

What, then, distinguishes the two ways of looking at the human mind? Is it simply a matter of complexity, the humanist or clinician dealing with more complex cases than the experimental psychologist? Not necessarily. It is true that experimentalists try to keep the phenomena they investigate as simple as possible. This does not keep them, however, from tackling quite complex situations. Or is it the exclusive privilege of experimentalists to deal with general types of behavior? Certainly not, because explorers of the human personality or clinicians also have no other way of describing individuals than by means of general concepts.

For, what is a description? There is no way of describing a particular case other than by general concepts. Call somebody "a proud, ambitious, imaginative person," and you have offered the building blocks from which an image of the individual may constitute itself. Call him, in clinical practice, a schizothymic introvert, and you have done the same with somewhat better defined concepts. Informally or professionally, any description is limited to adumbrating the uniqueness of the individual case by approaching it with a set of general concepts. Descriptions also try to ascertain the validity of their constructs by whatever proof is available.

A single item is said to have individuality when it is unique and irreducible. Strictly speaking, of course, all items meet this condition, because neither identical twins nor grains of sand are truly duplicates of one another. In social practice, however, conspicuous individuality is loaded with positive or negative value. Under certain social conditions, to be different from other specimens of the same category is a most precious possession. Doing things one's own way and own-

ing things nobody else does marks a person as an individual and gives him a distinctive identity. In the arts, in particular, originality, defined as being different from others, is cherished as the indicator of supreme quality. This value system has been promoted in our own society by the economics of individual enterprise, which is based on competition and therefore on the necessity of making one's own product or performance distinguishable from the next.

Under other social conditions, being different from the next person is something to be avoided. Conformity rules, for example, among our adolescents or in socialist societies. Being conspicuous is dangerous. When the arts are practiced as crafts, high quality does not imply originality but rather the striving for the best available standard.[3] The intertwining of positive and negative values in this respect makes for vexing complications, for example, in the practice of the sciences when cooperation is hampered by competition.

Some psychologists, in keeping with the principles of natural science, believe that the varieties of the human personality and its behavior and products must be reducible to a very few basic agents. By studying the constellations in which the basic agents combine, these psychologists expect to give a sufficient account of the more specific types of human beings and indeed of a particular individual. As I mentioned, this is also true for the practice of clinicians. To be sure, such a diagnostic syndrome can never match individual uniqueness exhaustively. But is the duplication of individual cases the duty and intention of science? Would it be useful? Does any description, scientific or otherwise, need to do more than identify the factors that account for the phenomenon one wishes to understand?

This approach looks crude to other students of the mind, who are under the spell of uniqueness, especially that of the great individuals. Is it not their irreducible uniqueness that distinguishes a Michelangelo, a Napoleon, an Einstein? Granted, one can trace some of the external or internal determinants, be they social, economic, or even physiological, that made these men become what they were. But what do these almost sacrilegious generalities matter in comparison with the irreducible greatness of the individual?

The upshot of it all turns out to be that there are not two different ways of being human, because principally there is only one way of accounting for it in theory and practice. A difference exists only in degree. An overall conceptual skeleton approaches an ever closer resemblance to the individual case. Full individuality escapes the grasp

of any conceptualization. It can only be experienced by sensory perception, because perception, too, enjoys full interaction. Novelists, poets, and other artists make the most direct use of it, but everybody else can profit from it as well.

Theorists, philosophers, and psychologists differ in the precision by which they define their concepts. Quantification allows for measuring and counting but is not necessarily closer to the truth of descriptions. Any level may be the appropriate one for one's objective. What finally matters is how deeply one penetrates to the core of what one is looking for.

NOTES

1. Rudolf Arnheim, *To the Rescue of Art* (Berkeley and Los Angeles: University of California Press, 1992), 220.
2. Wilhelm Dilthey, *Einführung in die Geisteswissenschaften* (Leipzig: Duncker and Humblot, 1883), 34. My translation.
3. See "The Way of the Crafts," above, 33–41.

Lemonade and the Perceiving Mind

Psychologists, impelled by the ingenious experiments of Jean Piaget, have studied the behavior of children with regard to such problems as that of "conservation." At what stage of their mental development do children realize that the amount or weight or other property of a substance remains constant even though the immediate evidence argues against it? The standard experiment is as follows. Equal amounts of lemonade are poured into two glasses of equal shape and size; then the content of one of them is transferred to a taller and narrower glass, in which the liquid now stands higher. Up to a certain age, a child will say that there is more lemonade in the taller glass. Later he or she will realize that the amount has remained the same.

How are we to understand the change taking place in the mind of the child? Two answers to this question seem to me crucial for any discussion of visual education. The first approach asserts that since the visual situation faced by the child suggests to him an incorrect judgment, the child must learn to distrust what he sees, to withdraw from the perceptual evidence and to solve the problem in a nonperceptual realm—"abstractly," "intellectually," "conceptually."

What exactly do these terms mean? Negatively, their message is clear: intellectual maturity requires withdrawal from the senses. But what do they suggest positively? Here the answers tend to be disappointingly vague. We may be told that the successful thinking of the older, more mature child takes place in the verbal realm. However, a moment of reflection reminds us that words are mere conventional shapes whose meaning lies exclusively in what they refer to. Therefore thinking can be *aided* by words but certainly cannot take place in the verbal realm. Thinking must deal with the referents to which words point. But of what nature could those referents be, if they were not to be perceptual imagery or, in the broader sense, mental imagery?

Prepared for a conference on Visual Communication in Art and Science for the Australian National Advisory Committee for Unesco, Melbourne, January 1972.

We may also be told that successful thinking presupposes a switch from perception to action. For example, how does one arrive at the abstract concept of number? Not through perception, we are told, because when the child counts dogs, cherries, or pebbles, the difference in the appearance of these species of things supposedly hides the way they can be compared quantitatively. However, the operation of counting is the same in each case; and therefore it is on the basis of the counting that the abstract concept of number is said to be acquired. Some such reference to active handling as a principle of explanation can be found already in the theories of Henri Bergson.[1] Whether anybody holds the theory seriously in this form today I cannot tell. It is a strange theory. Would it not seem evident that one cannot go through the operation of counting without possessing the notion of number in the first place? And who would perform the operation for dogs, cherries, and pebbles alike unless he knew already that the concept of number applies to them all?

In the case of the conservation experiment, active operation provides a more convincing solution of the problem, but not one to be proud of. By watching the lemonade pour first into one glass and then into the other, one can indeed conclude that the quantity must be the same, contradictory visual evidence notwithstanding. To limit oneself to such behavior, however, would be unworthy of human intelligence. After all, the problem presented reliably by the eyes does exist. To simply drop it means to refuse to try to understand. Is this the accomplishment of the older, wiser, more successful child? Innate curiosity being what it is, is this lazy way out really the typical behavior of children?

The question of how one solves problems against contradictory perceptual evidence is, like most good questions, not a new one. Almost a century ago, Ernst Mach examined the nature of abstraction and in so doing pointed to an alternative approach to our problem.[2] Mach, too, stresses the importance of practical operations, but not as a means of replacing perception. On the contrary, practical operations serve to provide new sensory elements, and those new elements imply the abstraction. Suppose, says Mach, we notice, entirely against our experience, that a lever lifts a heavy load by means of a small one:

> We search for the differentiating factor, which the perceptual data cannot offer us immediately. Only when by comparing various similar facts we have observed the effect of the weights and the lengths of the

lever arms and have raised ourselves through our own activity to the abstract concepts of *moment* or *work*, only then the problem is solved.

He concludes:

Therefore, the conceptual manipulation enlarges and enriches the facts and in the end simplifies them again. For when the new decisive perceptual element, e.g., the measure of the lever moments, has been found, one watches from then on only that element, and the most varied facts resemble each other and differ from each other only by this element. Just as in intuitive understanding, so here also everything comes down to finding, emphasizing, and segregating the decisive sensuous elements. Research attains by a detour that which presents itself directly to intuition.

And finally:

After what I have shown, the nature of abstraction cannot be said to be exhaustively characterized, in Kant's manner, as negative attention. It is true that during abstraction attention turns away from many perceptual elements, but only in order to address itself to other, new perceptual elements, and this is precisely what counts.

If we take advantage of Mach's remarkably topical observations, how do we describe the child's successful performance in the conservation experiment? As a withdrawal from the perceptual evidence? Surely not. I remember, at the time when I was thinking about these problems, being struck by a parallel in what Patricia Carpenter, a professor of musicology, told me about her beginning students. "They have no trouble following a melodic line," she said, "nor do they find it difficult to understand a harmonic progression. But when it comes to listening to a Bach fugue, which requires that they stay with the horizontal and the vertical structure at the same time, they stumble."

This seems to be exactly the problem of the preconservation child. He can compare the heights of the two columns of liquid vertically; probably he can also compare the widths horizontally, but he cannot combine the effect of the two dimensions to one result. The difficulty in handling more than one dimension at a time is not limited to any particular age. Everybody meets it at its own level: the music student in the Bach fugue, the owner of a flat tire in the mysterious lifting power of the jack. And how does one find the solution? Not by abandoning the perceptual situation; because, although that situation poses the problem, it—and it alone—also contains the solution.

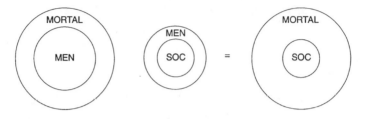

Figure 1. Leonhard Euler, Diagram of the Syllogism.

There is no realm to which one can escape from the evidence of the senses. The only open path leads straight ahead into the perceptual evidence itself. What is seen must be examined more deeply, more completely, according to a more complex model of interrelation. And here we realize the wisdom of what Mach said about abstraction. To abstract does not mean to leave the senses behind and to move to some no-man's-land of "pure" thought. It means to discover the crucial sensory elements within the problem situation itself or by comparison with other situations that are suitably similar and different. It means first to enrich the state of affairs by drawing in elements overlooked before, and then to simplify it by restricting observation to the few features that matter.

There is a long leap from the particular instances I have cited to the comprehensive assertion that abstraction never leaves the world of the senses behind. I cannot go here into the kind of psychological process that takes place when we think about a very general problem, such as the nature of freedom or the relation between individual and society. Suffice it to say that the imagery of abstract thinking is not limited to the tangible scenes of the physical world but often works most successfully with "pure shapes." Consider the pairs of circles that the mathematician Leonhard Euler drew in 1761 for the German princess to illustrate for her the logic of the syllogism (fig. 1). The traditional example says: If all men are mortal, and if Socrates is a man, then it follows that Socrates is mortal. Euler, however, depicted neither Socrates nor mortality. He used the abstract geometry of images that show nothing but what matters, namely, the relation of sizes.

Human thinking, then, is a continuum leading without break from the direct apprehension of the physical world to the most rarefied and universal concepts. At every level, it involves perception and conception, the concrete and the abstract. This seems to suggest that

the schooling of the human mind cannot be restricted in any field of learning to either the mere training of the senses or mere imageless thought. It must always employ an intimate union of both. And yet our educational system is still largely based on this schism. It conceives of the training of the intellect as a freeing of the mind from its sensory resources and considers the arts as an entertainment of vision, hearing and touch, below the level at which thought begins. To be sure, educational practice tends to circumvent this dogma to some extent. Good teaching and intelligent students search for practical examples, models, diagrams; and in the art room and studio much thinking is going on, although none is officially scheduled. Even so, the daily toll taken by the dogma is still heavy.

NOTES

1. Henri Bergson, *Matière et mémoire* (Paris: Presses Universitaires, 1946).
2. Ernst Mach, *The Analysis of Sensations* (New York: Dover, 1959), 321ff.

The Dynamics of Problem Solving

By a fortunate coincidence, I happened to learn about the work of Eugene A. Klotz, a professor of mathematics at Swarthmore College, who is doing innovative experiments on improving visualization in the teaching of mathematics for high school students. In the material he was good enough to send me, I came across a most enlightening diagram illustrating "Pythagorean variations." This diagram acquainted me with the fact, familiar to mathematicians but new to me, that the Pythagorean theorem is not limited to the relation between three squares. Although squares make for the simplest example of the theorem and also visualize the arithmetical squareness of the relation $a^2 + b^2 = c^2$, any shape such as figure 1 will meet the condition. Confronted with nothing but what this figure told me, I embarked on exploring the problem further: What range of generalization is compatible with the theorem, which states that the sum of the areas on two sides of a right triangle equals the area on the hypotenuse? Step by step, I was led through a broadening of the problem.

The first generalization, provided by figure 1, was that any shape placed on the three sides of a right triangle will meet the Pythagorean condition, once the three shapes are geometrically similar. At this point, Professor Klotz introduced me to another mathematician, Professor Doris Schattschneider of Moravian College, without whose generous help all my further questions would have remained unanswered.

My first question to her was: Are the variations of the Pythagorean figure limited to areas whose bases fit the three sides of the triangle? No, I was told. For example, circles whose diameters equal the side lengths of the triangle will meet the condition. Nor need the three shapes be geometrically similar. If, for example, the three basic squares are halved, their halves, whatever their shape, will obey the same condition as the full squares.

First published in *Gestalt Theory*, vol. 13, December 1991.

Figure 1. Variation of the
Pythagorean theorem.

Thus encouraged, I enquired further. Since the lengths of the triangle's sides, and therefore two of its angles, are variable, how about the third angle? Is the right angle indispensable for the Pythagorean condition? Again I was told that this is not the case. There are at least two ways of generalizing the Pythagorean theorem to any triangle. One of them, Pappus's theorem, states that "if parallelograms (not necessarily similar ones) are erected on two sides of any triangle, then another parallelogram can be constructed on the third side so that the area of the constructed parallelogram equals the sum of the areas of the other two."[1] The Pappus theorem contains the Pythagorean theorem as a special case.

What can be gleaned psychologically from this sketchy exploration? The decisive step toward a deeper understanding came when I was shown that the familiar piece of knowledge, the Pythagorean figure, was not bound to a particular shape. I note here that all problem solving has to cope with what I will call the fixating power of percepts. The more orderly a shape, that is, the better the gestalt, the more firmly a percept will impose itself on the memory, thinking, and learning of a person. The familiar figure depicting the Pythagorean theorem is particularly beautiful in its use of three similar shapes. Once this compelling shape has been fortified by tradition, it becomes all the more firmly tied to the geometrical theorem.

Progress of thought requires the overcoming of the fossilized shape—in our case, the discovery that squares are only one kind of shape among infinitely many, which are applicable. One component after the other of the given figure was questioned and found variable—the shape of the three attached figures, their attachment to

edges of the triangle, and finally the size of the crucial angle. The immobile shape of the original right triangle turns into a changeable figure with movable joints.

Max Wertheimer's study of the area of the parallelogram in his book *Productive Thinking* also takes off from the square as its base. The simplicity of the square's shape makes it one of the matrices for an infinite number of related shapes. This generalization, however, does not reduce the square to just one shape among all the others. Rather, throughout the whole analysis the square keeps and confirms its central structural position as the primary shape, to which all the others owe their basic nature—just as the size relation between the three areas remains the matrix for all the variations of the Pythagorean figure. This double character of the matrix is a decisive structural feature of shapes whose common nature we are trying to understand.[2]

In Wertheimer's study, the move from the original uniqueness of the square to the endless variety of rectangles is the first step toward understanding the structure of the parallelogram. It is indeed a "move" in that it comes about by a stretching or squeezing of the original object. It is a deformation of the original object. I consider it crucially important for the psychology of problem solving that the transition from one shape to the next be seen not simply as a sequence of static entities but as a dynamic deformation of the matrix into its variations.

Distinct sequences, however, are all that the printed page can show. A medium displaying movement, such as computer animation, convinces the eyes more directly how one shape leads to the next. The square undergoes a first deformation when we move to the rectangle and thereby transcend the notion that the four sides have to be of equal size. More clearly, a deformation results when in the next move the parallelogram gets rid of the equal size of the angles. Giving up the right angle also means giving up a strong aspect of the basic symmetry, which ties the mind to the original shape.

Once the deviations from the base of departure are recognized as dynamic moves, one comes to see that the variations within the structure of a figure are also dynamic processes. Wertheimer gives example in which by changing the placement of components the figure is transformed into a simpler one, that is, one offering the solution of the problem of how to determine the area of the figure. Moving a triangle from the left side of the parallelogram to the right side may turn a slanted figure into a manageable rectangle. The parts of the figure

have become mobile, detachable, amenable to positions that produce the desired structure.

Such an operation is not a mere reshuffling of pieces. When the figure representing the problem situation is viewed with the desired solution as the goal image, some of its components assume the character of being out of place. They exhibit dynamic pulls toward a different, better arrangement, and this dynamic restructuring of the whole figure constitutes the problem-solving process.

The generalization of the Pythagorean theorem, from which I started out, is a spectacular example of the dynamic restructuring of a figure at the service of productive problem solving. In this particular case, as in Wertheimer's study of the parallelogram, the problem consists in coming to recognize a given figure as the matrix of an infinite number of related variations. By revealing the wealth of this structural potential, we transcend the nearsighted fixation on a single, particular shape, whose finality had been taken for granted. We attain what Wertheimer describes as the grasping of the figure's inner structure, the true understanding of what was originally confined to the particular shape of the Pythagorean theorem.

One more example will illustrate the dynamic character of problem solving. I will slightly redraw two diagrams Wertheimer used in describing how an egocentric perspective distorts the structure of a situation. In this example, the problem-solving process does not issue from the simpler matrix, leading to a related complexity of shape, but takes off conversely from a distortion calling for simplification as the solution. In his parable of "a girl describing her office," Wertheimer uses the three-tiered structure of a company made up of its boss (B), two executives (Ego and E), and four staff members (A, C, D, F). Viewed from the distorted perspective of the Ego, the company presents a symmetrical arrangement focused upon the Ego. The boss appears properly in the center, but the rest of the staff is distributed at two levels of distance, determined by their relation to the Ego (fig. 2).

This distortion hides the equal weight of the two executives, Ego and E, in the hierarchy of the company and reveals an internal conflict between the structure as seen by the Ego and the actual, existing situation. The three-level hierarchy of the company and the corresponding distribution of the vectors do not fit the image given in figure 2. The result is a dynamic tension, similar to the subterranean forces preceding an earthquake, which pulls the given structure in

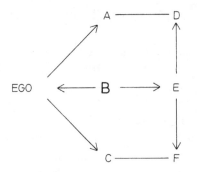

Figure 2. Self-centered view of social situation.

Figure 3. Distension by problem solving.

the direction of a better, more adequate gestalt. This dynamic re-structuring leads to a simpler figure whose symmetry is in harmony with the vectors inherent in it (fig. 3).

The solution of the problem consists in searching for the tensions inherent in the problem situation and using them as guides to the re-structuring they call for.

NOTES

1. Personal communication by Professor Doris Schattschneider.

2. Max Wertheimer, *Productive Thinking* (New York: Harper Brothers, 1959), 181–92.

Acknowledgments

I am indebted to the editors and publishers of the journals and books whose titles I have given in the text for permission to reprint essays first published by them. The paintings referred to below are identified at the places where they are reproduced in the text.

In addition, I owe thanks to

Mario Botta, architect in Lugano, for photographs of his Mogno church

Professor Walter N. Spink of Ann Arbor for the Warli painting

The Art Institute of Chicago for two copyrighted works by Gauguin

The Museum Folkwang in Essen for their painting by Gauguin

The Museum of Modern Art in New York for the copyrighted photograph of the Matisse painting

The Artists Rights Society of New York for reproduction of the Matisse painting

Ingeborg and Dr. Wolfgang Henze-Ketterer in Wichtrach/Bern for the copyrighted painting by Ernst Ludwig Kirchner on the cover.

New Directions, for permission to reprint "Human Being" and "Talking to Grief," from Denise Levertov, *Life in the Forest*. Copyright ©1978 by Denise Levertov. Reprinted by permission of New Directions Pub. Corp.

Index

Abstract paintings, 118
Adamson, Robert, 25
Aesthetics, 31–41, 65–77
Affordances, 13
Alberti, Leon Battista, 58, 81
Anabolic structure, 153
Anaximander, 76
Animation, 176
Anschauung, 123, 148
Architecture, 45–62; religious, 57–62
Aristippus, 73
Aristotle, 73, 97, 99, 144
Arithmetic, 116
Art as a property, 122
Art education, 118
Art history, 104–10
Assy, church of, 61
Attractors, 157
Authenticity, 24–30
Autun, 65

Bach, Johann Sebastian, 9
Bachelard, Gaston, 46
Ballet, 135
Balzac, Honoré de, 136
Bartenieff, Irmgard, 133
Baudelaire, Charles, 25, 92
Beauty, 34, 141
Beckmann, Max, 109
Beethoven, Ludwig van, 9
Bergson, Henri, 142, 169
Blatt, Sidney J., 13
Bohm, David, 157
Borromini, Francesco, 60
Botta, Mario, 57–62
Brecht, Bertolt, 109
Breughel, Peter, 158
Buddhism, 36, 83

Calder, Alexander, 50
Cameron, Jane, 127
Caravaggio, Michelangelo Amerighi,
 18, 80
Caricature, 143
Carpenter, Patricia, 171

Carpenter Center for the Visual Arts,
 Harvard, 55
Cartier-Bresson, Henri, 26
Carus, Carl Gustav, 142
Causality, 114, 147, 165
Cellini, Benvenuto, 40
Cézanne, Paul, 67
Chaos, 69, 156–62
Chemistry, study of, 117
Children's art, 120–25
Children's thinking, 169
Chuang Tzu, 6
Clausius, Rudolf Julius, 157
Cognition, 17–23, 69
Cognitive psychology, 123
Color, 65
Competition, 9
Computers, 52–56
Concavity, 44, 47
Concepts, perceptual and intellectual, 122
Condillac, Étienne Bonnot de, 148
Conformity, 167
Consciousness, 144–50
Conservation, 169
Contemplation, 73–76
Convexity, 44, 47
Corneille, Pierre, 98
Crafts, 33–41
Creativity, 92
Cubism, 67
Curie, Pierre, 152

Dance, 133–36, 154
Daumier, Honoré de, 85
Deformation, 176
Degas, Edgar, 90
Dembo, Tamara, 13
Democracy, 10
Descartes, René, 102, 147
Design, 39, 52–56
Determinism, 102
Dilthey, Wilhelm, 165
Dirac, P. A. M., 40
Disorder, 69, 157, 158
Donatello, 105

Down's syndrome, 127
Drama, 97–103
Drawings, 52–56
Dynamic direction, law of, 152
Dynamic forces, 149
Dynamics, 93, 134, 152, 176

Eddington, Arthur Stanley, 146, 152
Egocentrism, 177
Einstein, Albert, 149, 152
Empson, William, 71
Entropy, 152, 157
Equilibrium, 152, 157
Escher, Cornelis, 70
Ethics, 11
Euler, Leonhard, 172
Euripides, 99
Expression, 133–43

Fechner, Gustav Theodor, 36
Fein, Sylvia, 124
Figure and ground, 46, 71
Film, 24–30, 108
Focillon, Henri, 45
Folk art, 20
Folkcraft movement, 33–41
Forain, Jean-Louis, 85
Forces. *See* Dynamics
Form, 151–55
Foucault, Michel, 94
Francé, Robert H., 153
Frederic II, 101
Free will, 101
Freud, Sigmund, 96, 99, 105, 146

Galilei, Galileo, 60
Gardner, Howard, 123
Gauguin, Paul, 85–91
Geisteswissenschaften, 165
Genesis, book of, 79
Geppert, Dietmar, 130
Gestalt psychology, 4, 105, 109,
 154–59, 175
Gibson, James J., 13
Giotto di Bordone, 85
Gislebertus, 65
Gluck, Christoph Willibald, 9
Gnostics, 80
Goethe, Johann Wolfgang von, 81
Goldschmidt, Adolph, 104
Goldschmidt, Gabriela, 53
Gruisinger, Shan, 13

Hamada, Shoji, 34
Hardy, G. H., 40
Hartmann, Eduard von, 146

Heath, Tom, 34
Hedonism, 73
Hegel, Georg Wilhelm Friedrich, 81
Hegeso, monument of, 69
Heisenberg, Werner, 147
Herbert, George, 80
Herrigel, Eugen, 83
Hildebrandt, Edmund, 105
Hildreth, Gertrude, 124
Hill, David Octavius, 25
History, study of, 116
Hokusai, 95

Ibsen, Henrik, 100
Idiographic science, 166
Illumination, 80
Impressionists, 67, 79, 107
Individuality, 166
Infinity, 43
Inside and outside, 45–51
Instinct, 92
Intelligence, 117
Intelligences, 123
Invariantentheorie, 156

Janson, Horst W., 109
Japan, 33

Kabuki dancers, 135
Kant, Immanuel, 141
Katsura Palace, 37
Katz, David, 135
Kauffmann, Hans, 105
Kepler, Johannes, 60
Kläger, Max, 127
Klee, Paul, 120
Kleist, Heinrich von, 101
Klotz, Eugene A., 174
Köhler, Wolfgang, 152
Kooning, Willem de, 69
Korb, Werner, 117
Korea, 34
Kracauer, Siegfried, 26
Kretschmer, Ernst, 140
Kris, Ernst, 129

Laban, Rudolf, 133
Lamartine, Alphonse de, 27
Lamb, Warren, 135
Language, 22, 123
Lassenberger, Willibald, 127
Lavater, Johann Kaspar, 139
Lawfulness, 165
Leach, Bernard, 33
Learning, 13–16, 113–19
Le Corbusier, 55, 61

Leibniz, Gottfried Wilhelm, 161
Leonardo da Vinci, 60, 83, 105
Levertov, Denise, 93
Lévy-Bruhl, Lucien, 129
Lewin, Kurt, 14
Lewis, Dori, 133
Light, 78–82
Lipps, Theodor, 107
Lipchitz, Jacques, 61
Loos, Adolf, 37

Mach, Ernst, 144, 152, 169
Manet, Edouard, 66
Matisse, Henri, 61, 160
Metaphors, 149
Michelangelo Buonarotti, 60
Michotte, Albert, 115
Mitchell, William J., 29
Molière, 97
Monads, 161
Mondrian, Piet, 66
Monism, 144
Moore, Henry, 48, 107
Motivation, 73
Movement, 133–36
Munch, Edvard, 90

Naturalism, 120
Naturwissenschaften, 165
Newspapers, 17
Newton, Isaac, 36
Nietzsche, Friedrich, 76
Nomothetic science, 166

Okakura, Kakuzo, 37
Okinawa, 38
Order, 154
Ostwald, Wilhelm, 150
Outside. *See* Inside and outside
Ovid, 161

Panofsky, Erwin, 60, 67
Pappus's theorem, 175
Parallelism, 144
Perception, 169–73
Perspective, inverted, 122
Petit, Jean, 57
Petrarca, Francesco, 95
Pevsner, Nikolaus, 49
Photography, 24–30
Physics, 146
Physiognomics, 139
Piaget, Jean, 106
Picasso, Pablo, 7, 39, 105
Planck, Max, 153
Plastic surgery, 139

Plato, 78
Platonism, 80
Pleasure, 73
Poetry, 93
Poseidon, 83
Pottery, 34
Pozzi, Giovanni, 60
Prägnanz, 154
Pre-logical thinking, 129
Prigogine, Ilya, 156
Primitivism, 91, 120
Prinzhorn, Hans, 126
Problem solving, 53, 174–79
Psychiatry, 126, 140
Psychoanalysis, 66, 105
Psychology, 102
Pythagorean theorem, 174

Racine, Jean, 100
Radio, 108
Rausch, Edwin, 66
Reflex, 92
Rejlander, Oscar G., 27
Relativity, 156
Rembrandt van Rijn, 105
Restructuring, 177
Retardation, 126–32
Rivera, Joseph de, 13
Ronchamp, chapel at, 61
Rouault, Georges, 61
Rousseau, Jean-Jacques, 4
Rubin, Edgar, 46
Rubin, William, 61
Rudofsky, Bernard, 38
Rutz, Ottmar, 140

Saint-Servin, Toulouse, 49
San Carlo alle Quattro Fontane, 60
San Francesco, church of, Assisi, 85
Sant' Apollinare in Classe, 66
Schaefer-Simmern, Henry, 123
Schapiro, Meyer, 71
Schattschneider, Doris, 179
Schöne, Wolfgang, 80
Schrödinger, Erwin, 151
Sculpture, 83
Shakespeare, William, 139
Shape, 151–55
Skeleton, 40
Socrates, 76, 78
Sophocles, 99
Space, 42–51
Spinoza, Baruch, 102, 148, 165
Statue of Liberty, 47
Stengers, Isabelle, 156
Structural skeleton, 40, 54

Structural theme, 153
Structure, 3–12
Stumpf, Carl, 150
Syllogism, 172
Symbolism, 78–82, 93, 96

Television, 17, 124
Theater, 97–103
Titian, 66
Toepffer, Rodolphe, 142

Uelsmann, Jerry, 27

Valence (*Aufforderungscharakter*), 16
Valéry, Paul, 5, 76
Varnedoe, Kirk, 91
Vasarely, Victor de, 70
Vence, chapel of, 61
Verrochio, 105

Vischer, Robert, 107
Visual aids, 117
Vitruvius, 83
Volkelt, Johannes, 107

Warli tribe, 20
Weill, Kurt, 109
Wertheimer, Max, 10, 176
Wholeness, 156–62
Windelband, Wilhelm, 166
Wittkower, Rudolf, 60
Wölfflin, Heinrich, 107
Wood, John, 49
Wundt, Wilhelm, 107

Yanagi, Soetsu, 33
Yoga, 76, 83

Zen Buddhism, 83

Compositor: BookMasters, Inc.
Text: 10/13 Palatino
Printer: Data Reproductions Corp.
Binder: Data Reproductions Corp.